The Poet's Brush

郭繼生著

詩人筆墨

羅青墨彩世界

蕭滬周澄題

Also by Jason C. Kuo

Wang Yuanqi de shanshuihua yishu [Wang Yuanqi's Art of Landscape Painting]
Long tiandi yu xingnei [Trapping Heaven and Earth in the Cage of Form]
Innovation within Tradition: The Painting of Huang Pin-hung
The Austere Landscape: The Paintings of Hung-jen
Word as Image: The Art of Chinese Seal Engraving
Zhuang Zhe, 1991–92
Cuo wanwu yu biduan [Embodying Myriad of Things at the Tip of Brush]
Chen Qikuan
Yishushi yu yishu piping de tansuo [Rethinking Art History and Art Criticism]
Art and Cultural Politics in Postwar Taiwan
Yishushi yu yishu piping de shijian [Practicing Art History and Art Criticism]
Transforming Traditions in Modern Chinese Painting: Huang Pin-hung's Late
　　Work
Chinese Ink Painting Now
The Inner Landscape: The Paintings of Gao Xingjian
Lo Ch'ing: In Conversation with the Masters

As Editor

Meigan yu zaoxing [Sense of Beauty and Creation of Form]
Luo Qing huaji [The Paintings of Luo Qing]
Dangdai Taiwan huihua wenxuan, 1945–1990 [Essays on Contemporary Painting
　　in Taiwan, 1945–1990]
Born of Earth and Fire: Chinese Ceramics from the Scheinman Collection
Heirs to a Great Tradition: Modern Chinese Paintings from the Tsien-hsiang-chai
　　Collection
The Helen D. Ling Collection of Chinese Ceramics
Taiwan shijue wenhua [Visual Culture in Taiwan]
Discovering Chinese Painting: Dialogues with American Art Historians
Understanding Asian Art
Double Beauty: Qing Dynasty Couplets from the Lechangzai Xuan Collection
　　(with Peter Sturman)
Discovering Chinese Painting: Dialogues with Art Historians
Visual Culture in Shanghai, 1850s–1930s
Perspectives on Connoisseurship of Chinese Painting
Stones from Other Mountains: Chinese Painting Studies in Postwar America
Contemporary Chinese Art and Film: Theory Applied and Resisted

The Poet's Brush

Chinese Ink Paintings
by Lo Ch'ing

Jason C. Kuo

New Academia Publishing
in association with
Center for Art, Design, and Visual Culture,
University of Maryland, Baltimore County

Washington, DC

Library of Congress Control Number: 2016941797
ISBN 978-0-9974962-4-6 hardcover (alk. paper)

NEW ACADEMIA PUBLISHING | 4401-A Connecticut Ave., NW #236 - Washington DC 20008
info@newacademia.com - www.newacademia.com

Contents

List of Illustrations

Height precedes width and, unless otherwise indicated, all paintings are on paper. All illustrations are provided courtesy of the artist.

Acknowledgments

I am very grateful to Lo Ch'ing for many conversations and much generosity with material and information.

Research for this book has been made possible by generous support from the University of Maryland, College Park, including a semester Research and Support Award from the Graduate School during the 2010–11 academic year and a sabbatical leave during the 2012–13 academic year.

I also wish to thank the following units for their support and contribution: the Art Gallery, the Department of Art History and Archaeology, the Center for East Asian Studies, the Wang Fangyu Endowment for Calligraphy Education.

I also would like to thank many colleagues at the University of Maryland, especially Meredith Gill, Minglang Zhou, Robert Ramsey, Michele Mason, and Janelle Wong for their support and encouragement. The technical support of Ania Waller, Theresa Moore, and Deborah Down in the Department of Art History and Archaeology, and Quint Gregory of the Michelle Smith Collaboratory for Visual Culture, part of the Department of Art History and Archaeology, is very much appreciated.

I thank Ruoyu Zhu for her research assistance; her patience, intelligence, and organizational skills are simply remarkable. I would also like to thank Raino Isto, Suzie Kim, Lindsay Dupertuis, Connie Rosemont, and Yi Zhao, students in my graduate seminars, for their stimulating conversations. Rebecca McGinnis has kindly read the manuscripts and made useful suggestions. I am very grateful to her for her insights and suggestions. I also thank Leqi Yu, now a graduate student at the University of Pennsylvania, for providing very valuable research assistance.

I am most grateful to Symmes Gardner, Executive Director of the Center for Art, Design, and Visual Culture (CADVC) at the University of Maryland, Baltimore County, for his support and advice. For their enthusiasm, patience, generosity, and inspiration, I am grateful to Joseph Allen, Thomas Rose, Paul Manfredi, and Christopher Lupke.

Once again, Joel Kalvesmaki's editorial expertise has made my job much easier.

Jason C. Kuo

Note on Transcription

In general, the Wade-Giles system of transcribing Chinese names and terms is used in this book. Exceptions include self-chosen names of modern Chinese scholars and artists (such as Mayching Kao), names and terms in titles of publications using different systems of transcription (such as the pinyin system), and a few names in Southern Chinese dialects. Japanese names and terms are transcribed according to the modified Hepburn system.

The Poet's Brush:
Chinese Ink Paintings by Lo Ch'ing

Lo Ch'ing 羅青 (pen name; born Lo Ch'ing-che 羅青哲) is one of China's foremost contemporary poet-painters. An inheritance and renewal of the Chinese ink-color painting and calligraphy traditions, Lo Ch'ing's art has been hailed as the starting point of postmodern poetry, as well as a significant milestone in a new phase of literati painting. Lo Ch'ing is recognized with critical acclaim both in mainland China and in Taiwan as one of the leading artists of his time. His poetry has been translated into English, Italian, French, German, Spanish, Russian, Hebrew, Dutch, Swedish, Czech, Japanese, and Korean. His paintings have been exhibited and collected in many countries, and are now in public museums such as the British Museum, the St. Louis Art Museum, the Royal Ontario Museum (Canada), Museum für Ostasiatische Kunst (Berlin), the Ashmolean Museum (Oxford), Asia Society (New York), the National Taiwan Art Museum (Taiwan), the National Art Museum of China, and the Origo Family Foundation (Switzerland). His paintings are also featured in standard college art history textbooks such as *Art and Artists of Twentieth-Century China* by Michael Sullivan (University of California Press, 1996) and *Art in China* by Craig Clunas (Oxford University Press, 1997).

Lo Ch'ing reinvented ink color painting and calligraphy in the twentieth century by mingling imageries and styles of the deep past with the poignant present, and has opened new windows for artists in the twenty-first century. His works of art have won him numerous national and international critical acclaim both in the East and the West. Despite their intimate bond with Chinese classical civilization, many of his ink paintings are more audacious and more idealistic than much of what is being produced by contemporary Chinese artists who are regarded as avant-garde.

Lo Ch'ing's paintings come across as visually astonishing, harmonious compositions devoid of any extravagant or superfluous elements. For the artist, the surface of the paper becomes a field where ink colors

and brushwork play a key role. His imagery consists of monochromatic colors (often primary). His works are segmented tactile compositions, often created with calligraphic brush strokes, which make for a restrictive compartmentalized work structure, reminiscent of the Windows operating system. The results are ambiguous spaces in which shapes resembling geometric diagrams are filled with all sorts of juxtaposed or contrasted scenes.

The struggle of contemporary Chinese artists to assert their relevance to the immensely long and culturally essential tradition of ink painting and calligraphy is fascinating, and has led to great ingenuity, imagination, and groundbreaking creativity. Indeed, this attempt to develop a new pictorial and graphic language meaningful to life today resembles the fundamental transformation of the art of the West, indeed its entire culture, at the beginning of the twentieth century. At that time artists, musicians, and writers were struggling to express the vast changes in society ushered in with the Industrial Revolution. By abandoning oil painting and traditional hierarchies of media, they manifested new ideas about representation and the very ontology of art.

So too in China. Despite being reviled and denigrated for many decades as symbols of the decline of Chinese civilization by many Chinese reformers, and neglected until recently by mainstream Western scholars, modern Chinese painting actually embodies the heroic story of the renewal and reinvigoration of Chinese civilization amid rebellions, reforms, and revolutions. Even if the process appears confusing and bewildering, it demonstrates the persistence of tradition and the limits of continuity and change in modern Chinese culture.

Chinese artists today continue to try to create pictorial and graphic languages that can capture the transformation of Chinese society, a transformation that has intensified in the last four decades. New ink painting and calligraphy seem to be gathering momentum and attracting increased attention because they so clearly embody fundamental values: highly accomplished pictorial and graphic techniques allied with serious conceptual content. This is in contrast to the often hasty, slapdash, and ostentatious productions of Chinese artists working in styles more obviously derived from contemporary global art.

Lo Ch'ing began his formal study of Chinese painting and calligraphy at the age of thirteen. He studied the traditional blue-and-green landscape style under Pu Hsin-yu 溥心畬 (1896–1963, a cousin of the Last Emperor of China, Pu Yi 溥儀), a master of the Northern School of painting. Later, under Juyu 入迂, a Ch'an Buddhist monk, he learned

the impressionistic "splashing ink" style of the Southern School (Lo Ch'ing's early work can be seen in figs. 277–318). At the same time, he began to write modern poetry with new calligraphy, trying to revitalize the time-honored poetry-calligraphy-painting tradition initiated in the eleventh century and to usher it into the postindustrial world.

The age-honored heritage of ink-color landscape painting that shaped Lo Ch'ing's training has also represented traditional China well. Before the twentieth century, Chinese landscape painting, one of the major graphic vehicles by which artists conveyed their philosophical ideas and lyrical sentiments, served as artists' spiritual self-portraits.

Lo Ch'ing is convinced that it is now time to reinvent Chinese landscape painting, with multiple new approaches that live up to the times. The solid mountains and peaks of old will have to travel around the world, even to outer space, being dismembered, disseminated, and reorganized into different constellations of floating rocks, what he calls the DNA of Chinese landscape painting, to reflect the newly born Chinas that have emerged from a worldwide mixture of agrarian, industrial, and postindustrial ingredients.

Lo Ch'ing employs multiple aesthetics and techniques to portray different historical phases experienced by the Chinese people over the past 175 years in mainland China, in Taiwan, and around the world. His symphony of linear movements is intertwined with carnivals of colors. His new ink-color landscape paintings are at once traditional, modern, and postmodern, parallel to Taiwan's experience over the past sixty years, a marvelous combination or overlap of agriculture, industry, and postindustry moving side by side, braving the turmoil and vicissitudes of different national and international climates. Pastoral lyricism melds with urban modernism, cynicism with good humor, and criticism and satire with universal love and understanding. The graphic language of his paintings mixes with the verbal language of calligraphy. The poetics of his inscriptions merge with the aesthetic principles of the compositions.

In the past 175 years, since the Opium War of 1840, China has been moving from an agrarian society to an industrial one, and, in the last two decades, has merged into a postindustrial one with dazzling speed. The "traditional China" that was nourished and hatched in an agricultural milieu was smashed in the late nineteenth century by an invasive Western industrial expansion. The dismembered pieces of this mirror not only scattered throughout China proper but followed the footsteps of overseas Chinese, and were disseminated across many countries all

over the world. In Lo Ch'ing's painting and calligraphy, examples of his internalization of the conflicting states of tradition, modernity, and postmodernity are abundant, and the mixing of realistic and impressionistic techniques to create groupings of surrealistic images is too conspicuous in his works for anyone to miss.

While reflecting external worlds, Lo Ch'ing's newly invented landscape painting also delineates sophisticatedly and faithfully his internal spiritual pilgrimage from an agrarian past to the postindustrial present. Just as many intellectuals advocated reforms in the social and political arenas, they also espoused changes in painting. Two main approaches to "new" Chinese painting emerged. One was the eclecticism offered by K'ang Yu-wei 康有為 (1858–1927), an influential Confucian scholar, an advocate of moral, economic, and political reform, and a central figure in the failed Hundred Day Reform of 1898. The other approach espoused total rejection of tradition and was propounded by Ch'en Tu-hsiu 陳獨秀 (1879–1942), founder of the influential iconoclastic journal *Hsin-ch'ing-nien* 新青年 (*New Youth*), cofounder of the Chinese Communist Party, and one of the most important figures in the May Fourth Movement, a "New Culture" movement that brought in a new era of modern Chinese cultural history.

For several decades following 1949, under the newly established and largely insular People's Republic of China, three approaches to painting contended for official recognition and support in mainland China: conservative traditional Chinese painting; Soviet-derived Socialist Realism; and a narrowly defined synthesis of Chinese and Western art based on earlier importations.

These three strains have continued to endure, in one form or another. Nevertheless, many modern Chinese painters, no matter their circumstances, share one common trait: contact with contemporary Western art. But they have not merely imitated it; instead, they have rediscovered the abstract and expressionistic possibilities in their own tradition. It is in this sense that they are heirs to the great tradition of Chinese painting. Many modern Chinese artists, having been trained in the Western tradition by studying abroad, have succeeded in transforming Chinese tradition and rejuvenating it without appearing "Westernized," exemplifying the excellence of a modern Chinese artist. Through their synthesis of the theories, techniques, and styles of traditional literati painting, they have been able to achieve innovation that enriches the tradition. Many great modern Chinese painters have shown ways to resolve the tension between the effort to modernize and the desire to retain a traditional cultural identity in modern Chinese history.

Lo Ch'ing owes much of the internalization and the naturalization of his experimental ink work to the facts that he practices it in Taiwan and that his subject matters are distinctively Taiwanese. The "Chinese tradition" takes a not-so-subtle turn in the Taiwanese environment. Indeed, Taiwan was the most fascinating place for experimentation, particularly during the late 1970s to 1980s, when Lo Ch'ing rose to fame. The rise of industrialization, postindustrialization, and the intriguing issue of Taiwan's cultural identity created a nurturing and controversial ground for creative talents.

As a Newly Industrialized Country (NIC), Taiwan has been regarded as one of the Four Little Dragons (along with South Korea, Hong Kong, and Singapore) because of her recent economic "miracle." Her economic success helped to place the small island on the international map as the import-export gateway to East Asia. When Taiwan was under Japanese rule (1895–1945), struggling to maintain a sense of authenticity and Taiwanese cultural integrity, it was not nearly as problematic for the island to include foreign (Western) cultural experiences and influences that accompanied the rapid exchange of goods. In the aftermath of Japanese rule, that straightforward self-expression became at once more difficult and promising. In fact, Taiwan's complicated political and cultural past is directly related to its ability to thrive economically under the international spotlight. Whether accepting nonnative culture, repelling it, or both, the island is at its best when it pays attention to newness, changes, and differences.

Her cultural development has also received international scholarly attention, particularly in literature, film, music, and dance. Her visual arts in general and painting in particular, however, have received little, if any, attention in comparison with those on mainland China.[1] During the second half of the 1940s and throughout the 1950s, painting from Taiwan tended to be conservative and reflected strong government control in cultural policies, mainly because of postwar economic hardship, political instability, and military threats from mainland China. The controversy over the orthodoxy of a "national painting" (kuo-hua 國畫) exemplifies the tension between the legacy of Japan's fifty-year colonization of Taiwan and the assertion of power and legitimacy of the Nationalist government.

Cut off from the legacy of the modern art movement initiated by Hsu Pei-hung 徐悲鴻, Liu Hai-su 劉海粟, Lin Feng-mien 林風眠, and others who remained on mainland China, painting from Taiwan in the

1 Jason C. Kuo, *Art and Cultural Politics in Postwar Taiwan* (Taipei: SMC Publishing, 2000).

late 1950s and throughout the 1960s was characterized by the rise of a modernist movement in which young artists of the "Fifth Moon (*Wu-yüeh* 五月) Group" sought to combine Chinese tradition of ink painting with Abstract Expressionism and other currents of contemporary Western art. This movement paralleled a modernist tendency in poetry and fiction, seen in the work of the writers associated with the literary periodical *Hsien-tai wen-hsueh* 現代文學 (*Modern Literature*). Some of these writers in their critical essays lent their support to modernist painters, but the cultural establishment, still dominated by formal and informal state control, was not supportive and the modernist movement in painting, despite support from a handful of intellectuals and some foreign patrons residing in Taiwan, declined toward the end of the 1960s.

Taiwan experienced tremendous economic growth in the 1970s, but at the same time was frustrated by diplomatic setbacks with her expulsion from the U.N. and derecognition by the United States. A heated debate on a nativist literature (*hsiang-t'u wen-hsüeh* 鄉土文學 or Literature of Hometown and Soil) developed as a middle class arose, as the social and economic structure changed, as Taiwan underwent a crisis of identity within the international community, and as a political opposition emerged. Similarly in painting, a search for nativist roots was launched; folk arts and local antiques became the sources of inspiration, and depiction of the land and the people of Taiwan became fashionable. The work of the Japanese-trained, first generation of western-style painters began to be rediscovered and aggressively marketed just as interest in local history grew and political power became Taiwanized.

In the 1980s, with increasing liberalization of state cultural policies and the tendency toward pluralism in social, economic, and political arenas, art in Taiwan experienced a parallel instability, fragmentation, and commodification. Genres became blurred, and art suffered the loss of a grand metanarrative, as was the case in many other postindustrial, late capitalistic, and postmodernist societies. Interest in marginality, otherness, and difference can be found in Taiwanese intellectuals' questioning of the role of art museums, the cultivation of a nativist cultural identity, the emergence of alternative spaces for exhibiting art, and the heterogeneous pastiche in emergent art. The emphasis on the primacy of form in the modernist movement of the 1960s was replaced in the 1980s with an emphasis on social and political content.

Taiwan's industrialization and postindustrialization are central subjects in Lo Ch'ing's work. His painting shows a heightened awareness in its presentation of subjects and their modern and postmodern

environments. Certainly, there is an oddity in Lo Ch'ing's depiction of alien saucers and floating rocks and mountains, yet precisely for that very reason his work presents a fresh curiosity that had not been explored in the practice of ink painting.

Lo Ch'ing is probably one of the few contemporary Chinese artists to combine their own poems with ink paintings. Sometimes, inscribing titles or poems on painting can provide more information for viewers, but the inscription can be overemphasized, thereby demoting the painting into a mere illustration. From the Ming-Ch'ing dynastic periods (1368–1911) onward, such phenomena are numerous through Chinese art history (of course, this criticism is seldom applied to the well-known painters who are considered masters). Lo Ch'ing is aware of this problem. He believes that not every painting should have a title inscribed, and not every title should be extended to a poem; the most important thing is to explore the principle of the poetry-painting link in representations of "ideas beyond images" and "ideas beyond words."

Several scholars have commented on Lo Ching's poetry as well as the relationship between his poetry and painting. Joseph Allen has observed:

> [Lo Ch'ing's] creative strength lies in interpretation that yields an accessible but dynamic poetic language. Here is perhaps the height of that integration. Poem and painting interact in a synchronic stasis and diachronic flow, at once a moment and a progression, offered by the poet-painter but assembled by the reader-viewer. Lo Ch'ing has embraced traditional sensibilities and integrated them with non-traditional elements, offering us poetic configurations that are innovative and aesthetically harmonious.[2]

Perhaps one of the most important and well-known poems by Lo Ch'ing is "Six Ways to Eat a Watermelon," written in December 1970:[3]

2 Joseph R. Allen, "Lo Ch'ing's Poetics of Integration: New Configurations of the Literati Tradition," *Modern Chinese Literature*, 2, no. 2 (fall 1986): 143–69, at 165.

3 Translation taken from idem, "The Postmodern (?) Misquote in the Poetry and Painting of Lo Ch'ing," *World Literature Today* 65, no. 3 (summer 1991): 421–26, at 421. A slightly different translation is in idem, *Forbidden Games and Video Poems: The Poetry of Yang Mu and Lo Ch'ing* (Seattle and London: University of Washington Press, 1993).

Six Ways to Eat a Watermelon

The Fifth Way: Watermelon Lineages

No one would confuse watermelons and meteorites
Watermelons have nothing in common with starry nights
But we must admit that the earth is a satellite of sorts
Thus it is difficult to deny that watermelons and stars have
No family ties

Since watermelons and the earth are not only
Parent and child, but also love each other like
Brother and sister, that love is as
The sun and moon, the sun and us, us and the moon
A
Like

The Fourth Way: Watermelon Origins

We live on the surface of the earth obviously
And obviously they live in their melon interior
We run to and fro, with our thick skin
Trying to stay on the surface
Digesting rays of light into darkness
That envelops us, envelops our cold-craving warmth

In Zen meditation they concentrate on one thought
Inside sculpting it into calm concrete passion
Always seeking their own fulfillment, their personal development
But in the end we cannot avoid being pushed into the watermelon
And they sooner or later will burst out

The Third Way: Watermelon Philosophy

The history of watermelon philosophy
Is shorter than that of earth
And longer than ours
No way
Not practicing see no evil, hear no evil, say no evil, Having noth-
ing to do with each other
The watermelon haves and have-nots

No envy for ovum, no disdain for egg
Neither oviparous, nor viviparous
Comprehending the principle of finding life in death

The watermelon does not fear invasion, nor cringe
Before destruction

The Second Way: Watermelon Domains

If we were to smash a watermelon
It would be for jealousy, for
Smashing a watermelon is the same as bashing a global night
And that is to dash the stars from the starry sky
And to mash the entire universe, flat

And as a result we would be more jealous
Yet, because then
The relationship of meteorite and melon seed,
The friendship of melon seed and universe
Would be even clearer, and would again sink its
Blade deep into our
Domain

The First Way: Let's Eat and Then We'll Talk

(translation by Joseph R. Allen)

吃西瓜的六種方法

第五種　西瓜的血統

沒人會誤會西瓜是隕石

西瓜星星，是完全不相干的

然我們卻不否認地球是，星的一種

故而也就難以否認，西瓜具有

星星的血統

因為，西瓜和地球不止是有

父母子女的關係，而且還有

兄弟姊妹的感情——那感情

就好像月亮跟太陽太陽跟我們我們跟月亮的

一，樣

第四種　西瓜的籍貫

我們住在地球外面，顯然
顯然他們住在西瓜裡面
我們東奔西走，死皮賴臉的
想住在外面，把光明消化成黑暗
包裹我們，包裹冰冷而渴求溫暖的我們

他們禪坐不動，專心一意的
在裡面，把黑暗塑成具體而冷靜的熱情
不斷求自我充實，自我發展
而我們終究免不了，要被趕入地球裡面
而他們遲早也會，衝刺到西瓜外面

第三種　西瓜的哲學

西瓜的哲學史
比地球短，比我們長
非禮勿視勿聽勿言，勿為——
而治的西瓜與西瓜
老死不相往來

不羨慕卵石，不輕視雞蛋
非胎生非卵生的西瓜
亦能明白死裡求生的道理
所以，西瓜不怕侵略，更不懼
死亡

第二種　西瓜的版圖

如果我們敲破了一個西瓜
那純粹是為了，嫉妒
敲破西瓜就等於敲碎一個圓圓的夜
就等於敲落了所有的，星，星
敲爛了一個完整的宇宙

而其結果，卻總使我們更加
嫉妒，因為這樣一來
隕石和瓜子的關係，瓜子和宇宙的交情
又將會更清楚，更尖銳的
重新撞入我們的，版圖

第一種　吃了再說

On this poem, Silvia Marijnissen has perceptively observed: The way he deals with the Chinese tradition, through his efforts to combine the techniques from different arts, gives him his own specific voice. Luo Qing's [Lo Ch'ing's] approach is essentially a parodic one, both in a serious and non-serious sense of the word: he uses the logic of a certain vocabulary, he plays around with a certain way of thinking and applies it in a different, new way. At the same time this poetry is, in approach and effect, linked with postmodern literature, although the combination of the tradition and postmodernism may sound paradoxical, since postmodernism has often been said to go beyond all borders, and thus to mark the end of all tradition. However, as seen in the above examples it is clear that [Lo Ch'ing] is reworking Chinese tradition, and that his work has several postmodern characteristics. These include autoreflection, meaning that the poem is dealing with the process of its own creation; fragmentation, the idea that unity cannot be attained in our shattered world;

parody; and of course playfulness and irony, in the sense that writing is seen as a game.[4]

In October 1979, Lo Ch'ing wrote the poem "Dew" in the lyrical tradition of Chinese poetry, but with a clear modern sensibility:

They say
I should not dwell in mountains so high
should not work in the scorching gorges so deep
They say
I should not hide
Secluded within my many different rooms
With my dead branch like fingers
Painting white clouds, dream fantasies
All over the floor, the walls.

But they don't know
When darkness returns
From where I come,
Those many-splendored clouds
Will silently float out
Hovering above the most drought places
Transforming into sounds
Of intermittent showers.

(translation by Nancy Ing)

4 Silvia Marijnissen, "Digesting Tradition: The Poetry of Luo Qing," in *The Chinese At Play: Festivals, Games and Leisure*, ed. Anders Hansson et al. (London: Kegan Paul, 2002), 197–98.

甘露

他們說我不該隱居在那麼高冷的山上
更不該工作在那麼深熱的谷底
說我不該整天關在不同的屋裡
用瘦如枯枝的手掌
畫如夢如幻的白雲
畫得滿牆滿地都是

他們卻不知
當黑夜從我去的那個地方回來時
牆上地上那些多采多姿豐滿無比的白雲
便會悄悄飄了出去
在最苦最旱的地方
化做雨聲陣陣

As a poet, Lo Ch'ing is keenly familiar with the long Chinese tradition of integrating poetry and painting. In the Northern Sung Dynasty (960–1126), poets and critics such as Su Shih 蘇軾 (1037–1101) insisted on the unity of poetry and painting. Su Shih said: "Poetry and painting are the same; both should be natural and fresh." He also said: "When one savors Wang Wei's 王維 (701–78) poems, there are paintings in them; when one looks at Wang Wei's paintings, there are poems."[5] Fang Hsun 方薰, an eighteenth-century critic, pointed out: "Inscribed paintings began from Su [Shi] and Mi [Fu], and flourished in the Yuan and Ming Dynasties. Put inscriptions on paintings, so the paintings can benefit from inscriptions and have more lofty sentiments and elegant thoughts; the inscriptions also make up for weaknesses in the paintings. Later periods were influenced by this phenomenon."[6]

5 Quoted in Susan Bush, *The Chinese Literati on Painting: Su Shih (1037–1101) to Tung Ch'i-ch'ang (1555–1636)* (Cambridge, MA: Harvard University Press, 1971), 188.
6 Quoted in Yu Chien-hua, *Chung-kuo hua-lun lei-pian* (Taipei: Ho-lo, 1975), 241.

In the history of Chinese painting, the earliest to put inscriptions on paintings was the Yuan painter Chao Meng-fu 趙孟頫 (1234–1322). For example, in his short handscroll *Sheep and Goat* (ca. 1300–1305, now in the Freer Gallery of Art, Washington, D.C.), the painter inscribes on the left: "I have painted horses, but never painted goats. Because Chunghsin requests such a painting, I playfully paint it from life. Although this piece cannot compare with ancient masters' art, they more or less match up in spirit."[7] This inscription not only points out the painter's intention and gives viewers hints about the painting's meaning but also organizes the composition. Two goats form a circle on the right side of the painting, and the inscription fills the empty space on the left.

Obviously, Lo Ch'ing has made an effort to place inscriptions on his paintings as well. For example, *Life, a Taxi Ride,* a work in his series Asphalt Road Variations, is composed of two wide ink lines, fading from the bottom upward, that form the asphalt road. Two trees scatter and spread to either side, and a red taxi at the bottom left is the focus (fig. 124). He inscribes his poem:

> Life is a bumpy, dark road.
> The scenery to the sides sometimes is incomplete, and sometimes complete.
> But we are all guests in the taxi;
> Cannot control our own fate, constantly moving forward.
> The distance is calculated;
> The time is also calculated;
> But the taxi fee must be paid with our lives.

> 命運是一條顛躓灰暗的路
> 兩旁的風景有時殘缺有時圓滿
> 而我們都是計程車中的過客
> 身不由己，不斷向前進行
> 距離計程
> 時間也計程
> 車費則一定要用生命來支付

Lo Ch'ing cleverly inscribes the sentences "the distance is calculated; the time is also calculated" opposite to the red taxi, thus allowing the adorning poem to be part of the whole composition, as well as an integral part of the whole meaning. His depiction of the movement of

7 Conveniently reproduced in Norinda Neave, Lara Blanchard, and Marika Sardar, *Asian Art* (New York: Pearson, 2015), 188.

an asphalt road represents the pulse of modern urban life in Taipei. In such works, the phenomena of "images inside images" and "worlds inside worlds" exemplify the great fusion of his rationality and sensibility.

Chinese literati painting is part of a glorious tradition that has lasted around nine hundred years. But nearly all old customs become unavoidable burdens for artists. After such a long time, what should be said has been said, and the potential for a painter's creativity has decreased. However, the hope for innovation is not lost. If we do not treat creation as the most important and necessary tool of the aesthetic process, but rather if we regard creation as the painter's interpretive prerogative when he faces all external phenomena of his world and the artistic traditions that preceded him, then we are unlikely to use the concept of creation as a synonym for art. Furthermore, we will not feel disheartened or discouraged by the burden of tradition, or even unnecessarily submit to its perceived authority and significance.

Lo Ch'ing's work provides us with an opportunity to think about this issue. With a consistently experimental spirit, he attempts to broaden the subjects of Chinese ink painting and poetry. For example, Lo Ch'ing has written many poems on the palm trees seen everywhere in subtropical Taiwan, including "The King Palm," written for the 2001 "Markers: Outdoor Banner Event of Artists and Poets" in Venice:

If it were in daytime
I should have been a dark green brush
With golden sunshine painting my gossamery dream
Ascending and transforming into white clouds
It will soar up to the zenith of the world
Descending and dissolving into spring rain
It will visit the lowest ditch on earth.

If it were in nighttime
I should have been a pale green torch
Slicing and burning the darkness into ashes of fireflies
Ascending the firefly radiates into a meteor
Scratching to awaken a sky of timid stars
Descending the firefly concentrates into an ebony match
Striking to light up the smallest stove in the world.

However, it is now
A thick misty smoggy day
I am, alas, nothing but
A broken green bloom.
Leaning against
A lonely forsaken wall
Cobwebbed with refuse and dust.

(Translation by Stefan Hyner and Lo Ch'ing)

大王椰子

要是在青天白日下
我一定是一支墨綠色的毛筆
蘸金色的陽光畫透明的夢幻
夢幻上昇化做白雲
飛臨世上最高的頂峰
夢醒下降化做春雨
拜訪地下最低的溝渠

要是在冷風夜晚裡
我一定是一支青綠色的火把
焚片片黑暗成點點螢火
螢火向上猛衝　化成火柴一根
用力化亮漫天膽怯閃躲的星斗無數
螢火向下浪遊　化做流星一顆
輕輕點燃違章建築中小小的爐火一個

可是現在　現在卻是一個

陰雲迷霧紅塵污染人人發昏的黃昏

而我也只能是一支

斜靠在廢牆角的慘綠掃把

任由一大群語言律法的蜘蛛

在體內體外穿梭編織

一襲修辭華麗的壽袍

Lo Ch'ing's experimental spirit is also reflected in the interaction of painting and inscription, especially in his poetry-painting album *Ode to Palm Trees* (plates 1–8).

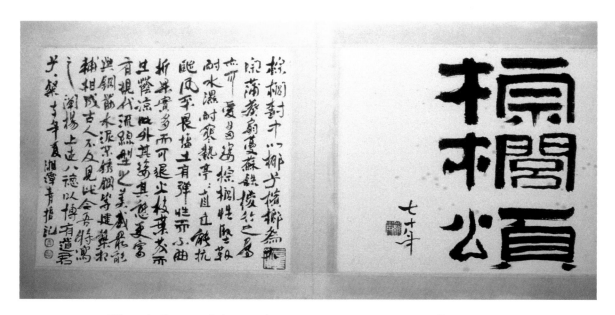

Plate 1. Cover, *Ode to Palm Trees*, poetry-painting album, 1981

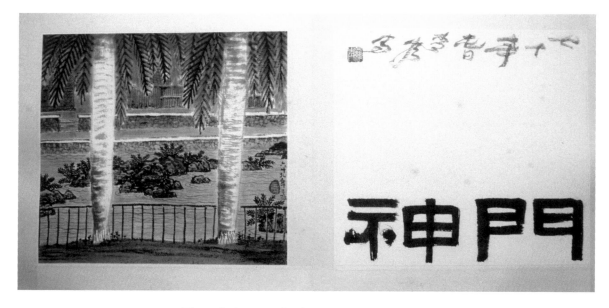

Plate 2. "Door God," *Ode to Palm Trees*

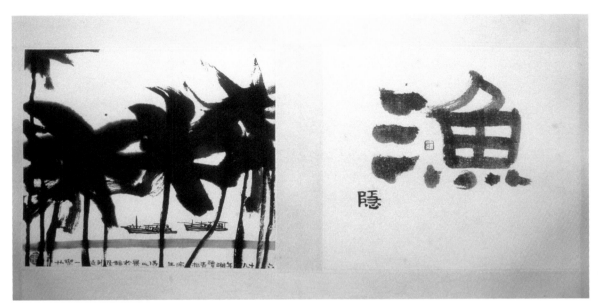

Plate 3. "Fishing Reclusion," *Ode to Palm Trees*

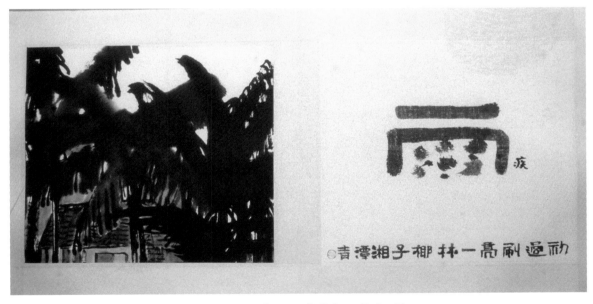

Plate 4. "Rapid Rain," *Ode to Palm Trees*

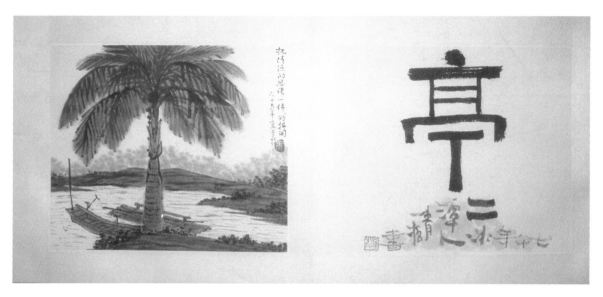

Plate 5. "A Palm Tree as Pavilion," *Ode to Palm Trees*

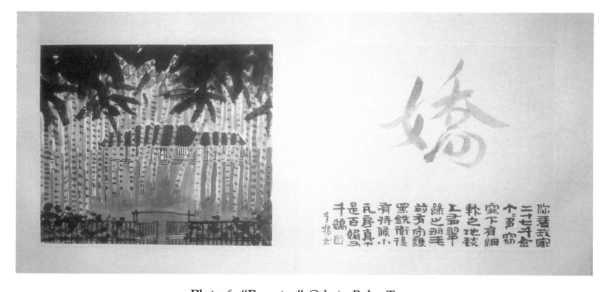

Plate 6. "Beauty," *Ode to Palm Trees*

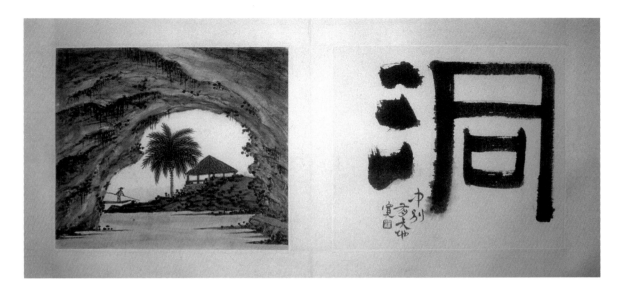

Plate 7. "Cave," *Ode to Palm Trees*

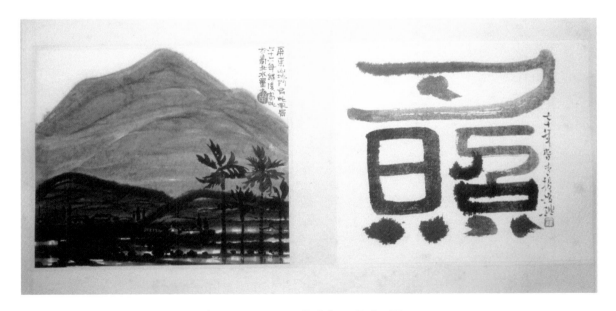

Plate 8. "Sunset," *Ode to Palm Trees*

When a painter inscribes thoughts, reflections, or praise on a painting (no matter if it is a word, a sentence, a poem, or a prose poem), the viewer cannot miss these non-pictorial symbols. The text influences the viewer's aesthetic process, becoming part of the painting's meaning. Unless the viewers ignore or fail to understand these inscriptions, their feelings about this painting are unavoidably affected by the inscriptions' contents and placement.

For example, in Lo Ch'ing's *Ode to Palm Trees* poetry-painting album, most images and words correspond to each other. Particularly in "Door God," "Fishing Reclusion," and "Rapid Rain" (plates 2–4) as well as some others, the relationship between images and words is quite close, thereby shaping the whole meaning.

Sometimes, the tension in Lo Ch'ing's painting derives from his subtle juxtaposition of different images, not just from his realistic representation of images themselves. What he really cares about is how to attribute new relationships and new meanings to individual images that are seemingly unrelated, as seen in his paintings from the 1980s and 1990s, such as *Moon Worshippers* (fig. 151). Therefore, if we agree that one of art's aims is to broaden the horizon of our mind, to strengthen our life experience, or to reorganize our chaotic daily life into order, then we should admit that Lo Ch'ing's works have in fact made advancements in this field. Such works illustrate again the spirit of exploration in his paintings.

In many of his paintings, poems, and written artist's statements published in the past four decades, we realize and understand his ambition to pursue new painting languages and subjects. On the one hand, when we deal with a painter like Lo Ch'ing, who is still developing and exploring, it is unwise and irresponsible to predict his future direction. On the other hand, as for the painter's artistic aims (such as how poetry and painting might stimulate each other, how to adopt and surpass traditions, how to represent modern life experiences, and so on), Lo Ch'ing has accomplished much. Based on his keen sensibility as a poet, and his ability to shape the relationships between objects and concepts, complemented by his spirit of adventure and discovery, if he could continue to work in this way, Lo Ch'ing would definitely realize a new road for modern Chinese ink painting, and impart new vigor to the glorious tradition of Chinese literati painting.

Lo Ch'ing's artistic production consists primarily of landscape, figures, birds, flowers, and animals. His painted imageries that portray, illustrate, and reflect the aesthetic changes over the past 175 years from

the Opium War to the present are fundamentally different from traditional representations. His new ink-color practice attempts to reestablish a balance between the spiritual past and the material present, between the decorative color tradition before the T'ang dynasty (618–906) and the pure ink tradition after the Five dynasties (907–960), and above all between the Neolithic Chinese pottery patterns (5000–3000 B.C.) and the postmodern computer chip board. Lo Ch'ing's art can be regarded as a poetic record of his meditation on the transformation of an age-old agrarian culture into a modern or postmodern world: he innovates and renovates conventional patterns and forms and creates fresh conversations with the past in order to remove traditional clichés. Through different processes of serialization and varieties of themes, multipurpose conversations have been developed as characteristic of Lo Ch'ing's art.

As a leading scholar of art and literature of Taiwan, Lo Ch'ing is one of the most prolific writers on art in contemporary China. His writings provide us with insightful comments on his creative intention and his understanding of art history. For example, in his essay on "See a Cosmos in a Vignette," he writes:

> About painting, size would be the least thing of one's concern. The clarity of an artistic mind should be fundamental. When the essence of things are captured and the humor of the subjects disclosed, when wordy descriptions spared and gaudy colors avoided, a unique atmosphere and celestial realization is to be revealed upon even the most ordinary scene. Things that touch the deepest part of your heart are indeed often found unexpectedly lurking around behind you, waiting for a serendipitous eye to detect. This is especially true in the vignette practice of Chinese ink-color painting.
>
> Chinese vignette has been popular since the eleventh century of the North Sung Dynasty in the forms of round fan and album-leaf, covering subjects of all sorts, including the popular idyllic landscape, poetic flower-and-bird, and recluse figure. Its composition is simple and concise, one single scene depicted in one single painting with a sharp focus that is reminiscent of short and terse lyrical poetry. During the twelfth and thirteenth centuries, echoing the trendy Neo-Confucianism of its period, believing that correct knowledge could be obtained only through the scientific investigation of the principles of things,

the Sung painters took the lyrical vignette to its peak by combining poetry and painting organically while realistically painted images expressed and evoked lyrical meaning beyond colors and lines. The inscribed words beyond followed the same principle: implementing the part to suggest the whole, the less to symbolize the more.

After the Sung dynasty, from the fourteenth to the sixteenth centuries, in the field of vignette, besides the round-fan and album-leaf, the painted folding fan emerged to dominate the scene. And at the same time, artists launched a search for new aesthetic approaches. On the one hand, they conducted a graphic conversation with past masterpieces and demonstrated an unprecedented strong historical sense, and on the other, they followed the philosophy of intuition advocated by Wang Yang-ming 王陽明 (1472–1529), the renowned Neo-Confucian idealist who affirmed that true knowledge should occur within the mind rather than through actual objects and that knowledge and action are codependent. A great variety of art styles therefore burst out during the sixteenth and seventeenth centuries, witnessing the second phase of flourishing lyrical vignette.

Now three hundred years have passed since the end of the seventeenth century. Contemporary Chinese ink-color painting now is developing in a threefold context of agrarian, industrial, and postindustrial societies. Signs of postmodern conditions have been emerging everywhere in China. With novel artistic experiments, Chinese contemporary artists will indeed reach out with wide open arms to welcome a third phase of lyrical vignette, yet to come.[8]

Like many artists in Chinese history, Lo Ch'ing has a strong sense of and appreciation for tradition, but he also recognizes the tyranny of tradition in the creative process, seen in one of his most important essays, "The Chinese Language and Chinese Landscape Painting." Among the many insights in this essay are the following comments:

The principle followed by the editors of painting manuals can be best illustrated with Ferdinand de Saussure's semiotic the-

8 Lo Ch'ing, "See a Cosmos in a Vignette," in *See a Cosmos in a Vignette: Lo Ch'ing's Lyrical Vignette* (Shanghai: Degas Gallery, 2010), n. p., with minor modifications.

ory. The laws of making landscape compositions are defined with rules and examples which equal the paradigms produced by the interactions of the syntagmatic axis and associative axis. Under the category of trees, pine and cypress are designated as "hosts" and others as "guests." The position of mountains and peaks is classified with the same principle, the big one is "master," and the small ones are "guests" or "servants" that should wait on the host. The relationship between nature and time is also defined with model examples: red maples appear only in autumn, green willows are signifiers of summer, peach and plum blossoms decorate the spring scenes, pines and cypresses stand against snowstorms in winter.

The significance of Wang Kai's [active ca. 1677–1705] manual [*Chieh-tzu-yuan hua-chuan* or *Painting Manual of the Mustard Seed Garden*] is that it offers a thorough categorization of all the elements necessary for a landscape painting, including details such as five different ways to depict pine needles and trunks, and twelve different ways to portray waterfalls. Furthermore, the manual gives copies of both contemporary and ancient paintings through somewhat simplified woodcarving reproductions. Landscape composition is divided into seven parts: (1) mountains, peaks, hills, rocks, pebbles; (2) trees, groves, woods, grass; (3) rivers, creeks, waterfalls, lakes, ponds; (4) all kinds of clouds; (5) cottages, boats, bridges; (6) figures; (7) colophons and seals. The beginner is asked to memorize them, just as writers learn and store morphemes, words, word groups, and clauses in their memories from the associative axis. Writers organize the signifiers they acquire into a composition according to given rules based on the grammar of the syntagmatic axis to accommodate or portray the target situation with semantic coding. At the same time, the painter will employ different quality of lines such as broken, continuous, thin and thick, and different tone of inks such as dark, light, dry, wet to express his feelings. This is similar to the writer's use of phonemes, syllables, rhythmic groups and tone-groups. The painter can quote and reorganize the relatively simplified pictorial reproductions of the works of the masters, ancient and contemporary, and then, on the blank space of his painting, write down his own or another's poetry or prose as colophons with beautiful calligraphy to reinforce the message he wants to convey. Painting language and written language become equal signifiers and can be mixed and utilized

to serve painters. It is indeed a "dictionary" of Chinese land-scape painting containing both synchronic and diachronic information to meet the needs of artists, connoisseurs, art critics, and general audiences.

Seventeenth-century painters spent considerable time systematically learning and digesting painting traditions from the past. To them, nature was not the only source from which artists receive inspiration: if one wanted to be a successful painter with one's own style, to imitate nature was not the only approach nor the necessary step to adopt. Art should be judged according to a historical perspective. The audience should face and trace not the original material from which the painting was derived, but the meaning conveyed and signified through the arrangement of the signifiers. This explains the appearance of numerous new styles in the seventeenth century: painters of that era enjoyed a freedom never experienced before in Chinese art history. They had the freedom to use a fully fledged painting language endowed with a rich vocabulary and flexible grammar.

The publications of painting manuals, on the one hand, freed innovative painters from the bondage of reality to create individual styles as they desired.[9]

Toward the end of the essay, Lo Ch'ing writes:

The true treasure house of art signifiers is in art history. Most seventeenth-century painters, like Tung, were convinced that artistic creation should depend upon ingenious applications of signifiers either inherited from the past or of one's own innovations. Only with a pictorial language blending individual and conventional signifiers can an artist rediscover the essences of reality and nature without any hindrance and create novel compositions that convey profound thoughts and feelings. When content has been separated from form, the generative process of styles begins, and a kind of artistic transformation thus ensues.

This not only happened in the evolution of Chinese land-scape painting, but also in the development of Chinese architecture. The famous Ming dynasty (1368–1644) garden design, which combines poetry, painting, miniature rockery and build-

9 Lo Ch'ing-che, "The Chinese Language and Chinese Landscape Painting," *Studies in English Literature & Linguistics* (May 1987): 77–104, citation from 92–93, slightly adjusted.

ings into an organic whole, clearly demonstrates that when signifiers acquire their independence and autonomy, they can float freely from one genre of art to another. The ingenious designs of Ming gardens, demonstrating the synthesis of all arts, will serve as inspiring examples for postmodern architects to meditate upon and assimilate into their own creations.[10]

Lo Ch'ing's creative use of tradition can be seen in the series of paintings based on Fan K'uan's masterpiece "Travelers amid Streams and Mountains," from the late tenth to the early eleventh century and now in the collection of the National Palace Museum in Taipei.[11] The series is entitled "Calling for Fan K'uan." (figs. 70, 72, 79). According to Lo Ch'ing:

> I started the "Calling for Fan K'uan" series in 1997 and have finished 7 paintings so far and am about to finish the 8th one in 2015. My inspiration for the series is derived from the 1979 National Palace Museum Taipei publication on Fan K'uan's "Travelers amid Streams and Mountains."[12] The book is the first of its kind, devoted to one single painting with full page color plate and black and white photo details reproducing and enlarging the various parts of the painting, now rearranged, regrouped, segregated, and compartmentalized.
>
> This is unprecedented in the history of Chinese art since the Neolithic times and is a perfect example demonstrating how the mode of thinking of industrialization has influenced the way of looking at and viewing classical Chinese landscape painting. Thirty years have passed since the publication of this pioneering book and no one so far has recognized its significance visually, aesthetically, or culturally. I am probably the first to take advantage of the publication of the book to conduct a "profound multilayer conversation" with the art of Fan K'uan at the juncture of the twentieth and the twenty-first centuries.[13]

Another good example of Lo Ch'ing's creative dialog with the Chinese cultural tradition is his "Peach Blossom Spring" Series (figs. 73, 78, 83).

10 Ibid. 101–2, slightly adjusted.
11 Conveniently reproduced in Yang Xin, Nie Chongzheng, Lang Shaojun, Richard M. Barnhart, James Cahill, and Wu Hung, *Three Thousand Years of Chinese Painting* (New Haven: Yale University Press, 1997), 103.
12 *Fan K'uan Hsi-shan hsing-lu-t'u* (Taipei: National Palace Museum, 1979).
13 Lo Ch'ing, unpublished paper, "My 'Calling for Fan K'uan' Series," slightly adjusted.

Explaining why he painted it, he states:

> The original story is from the "Preface" to the poem "Peach Blossom Spring" by the great fourth-century poet Tao Ch'ien [365–427].[14] In the past, the preface has been regarded as a piece of prose work and is edited for numerous text books for high school students to read and memorize. Traditional scholarship and interpretations of the piece have always been related to the idea of Shangri-La or utopia, which many have tried to identify with remote regions of China, most of them supposedly in Hunan, my father's home province.
>
> I wrote a paper years ago to argue that the piece is not an essay but a standard piece of short story in which (a) long and (b) short seemingly irrelevant events (characterizations of a sly fisherman and an upright Confucian gentleman) are juxtaposed to suggest a (c) realization or revelation to the readers that the peach blossom spring is not a concrete real place of any sort but only a state of mind that could be discovered and attended solely through accident without any conscious deliberation. There is a hidden *Chan* Buddhist message in the story without the influence of *Chan,* before the birth of the idea of *Chan* Buddhism in China.
>
> My parents fled to Taiwan from Mainland China after 1949 while I was still a little baby. Originally they were planning to take me back to Hunan from the beautiful harbor city Tsingtao to see my grandma, but the journey was interrupted by the civil war and they arrived at Taiwan, provisionally coincidentally still hoping that they could return home within a few months. However, the separation between Taiwan and China was abrupt and complete and lasted for forty grim years, communication between family members on both sides of the strait had been absolutely impossible and poisonously dangerous. The irony is that my father's mainland family thought that my father was lucky enough to be able to escape to Taiwan, the new Peach Blossom Spring, evading the Communist rule and the Cultural Revolution once and for all. Nevertheless my father was constantly yearning to return home to his mother, to his childhood, to his home town, to his memories. Sadly, he didn't

14 Cyril Birch, ed., *Anthology of Chinese Literature from the Earliest Times to the Fourteenth Century* (New York: Grove Press, 1965), 167–68.

realize that he could never go home again. His first and last trip back home after a forty-year separation was a series of disastrous and tragic disillusionments. The ideal Peach Blossom Spring can be discovered and visited only contingently by fortuity in one's dream.[15]

Now in his late sixties, Lo Ch'ing produces compositions full of discipline, rigor, and precision. Lo Ch'ing translates representation or narrative into poetic conversations. He also emphasizes the pure, clean expressive methodology of the process of production and its serialization, or repetition of themes. Lo Ch'ing therefore creates a self-referential world that follows an inner logic. Silence comes to powerfully address the intimacy between the artist's mind and material society.

As I have pointed out earlier, Lo Ch'ing is one of the few modern Chinese painters who has united modern poetry and ink-color painting with profound ingenuity and dexterous techniques. Utilizing traditional, folk, and modern pictorial signifier systems, he forges a new graphic language of his own, which is deeply rooted in a surrealistic symbolism with a postmodern touch. His fresh compositional arrangements of novel subject matter, along with unique perspectives, penetrate into the relationship of his carefully selected and painted subjects, allowing him to present his ideas and feelings with profound, dramatic tension. Despite the cold, desolate, and tragic imaginations apparent in some of his paintings, Lo Ch'ing also quite adeptly expresses his humorous attitude toward the incongruities experienced in the hustling-bustling urban lives of cosmopolitan metropolises. Wittiness and a lofty conceit are evident in all his works.

The ultimate concern of Lo Ch'ing's painting and calligraphy is to reflect his own *Weltanschauung*—a comprehensive conception or image of the universe and of humanity's relation to it. This worldview, from Lo Ch'ing's standpoint, enables him to reflect on, discuss, and represent urgent social, political, as well as aesthetic issues. Above all, with a historical perspective, he is on a quest for new sensibilities mirroring the dilemmas faced by China over the past centuries, when Chinese culture underwent different phases of predicaments, confronted unprecedented national and international challenges, and suffered kaleidoscopic changes. This traumatic transformation may be best summarized in three stages—from the agrarian period to an industrial one, and finally to a postindustrial phase, all overlapping. The consequent

15 Lo Ch'ing, unpublished paper, "My 'Peach Blossom Spring' Series."

aesthetic complexities that have arisen have affected almost every single aspect of the life and art of Chinese artists.

With his painting and calligraphy, and with semiotic and postmodern approaches, Lo Ch'ing tries to tackle the problems inherited by modern Chinese intellectuals of the past and present by utilizing signs, symbols, metaphors, and a new vocabulary of techniques. He has taken it upon himself first to develop new techniques and forms. These take shape in his iron-web textural-strokes, seal-paste coloring methods using thick, dense applications of color, and the creation of a collage of multiple imageries with a deliberate scattering of gold flakes. Second, he has coined new graphic vocabularies and idioms, such as his portrayal of cracked surfaces with near and distant perspectives, and his play of 2-D and 3-D inconsistencies. Third, he has created a brand new system of graphic signifiers expressing his feelings and ideas, voicing his arguments and contentions. Last of all, he negotiates with current issues, both East and West, and converses with artists, both ancient and modern. For example, he sprinkles and pastes gold flakes onto images in his *UFO* series, combining a style of surface enhancement from the folk art tradition with modern subject matter.[16]

His dynamic use of ancient technique, on the other hand, is seen in his Extraordinary Arhats (or Eighteen New Arhats) Series (figs. 187–216).[17] He has integrated the radiant, glowing, intensely bright colors of the cave art of the T'ang Dynasty with subtle ink tonal variations of the Sung and Yuan Dynasties. He uses this technique to illustrate scenes of *Chan* Buddhist enlightenment reinterpreted in the context of contemporary living in an urban environment. He demonstrates the wonder of this new approach by fusing Chinese characters (the *Heart Sutra*), calligraphy, and willow leaves into a magnificent combination that integrates verbal, graphic, and natural signifiers into one whole.

Lo Ch'ing's reinvented graphic language of ink and color enables him to express novel content with new compositions, to explore unfamiliar or uncommon subjects with new techniques, and to present a new aesthetic posture to the artistic spirit and environment of his contemporaries.

16 See for example in Jason Kuo, ed., *Lo Ch'ing hua-chi* (Taipei: Tung-ta, 1990), 53.

17 In Buddhism, an *arhat* (Sanskrit; *lohan* in Chinese) is a being who has attained the state of enlightenment. See Wen Fong, *The Lohans and a Bridge to Heaven* (Washington, D.C.: Freer Gallery of Art, 1958). See, for example, the set of sixteen *arhats*, attributed to Kuan-hsiu (832–912) and now in the Japanese Imperial Household Collection in Tokyo.

The following topics and titles of Lo Ch'ing's paintings exemplify well his range of interests:

The Postmodern Turn
Self-Portrait Series (figs. 1–30)
Landscape Deconstructed Series (figs. 31–64)
Windows Landscape Series (figs. 65–118)
One Man's Cultural Revolution Series (figs. 50, 54–57, 208–9)

Modernism Revised
Asphalt Road Series (figs. 119–33)
Flying Series (figs. 134–41)
Nocturnal Scene Series (figs. 142–57)
Iron-and-Steel Landscape Series (figs. 158–66)

Classical Renovation
Birds and Flowers (figs. 167–86)
Extraordinary Arhats Series (figs. 187–216)
Calling for the Ancients Series (figs. 217–52)
Palm Tree Series (figs. 253–61)
Multiple Collages (figs. 262–76)

Other Series
Finding the Recluse Series
Cityscape Series
Here Comes the UFO Series
Broken Mirrors of China Series
The Traveling Stones Series
Ten-Thousand Landscape Series
Anecdote of Jars Series

Early Work (figs. 277–318)

The loose-leaf book project developed by the American artist Thomas Rose and Lo Ch'ing is a case in point of Lo Ch'ing's ability to combine Western iconographic architectural images and link them to a larger cross-cultural poetic narrative. This and Rose's history of working with and curating contemporary Chinese artists provided a basis for the back-and-forth discussions that, in 2012, resulted in their enigmatic work, *Secrets* (plates 9–18), now in the collection of the

Plate 9. Thomas Rose and Lo Ch'ing, *Secrets*, book closed

Whitney Museum of American Art in New York and other public and private collections).[18]

18 Minneapolis: Indulgence Press, 2012. Portfolio. Ten copies were produced, signed and numbered by Thomas Rose and Lo Ch'ing. This is one of several books produced by Wilber "Chip" Schilling, owner of the Indulgence Press, in collaboration with Rose. The eight photographic prints are originals by Rose and were printed at Digi-Graphics, and Lo Ch'ing wrote the interpretive poems for this book, with his original brushwork and translations. They were letterpress printed from plates by Schilling. Each image is printed in color on fine woven paper. Each poem is printed in Chinese and English along with the striking black brushwork on a light and semi-transparent paper that slightly reveals the image beneath. The elephant folio sized sheets are housed in a green and black cloth portfolio with diagonal boards fastened with a black bone closure. Binding assistance was provided by Mary Ila Duntemann.

Plate 10. Thomas Rose and Lo Ch'ing, *Secrets*, title page

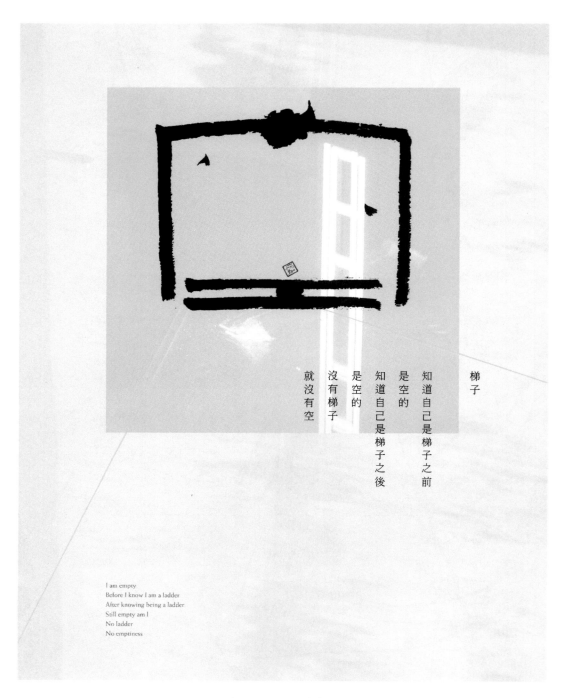

就沒有空
沒有梯子
是空的
知道自己是梯子之後
是空的
知道自己是梯子之前

梯子

I am empty
Before I know I am a ladder
After knowing being a ladder
Still empty am I
No ladder
No emptiness

Plate 11. "Ladder"

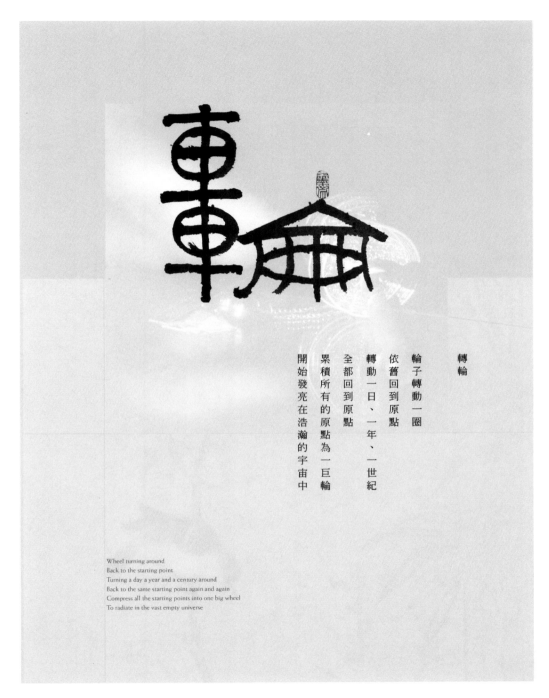

轉輪

輪子轉動一圈
依舊回到原點
轉動一日、一年、一世紀
全都回到原點
累積所有的原點為一巨輪
開始發亮在浩瀚的宇宙中

Wheel turning around
Back to the starting point
Turning a day a year and a century around
Back to the same starting point again and again
Compress all the starting points into one big wheel
To radiate in the vast empty universe

Plate 12. "Turning Wheel"

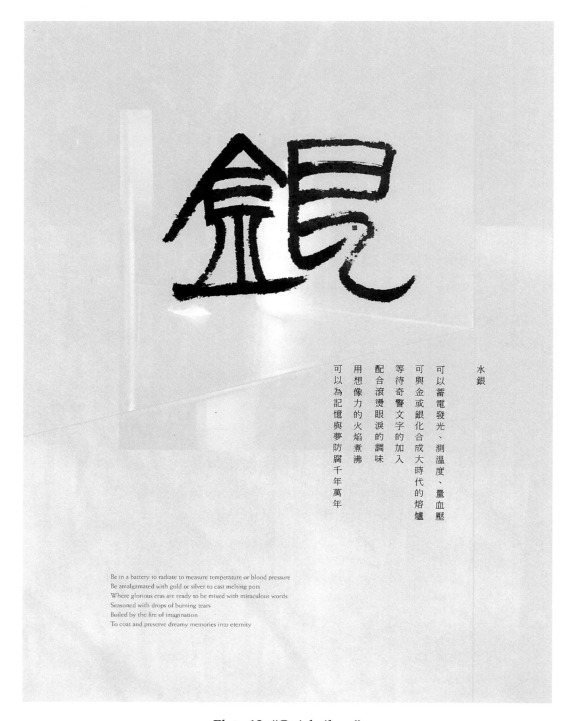

水銀

可以蓄電發光、測溫度、量血壓
可與金或銀化合成大時代的熔爐
等待奇譽文字的加入
配合滾燙眼淚的調味
用想像力的火焰煮沸
可以為記憶與夢防腐千年萬年

Be in a battery to radiate to measure temperature or blood pressure
Be amalgamated with gold or silver to cast melting pots
Where glorious eras are ready to be mixed with miraculous words
Seasoned with drops of burning tears
Boiled by the fire of imagination
To coat and preserve dreamy memories into eternity

Plate 13. "Quicksilver"

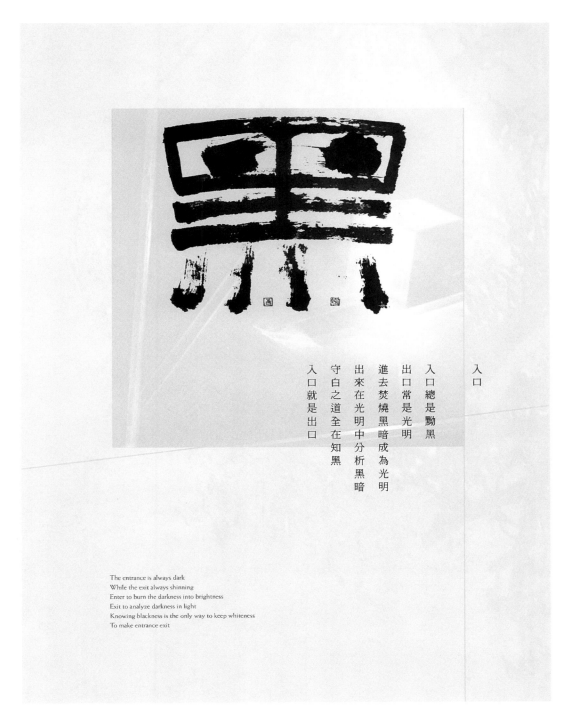

入口總是黝黑
出口常是光明
進去焚燒黑暗成為光明
出來在光明中分析黑暗
守白之道全在知黑
入口就是出口

入口

The entrance is always dark
While the exit always shinning
Enter to burn the darkness into brightness
Exit to analyze darkness in light
Knowing blackness is the only way to keep whiteness
To make entrance exit

Plate 14. "En-trance"

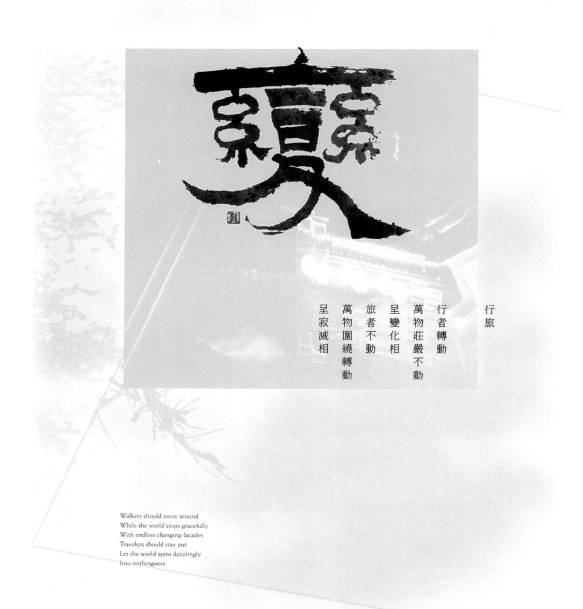

行旅

行者轉動
萬物莊嚴不動
呈變化相
旅者不動
萬物圍繞轉動
呈寂滅相

Walkers should move around
While the world stops gracefully
With endless changing facades
Travelers should stay put
Let the world spins dazzlingly
Into nothingness

Plate 15. "Journey"

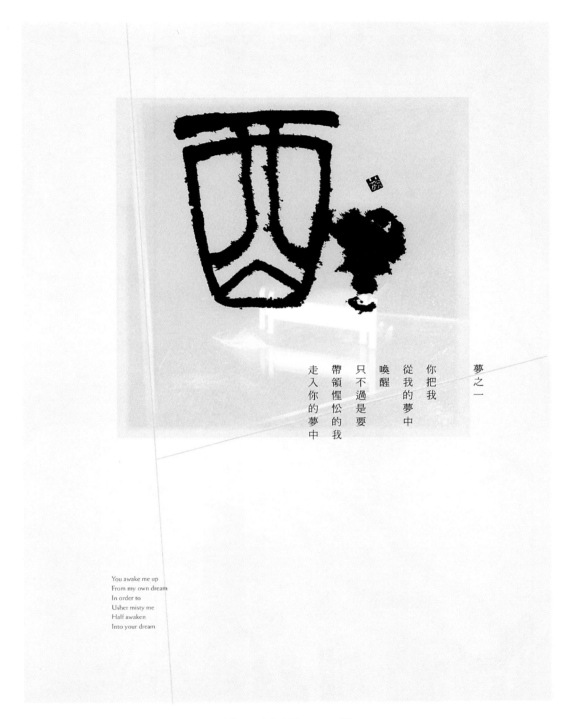

夢之一

你把我
從我的夢中
喚醒
只不過是要
帶領惺忪的我
走入你的夢中

You awake me up
From my own dream
In order to
Usher misty me
Half awaken
Into your dream

Plate 16. "Dream 1"

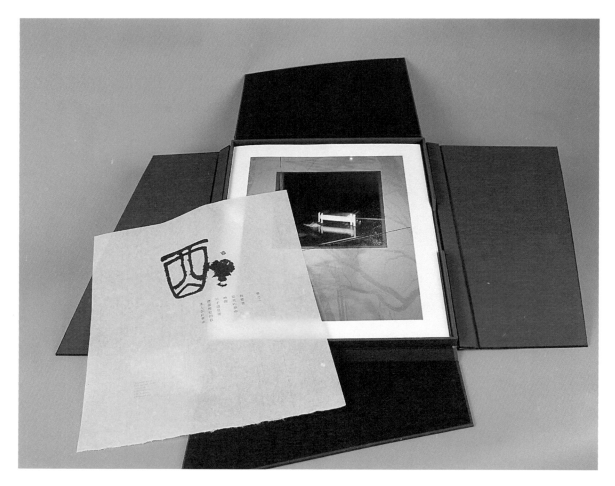

Plate 17. Thomas and Lo Ch'ing, "Dream 1"

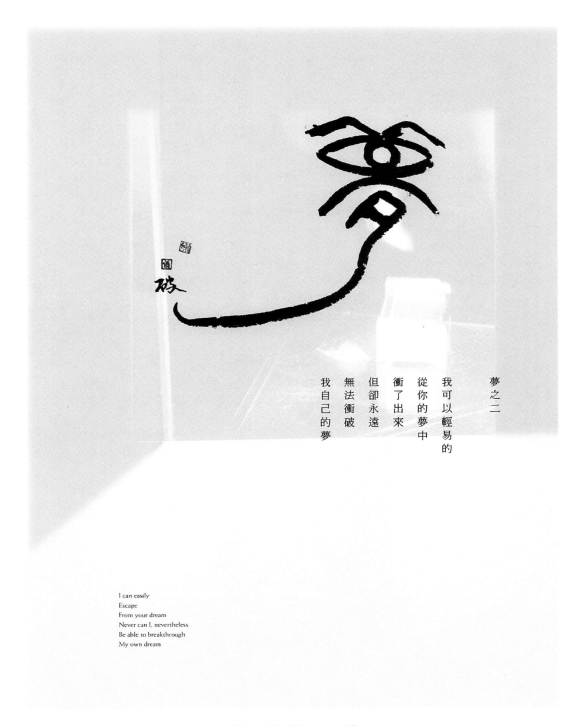

夢之二

我可以輕易的
從你的夢中
衝了出來
但卻永遠
無法衝破
我自己的夢

I can easily
Escape
From your dream
Never can I, nevertheless
Be able to breakthrough
My own dream

Plate 18. "Dream 2"

Initially, neither artist had a specific idea or end result in mind; both were comfortable with the ambiguity of a free-flowing process. Both began by discussing various possible directions for the problems that arise from working across miles and cultures. Rose was working at the time with spatial reflections in glass of doll house furniture and other small objects, his interest being the vague and blurred image that resulted when the reflection was photographed, these appearing to float in the space of the photograph, corresponding to dreams and memories emanating from his literary interest in Proust and Flaubert—interests in domestic interiors. Lo Ch'ing responded with calligraphic works and poems. These first exchanges continued, ultimately to arrive at a selection of eight images, accompanying poems and calligraphy. The pairings of the photographs and poems are open-ended and intentionally ambiguous, allowing for conjecture as to how the images and text meet. As Rose eloquently observes in his "Foreword" to *Secrets*:

> Lo Ch'ing's poems give these images the depth and richness that brings to mind narrative scrolls as well as the Medieval tradition of the devotional Book of Hours. The intention here is to place the poems in the context of the images without the image being illustrative or the text being explanatory. Rather than the specificity of the devotional, these parings are open-ended and resist any specific reading. The ambiguity of the connections allow for conjecture as to how the image and text meet. As art is the embodiment of meaning in form, my hope is that the placement of the objects, the tone of the text, the proscenium opening in the page and the color tonalities reflect the contemplative character of our dreams.

Each aspect of these images, and the poems, has been enhanced through the precise orchestration of idea and material by Wilber Schilling—his exquisite sense of a unified whole foregrounds the work's fundamental narrative of the transit of life.

1 書桌 Desk

我是一張書桌
但一直以獨腳站立
讓三隻腳微微懸空
準備用秘密飛翔
抵抗世俗的地心吸引力
而無人察覺
(calligraphy: 懸空 dangling air)

I am a desk
Standing but with only one leg
the rest of the three slightly dangling in the air
ready to take a secret flight
fighting against the mundane gravity
Nobody has ever detected this

2 椅子 Chair

我是一把椅子
以自我克隆的方式
繁殖成千萬隻自己
然後藏身其間
不斷微微變色移形換位
而無人察覺
(calligraphy: 換位 change seat)

I am a chair
by self-cloning
I multiply myself into hundreds and thousands
to hide myself among them perpetually
changing colors subtly and positions, shapes slightly
Nobody has ever detected this

3 木床 Wooden Bed

一張一腳獨立的床
上面必定有一個
倒立的人
站在空無一物的空氣裡
站在地球的反面
以一張床舉起全世界
(calligraphy: 反面 opposite side)

On any wooden bed erecting in one leg
Must there be an invisible headstand man
standing at attention
upon the air of nothingness
the opposite side to the solid earth
lifting the whole world with a crane like bed

4 梯子 Ladder (plate 11)

知道自己是梯子之前
是空的
知道自己是梯子之後
是空的
沒有梯子
就沒有空
(calligraphy: 空 empty)

I am empty
Before I know I am a ladder
After knowing being a ladder
Still empty am I
No ladder
No emptiness

5 轉輪 Turning Wheel (plate 12)

輪子轉動一圈
依舊回到原點
轉動一日、一年、一世紀
全都回到原點
累積所有的原點為一巨輪
開始發亮，在浩瀚的宇宙中
(calligraphy: 輪 wheel)

Wheel turning around
Back to the starting point
Turning a day a year and a century around
Back to the same starting point again and again
Compress all the starting points into one big wheel
To radiate into the vast empty universe

6 水銀 Quicksilver (plate 13)

可以蓄電發光、測溫度、量血壓
可與金或銀化合成大時代的熔爐
等待奇警文字的加入
配合滾燙眼淚的調味
用想像力的火焰煮沸
可以為記憶與夢防腐千年萬年
(calligraphy: 銀 silver)

Be in a battery to radiate to measure temperature or blood pressure
Be amalgamated with gold or silver to cast melting pots
Where glorious eras are ready to be mixed with miraculous words
Seasoned with drops of burning tears
Boiled by the fire of imagination
To coat and preserve dreamy memories into eternity

7 入口 En-trance (plate 14)

入口總是黝黑
出口常是光明
進去，焚燒黑暗成為光明
出來，在光明中分析黑暗
守白之道全在知黑
入口就是出口
(calligraphy: 黑 black)

The entrance is always dark
While the exit always shinning
Enter to burn the darkness into brightness
Exit to analyze darkness in light
Knowing blackness is the only way to keep whiteness
To make entrance exit

8 行旅 Journey (plate 15)

行者轉動
萬物莊嚴不動
呈變化相
旅者不動
萬物圍繞轉動
呈寂滅相
(calligraphy: 變 change)

Walkers should move around
While the world stops gracefully
With endless changing facades
Travelers should stay put
Let the world spins dazzlingly
Into nothingness

9夢之一 Dream 1 (plates 16 and 17)

你把我
從我的夢中
喚醒
只不過是要
帶領惺忪的我
走入你的夢中
(calligraphy: awake 醒)

You awake me up
From my own dream
In order to
Usher misty me
Half awaken
Into your dream

10夢之二 Dream 2 (plate 18)

我可以輕易的
從你的夢中
衝了出來
但卻永遠
無法衝破
我自己的夢
(calligraphy: 破夢 break dream)

I can easily
Escape
From your dream
Never can I, nevertheless
Be able to breakthrough
My own dream

Lo Ch'ing's art is permeated by an innovative painting language, new forms and content, and new grammar and composition. These factors record and reflect the multiple aspects of various developments in Chinese culture over the past scores of years. One might apply the

linguistic theory of "topic-comment" to Lo Ch'ing's painting in general. (In linguistics, the topic, or theme, of a sentence is what is being talked about, and the comment is what is being said about the topic.) Lo Ch'ing's painting allows him to become a conversationalist in art, constantly initiating dialogues not only with the past and present of Chinese culture, but also with that of the West and other cultures.

In a recent essay on his "Windows Landscape" series, Lo Ch'ing writes:

> "Window Landscape Series" or "Email@ landscape.com series" enables the landscape artist to incorporate various views and perspectives of mountains and waters simultaneously into one composition, and at the same time, to offer juxtapositions of the imageries extracted and digested from traditional heritages and contemporary novelties. In this milieu or setting, then, there are parallels of scenes seemingly related and yet not related; ostensibly not connected yet connected, such as agrarian scenes and industrial ones; political and idyllic. Urban construction and mythological Shangri-la could be comfortably nestled against each other to reflect a world of multiple choices offered by postmodern conditions and internet technologies; there is an endless variety of choices and possibilities.
>
> With the application of calligraphic strokes in a composition, the structure of the painting becomes configured by segregated linear compartments, whose formal features echo a Windows program, the most welcome computer operating system around the world. The pictorial scenes, poetic texts, and electronic signs that are brushed in to fill in the irregular linear compartments constitute multi-leveled linkages to each other, and enable the painting to mean much more than what is shown on the surface. Consequently, the artistic methods and creative strategies employed, and their compatibility with the subject matter in the painting, reflect not only the spirit of the new century, but also the aesthetic attitude of the artist in the present time.[19]

This new aesthetic stand allows him on the one hand to continue to create exciting new works of art for his contemporaries to enjoy and meditate on and, on the other hand, to reinterpret Chinese art traditions with a new historical perspective and understanding.

19 Lo Ching, "Windows Landscape," unpublished paper.

The Postmodern Turn:
Self-Portrait Series

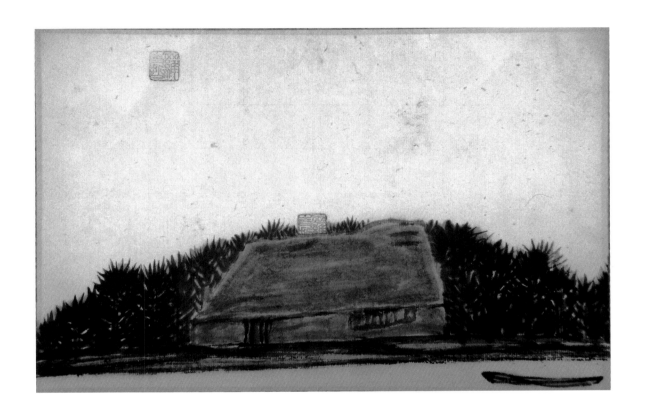

Figure 1. 旭日初升 / The rising sun,
22.5 × 34 cm (1969)

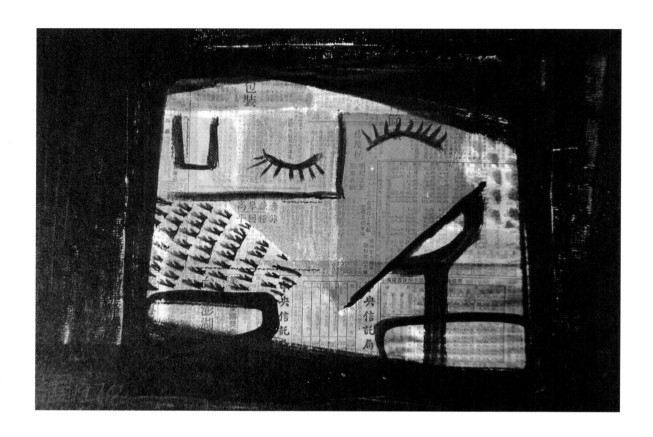

Figure 2. 憶（自畫像） / Recollection (self-portrait),
29 × 27 cm (1970)

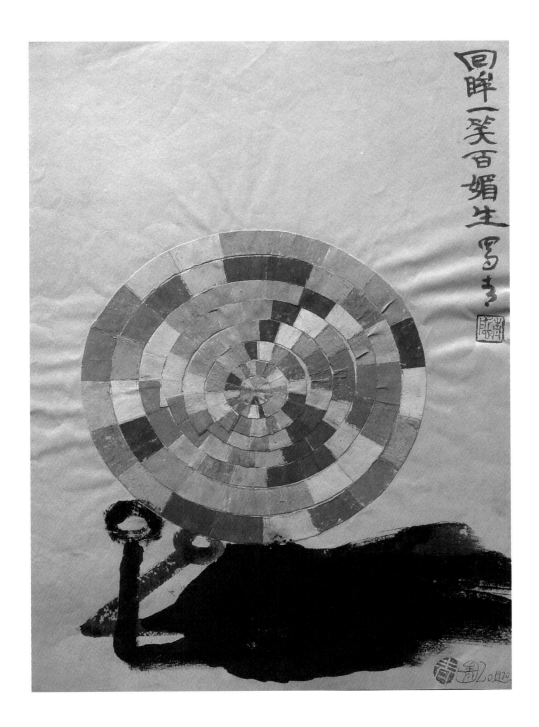

Figure 3. 回首一笑（自畫像）/ Glancing and smiling (self-portrait),
32 × 27 cm (1972)

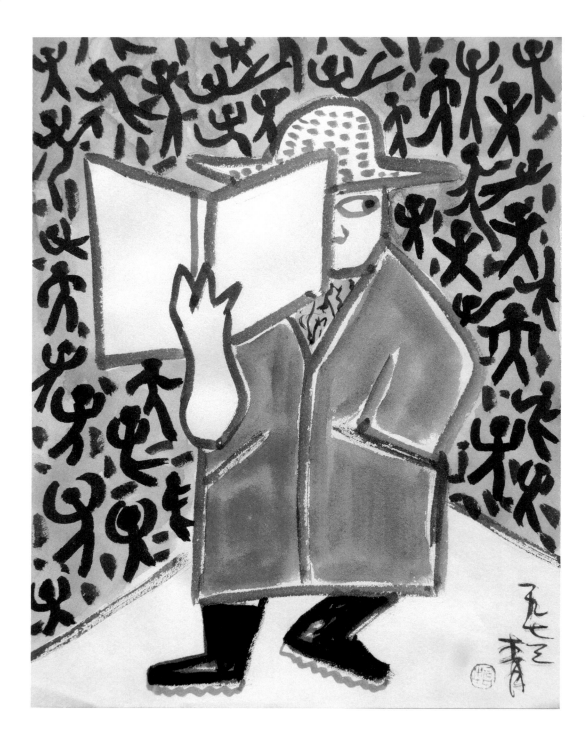

Figure 4. 懷疑論者（自畫像）/ A sceptic (self-portrait),
27 × 20 cm (1973)

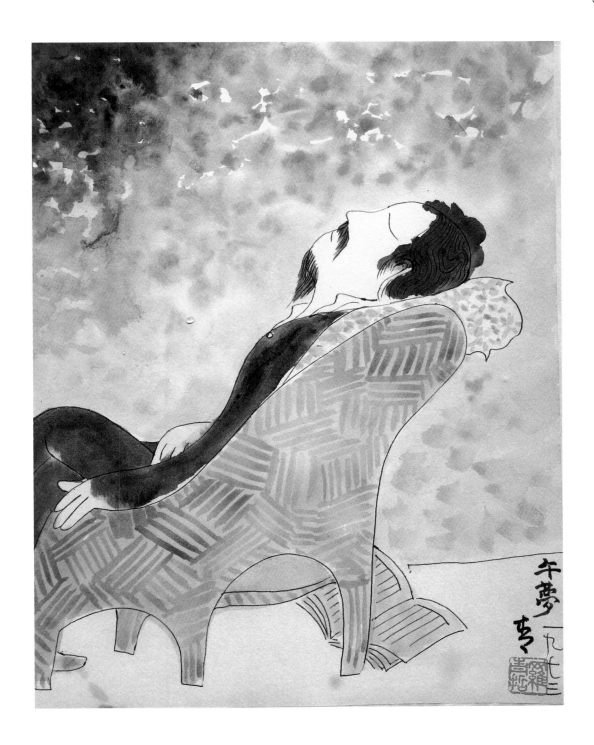

Figure 5. 午夢（自畫像）/ Afternoon dream (self-portrait),
27 × 20 cm (1973)

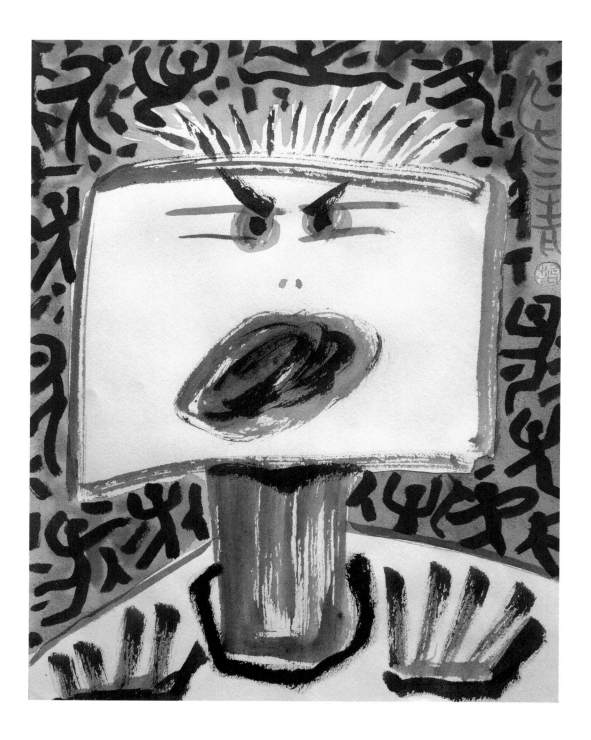

Figure 6. 怒（自畫像）/ Anger (self-portrait),
27 × 20 cm (1973)

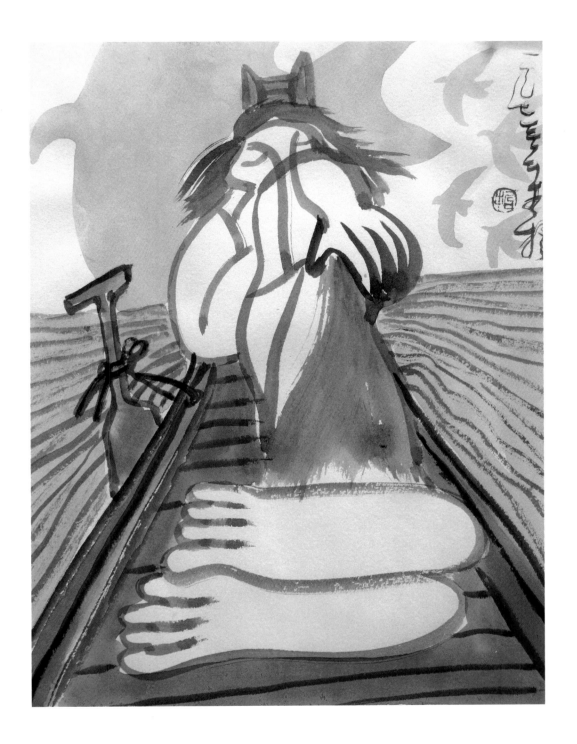

Figure 7. 自在（自畫像）/ Free and easy (self-portrait),
27 × 20 cm (1973)

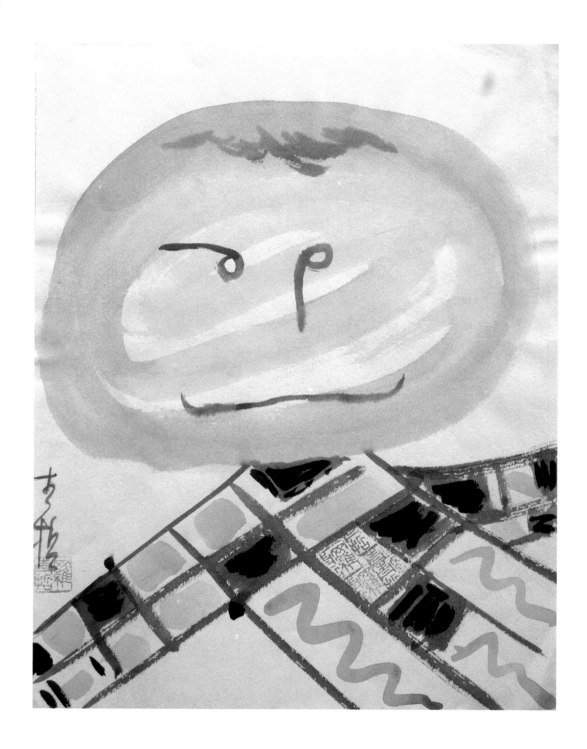

Figure 8. 頑皮（自畫像） / Mischievous (self-portrait),
27 × 20 cm (1973)

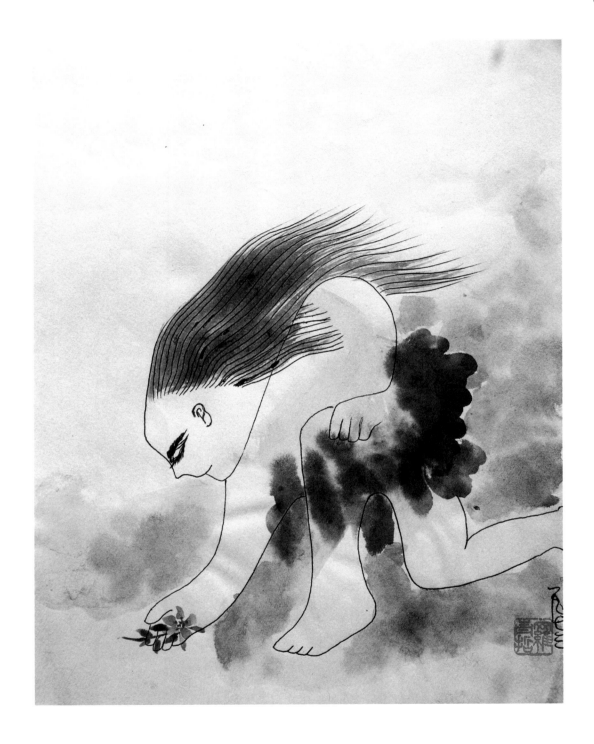

Figure 9. 細嗅（自畫像） / Sniffing carefully (self-portrait),
27 × 20 cm (1973)

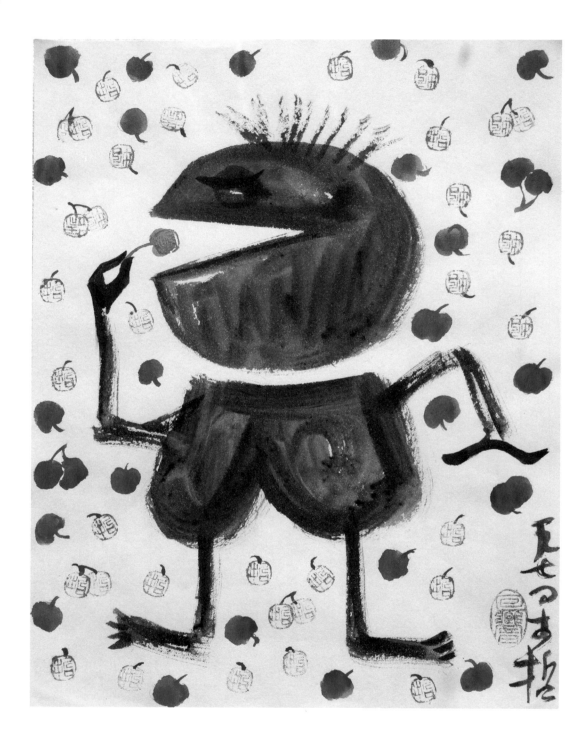

Figure 10. 老饕（自畫像）/ A glutton (self-portrait),
27 × 20 cm (1974)

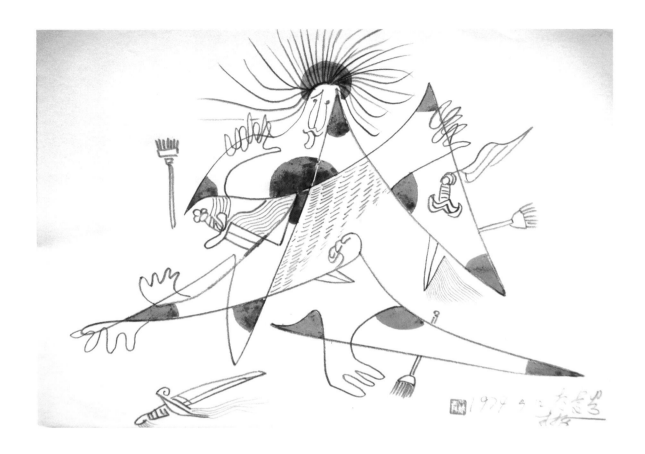

Figure 11. 撕裂人（自畫像）/ A ruptured man (self-portrait),
27 × 20 cm (1974)

62

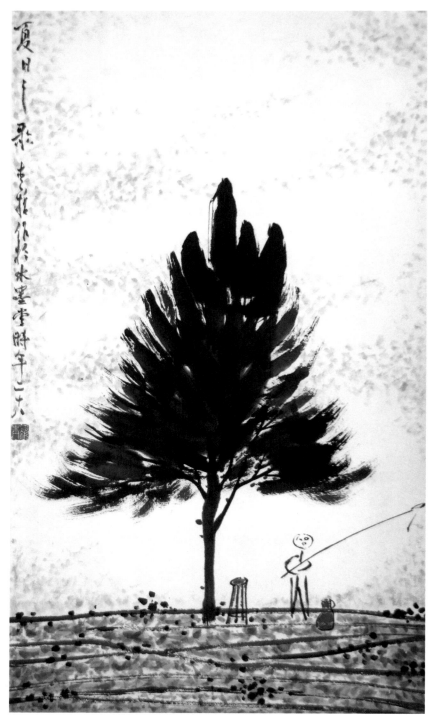

Figure 12. 夏日之歌（自畫像）/ Song of summer (self-portrait),
70 × 40 cm (1975)

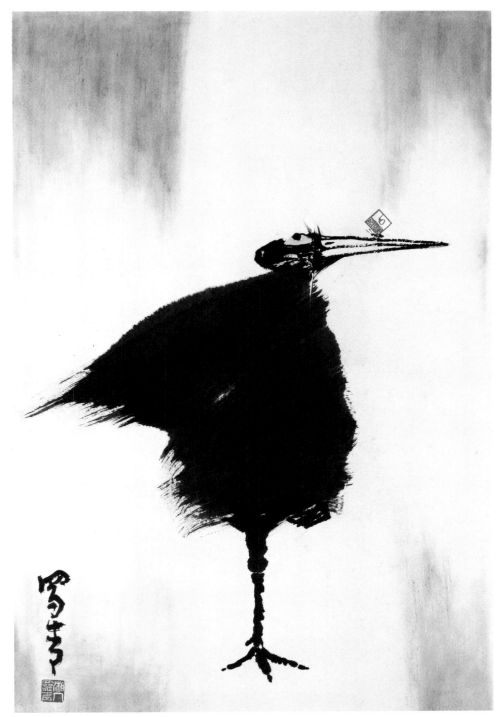

Figure 13. 做什麼（自畫像）/ What are you doing over there? (self-portrait), 76 × 50 cm (1982)

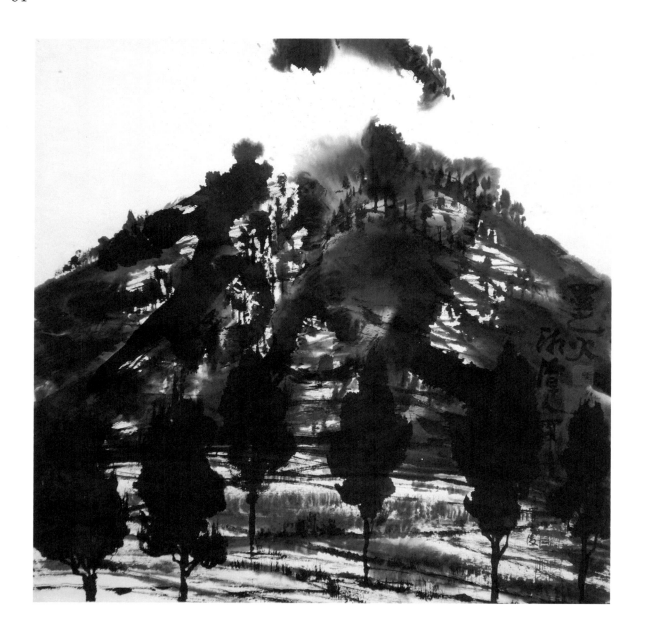

Figure 14. 墨火山（自畫像）/ Ink volcano (self-portrait),
70 × 69.2 cm (1992)

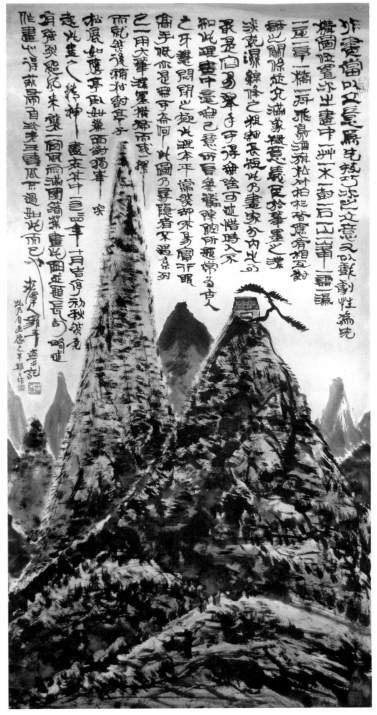

Figure 15. 寂寞如奇峰突起（自畫像）/ Loneliness towering like a peak (self-portrait), 137 × 69 cm (1994)

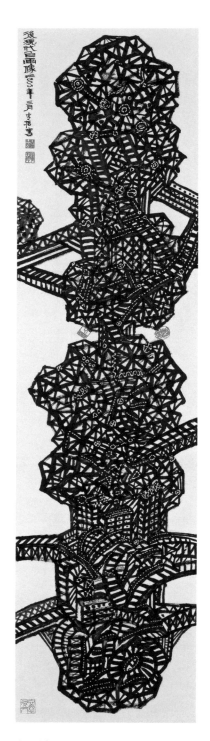

Figure 16. 機械自畫像 / Mechanical self-portrait,
136 x 34.5 cm (2000)

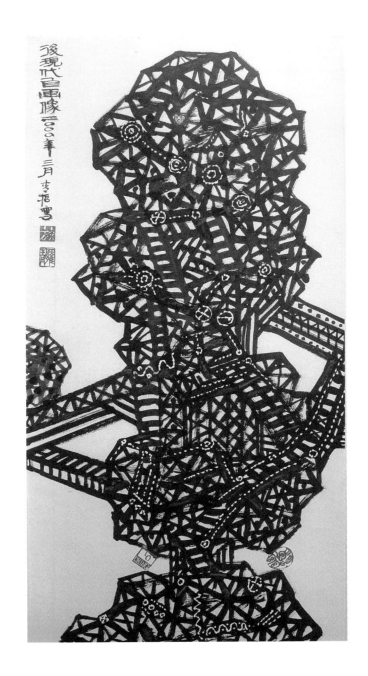

Figure 17. 機械自畫像（局部） / Mechanical self-portrait (detail),
136 x 34.5 cm (2000)

68

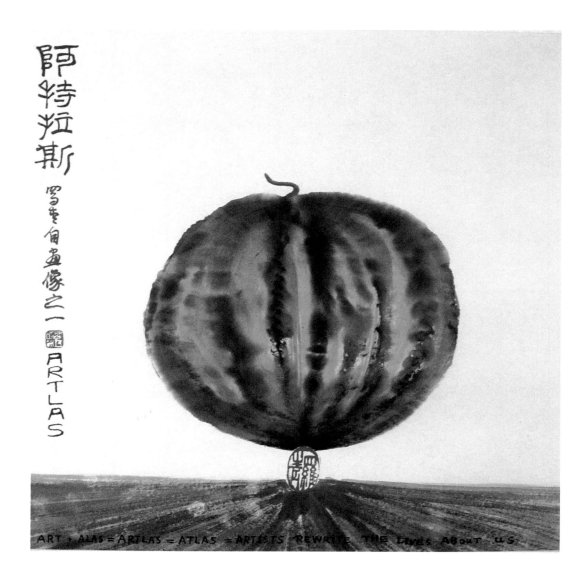

Figure 18. 阿特拉斯（自畫像）/ Atlas (self-portrait),
46 × 46 cm (2003)

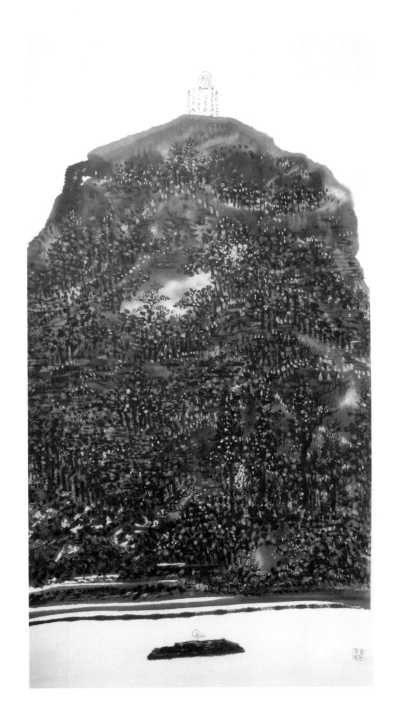

Figure 19. 白鳥（自畫像）/ White bird (self-portrait),
137 × 69 cm (2003)

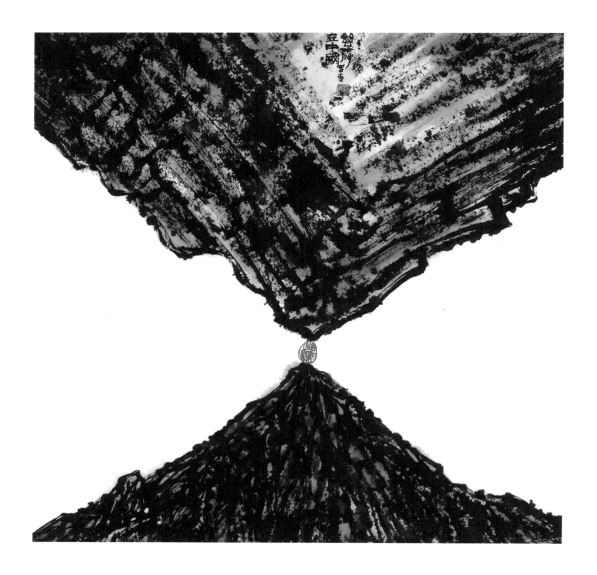

Figure 20. 幽浮在中國（自畫像）/ UFO in China (self-portrait),
69 × 69 cm (2006)

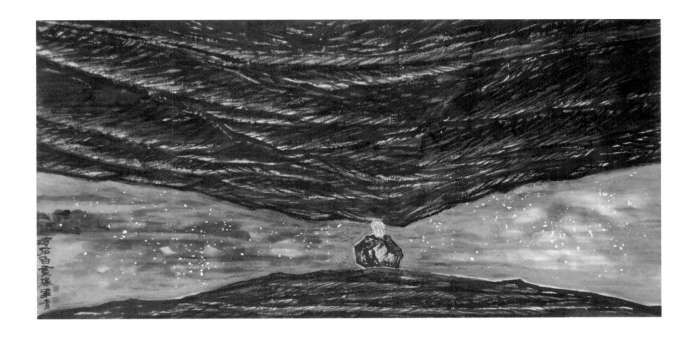

Figure 21. 頑石擎天（自畫像）/ Hard rock holding up the sky (self-portrait), 69 × 137 cm (2008)

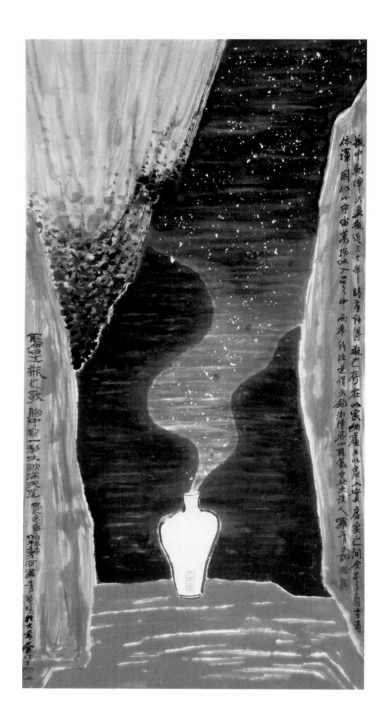

Figure 22. 聚星瓶之歌（自畫像）/ Song of the star-collecting jar (self-portrait),
137 × 69 cm (2008)

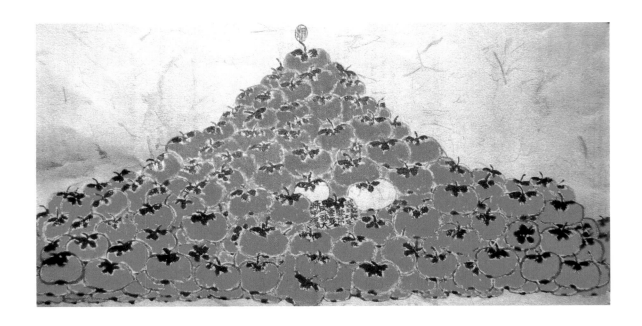

Figure 23. 還沒決定要不要變成柿子（自畫像）/ Not yet a persimmon (self-portrait), 69 × 137 cm (2009)

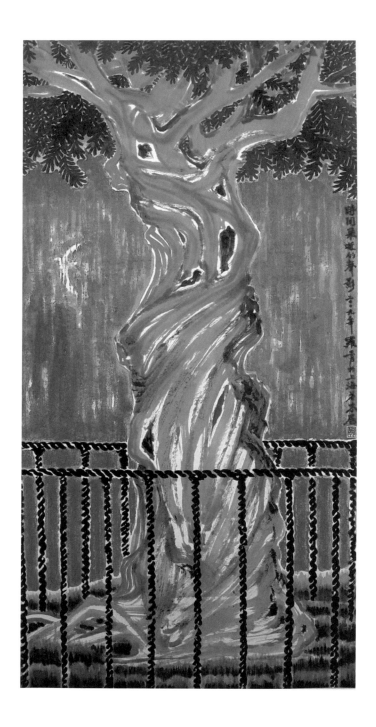

Figure 24. 時間牢籠（自畫像）/ In the cage of time (self-portrait),
137 × 69 cm (2009)

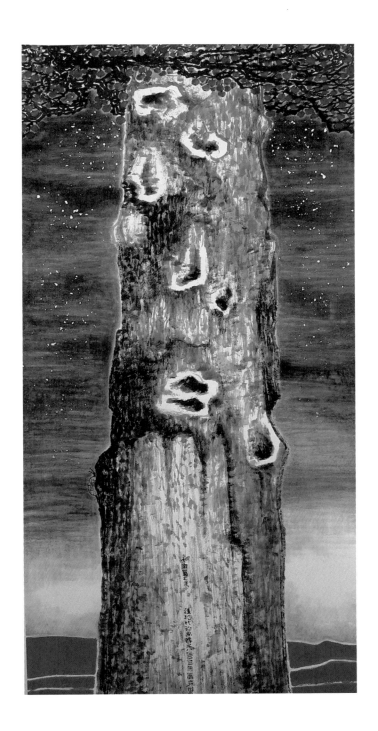

Figure 25. 大樹藝道（自畫像）/ A huge tree, the true way of art
(self-portrait), 137 × 69 cm (2009)

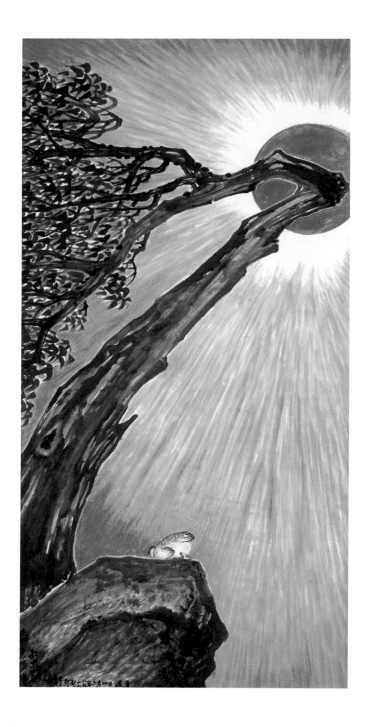

Figure 26. 綠樹青葉撞太陽（自畫像）/ An imaginary toad elbowing the red sun (self-portrait), 137 × 69 cm (2009)

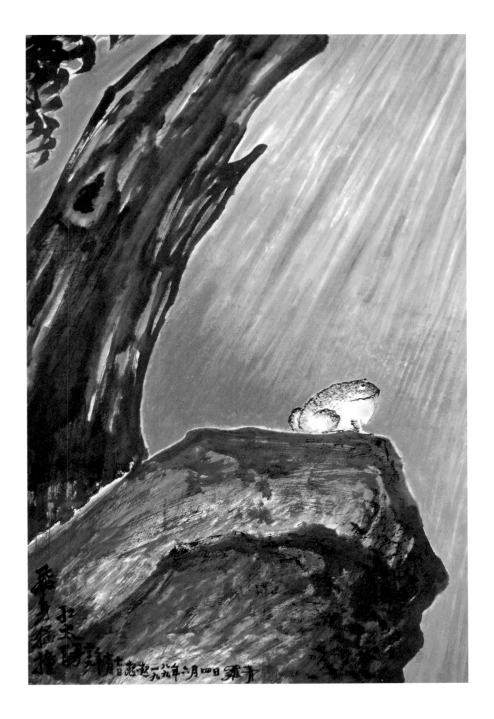

Figure 27. 綠樹青葉撞太陽（局部） / An imaginary toad elbowing the red sun (self-portrait) (detail), 137 × 69 cm (2009)

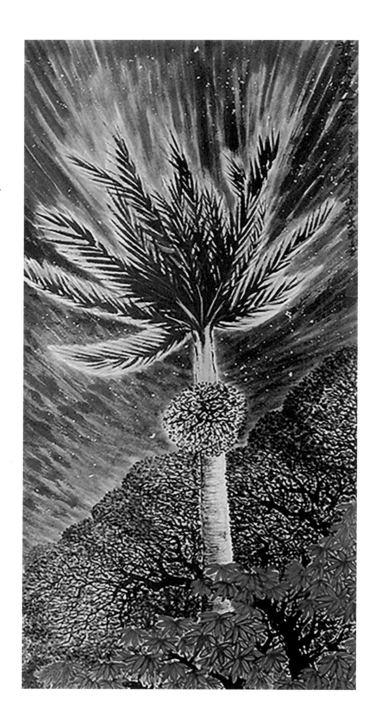

Figure 28. 揚臂揮灑一天星（自畫像）/ Scattering a sky of stars
(self-portrait), 137 × 69 cm (2009)

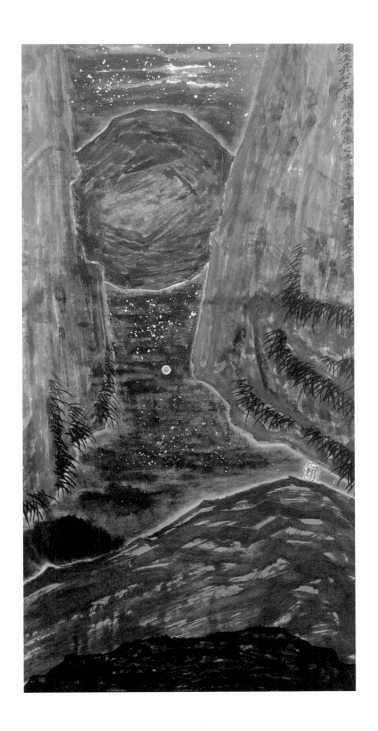

Figure 29. 抗擠石（自畫像）/ The struggling rock
(self-portrait), 137 × 69 cm (2009)

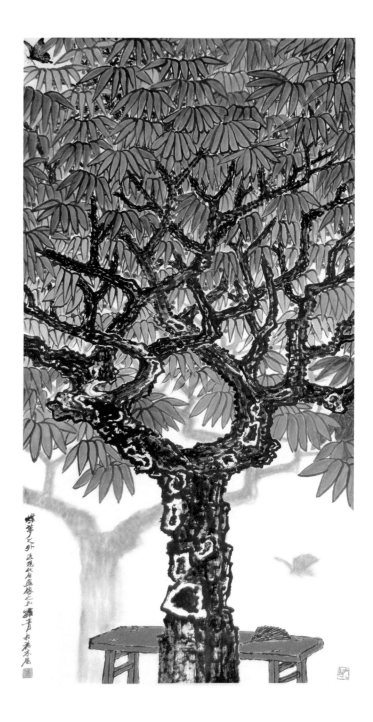

Figure 30. 蝶夢之外（自畫像）/ Butterfly dream on a red bench
(self-portrait), 137 × 69 (2011)

The Postmodern Turn:
Landscape Deconstructed Series

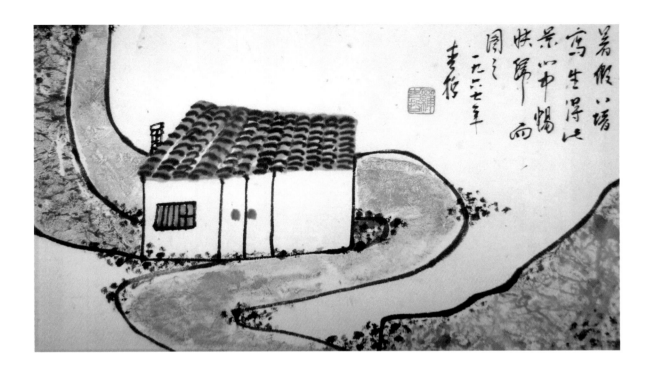

Figure 31. 八堵寫生 / An impression of Badu district,
23 × 39 cm (1967)

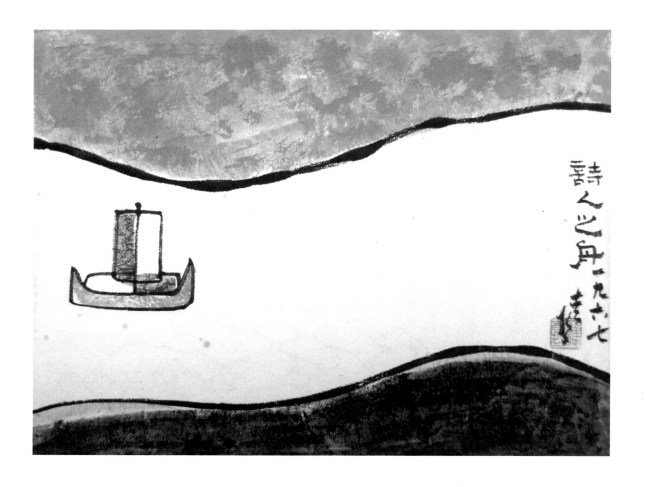

Figure 32. 詩人之舟 / The boat of poetry,
26.2 × 34.6 cm (1967)

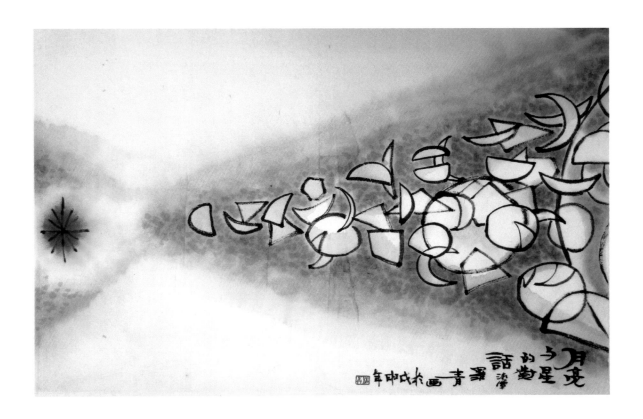

Figure 33. 星星與月亮的對話 / A conversation between
the moon and the stars, 41.5 × 62.4 cm (1968)

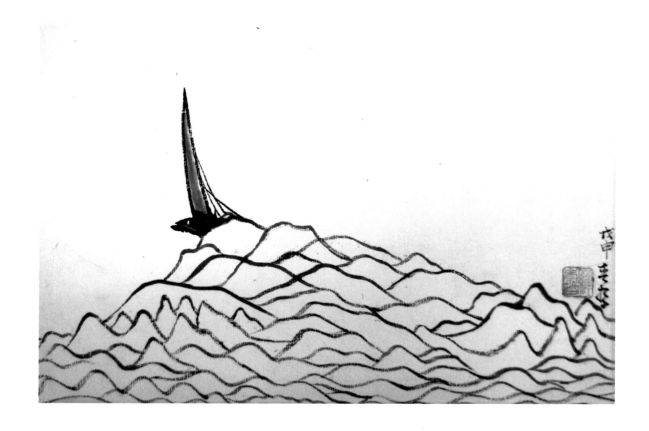

Figure 34. 小舟搏浪如翻山 / Braving billows like climbing mountains, 24 × 34.5 cm (1968)

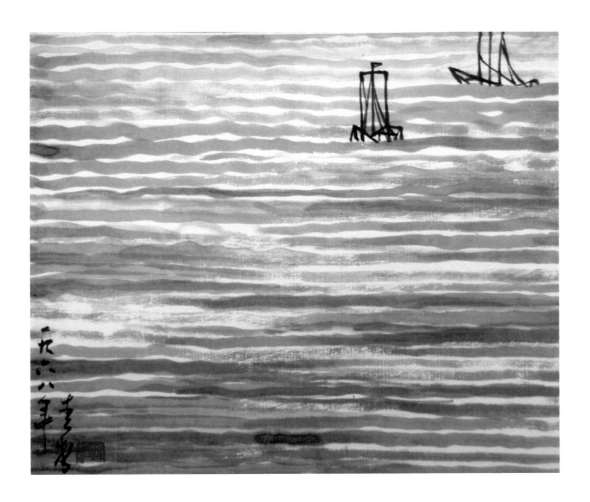

Figure 35. 人海浮沉自在行 / Floating in the sea,
29.3 × 34.2 cm (1968)

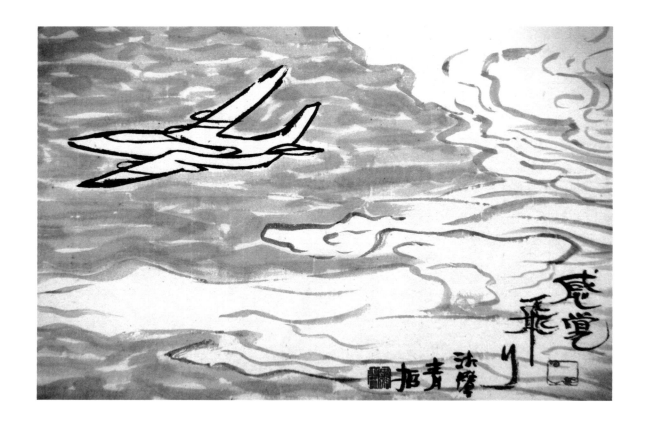

Figure 36. 感覺飛行 / Fly to touch and feel,
34.8 × 56.3 cm (1968)

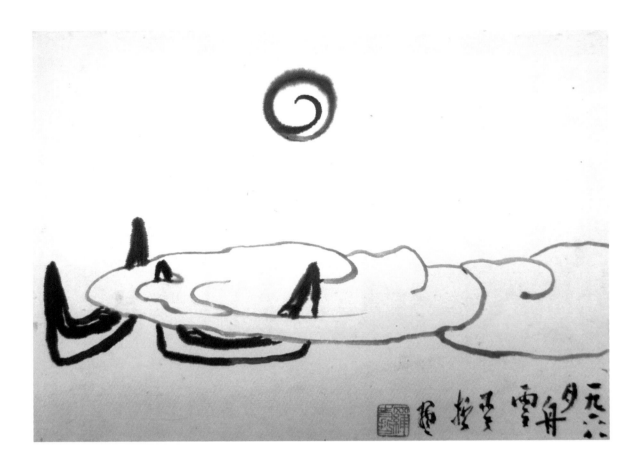

Figure 37. 月如舟如雲 / Moon like boat like cloud,
24 × 32.5 cm (1968)

Figure 38. 雲破月來花弄影 / Suddenly the moon emerging from the cloudy shadows, 14.8 × 43 / 24.8 × 43 cm (1969)

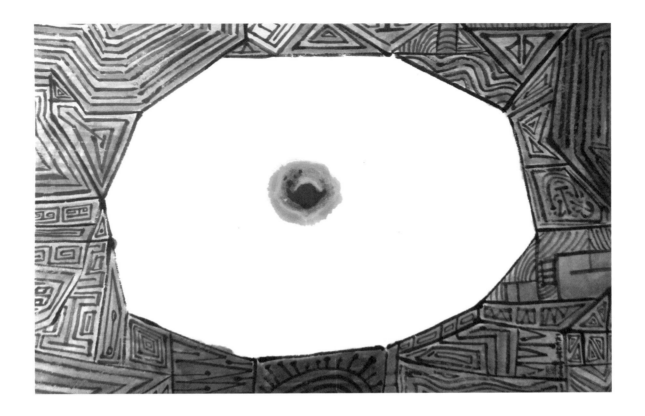

Figure 39. 一點紅 / A red spot, 46.5 × 68.5 cm (1970)

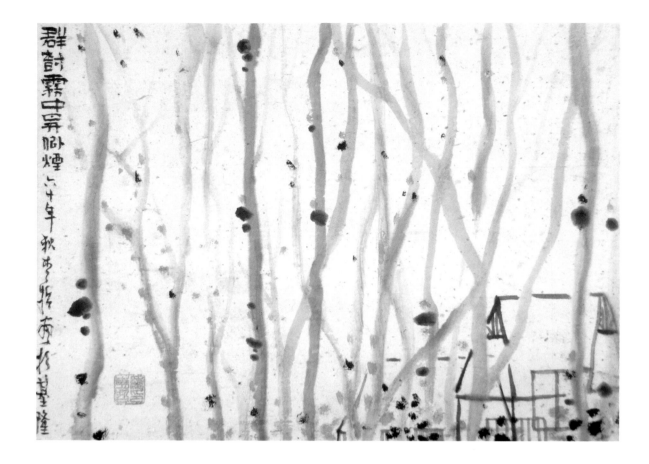

Figure 40. 群樹霧中升似煙 / Woods vaporizing like mist,
25.5 × 34 cm (1971)

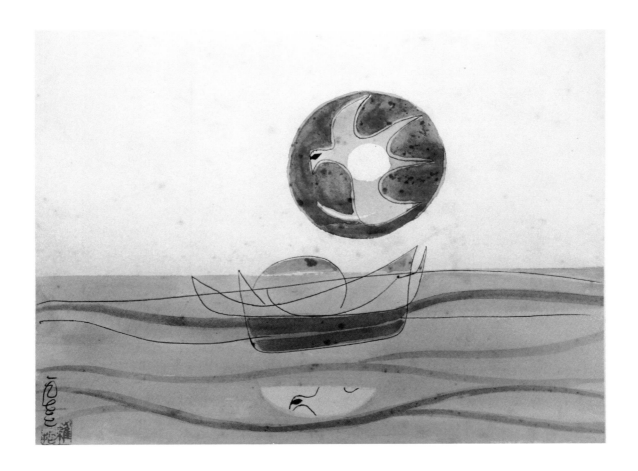

Figure 41. 鯤飛成鵬 / Huge fish transforming into a giant bird,
20 × 26.5 cm (1973)

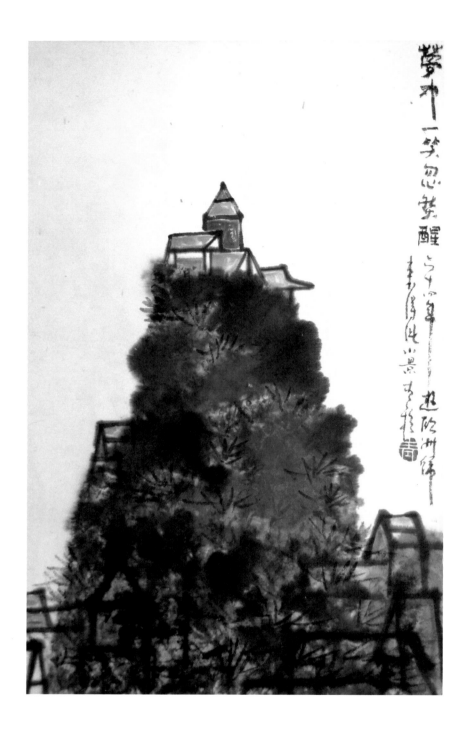

Figure 42. 夢中一笑忽然醒 / Laughing to awaken in the dream of trees,
41 × 26 cm (1974)

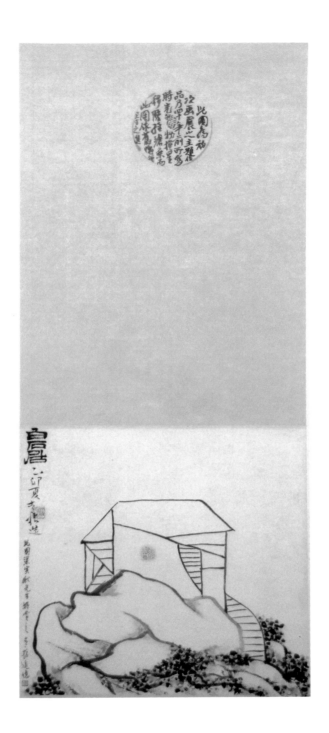

Figure 43. 白石居 / The ivory house on the white rock,
25.5 × 34 cm (1975)

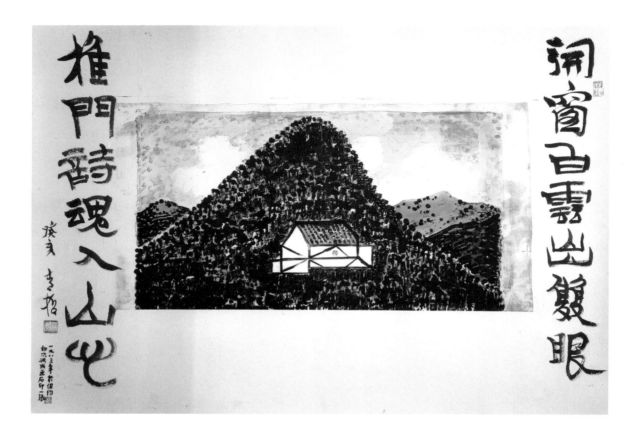

Figure 44. 詩魂入山心 / Poetic spirit echoing in the mountain deep,
54 × 75 cm (1983)

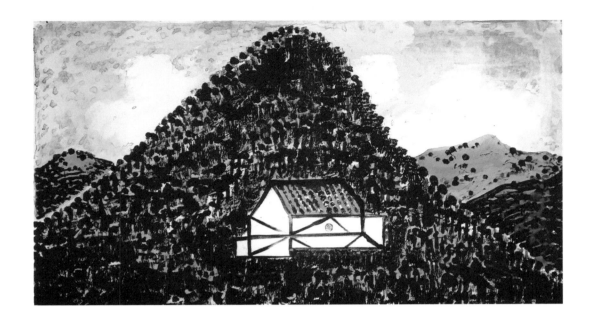

Figure 45. 詩魂入山心（局部）/ Poetic spirit echoing in the mountain deep
(detail), 54 × 75 cm (1983)

Figure 46. 向冬夜講述溫暖 / Relating the story of summer in the
wintry night, 34 × 50 cm (1990)

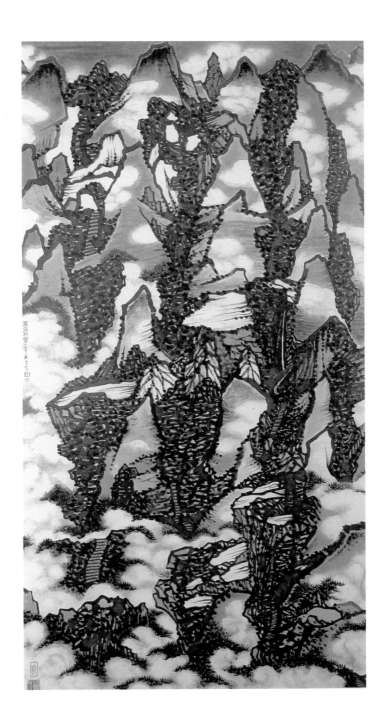

Figure 47. 萬壑祥雲 / Ten thousand auspicious clouds,
137 × 69 cm (1997)

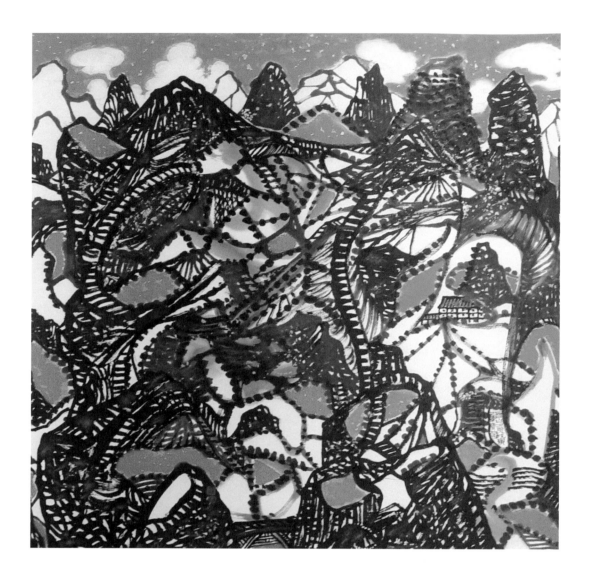

Figure 48. 高呼敦煌 / Calling for Tun-huang Cave paintings,
137 × 69 cm (1998)

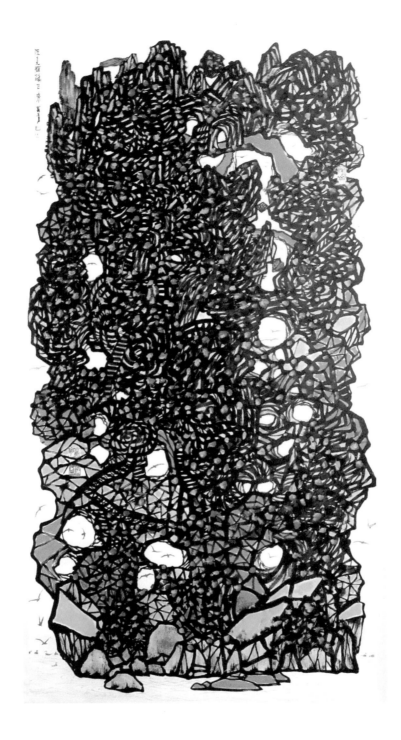

Figure 49. 高呼杜甫 但見群鷗日日來 / Calling for Tu Fu the T'ang poet,
137 × 69 cm (2002)

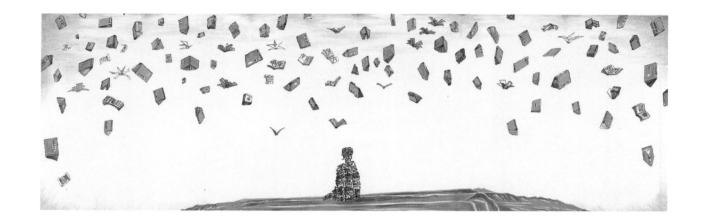

Figure 50. 空山尋書鬥（一人文化大革命）／ Fighting of the books
(One Man's Cultural Revolution), 137 × 414 cm (2006)

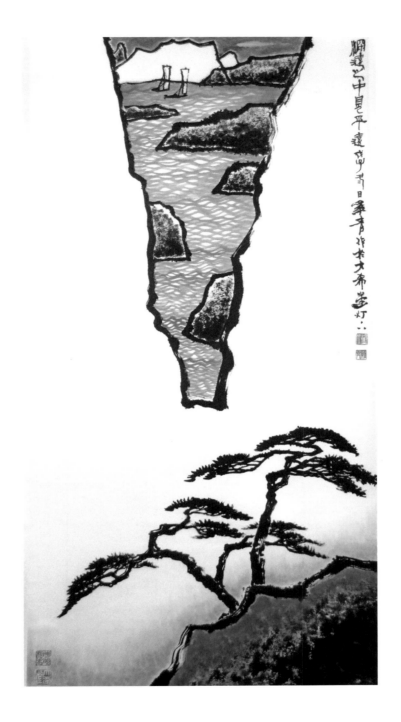

Figure 51. 深遠之中見平遠 / Seeing sea in the heart of the mountain, 137 × 69 cm (2008)

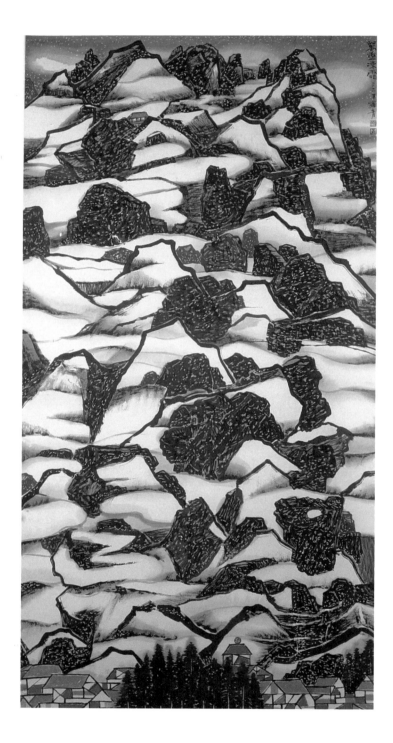

Figure 52. 萬重凍雲 / Ten thousand frozen clouds,
137 × 69 cm (2008)

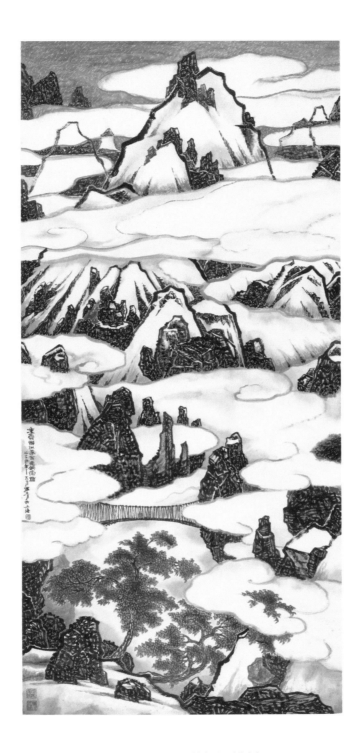

Figure 53. 凍雲懶得過鐵橋 / The frozen cloud is too lazy to use
the iron bridge, 137 × 69 cm (2009)

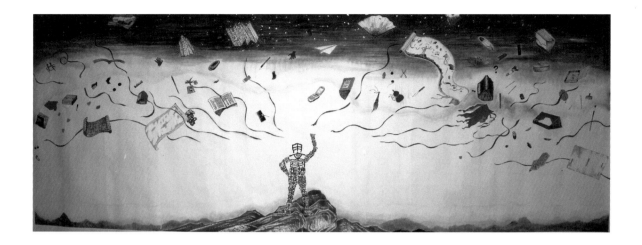

Figure 54. 空山文字鬥（一人文化大革命之三）/ Fighting of words
(One Man's Cultural Revolution 3), 192 × 479 cm (2012)

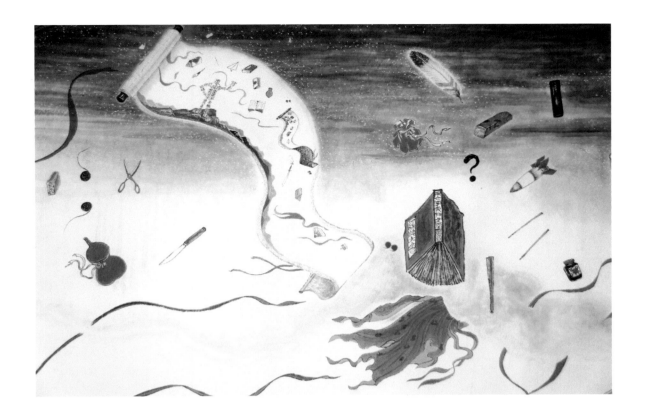

Figure 55. 空山文字鬥（局部一）/ Fighting of words
(detail 1), 192 × 479 cm (2012)

108

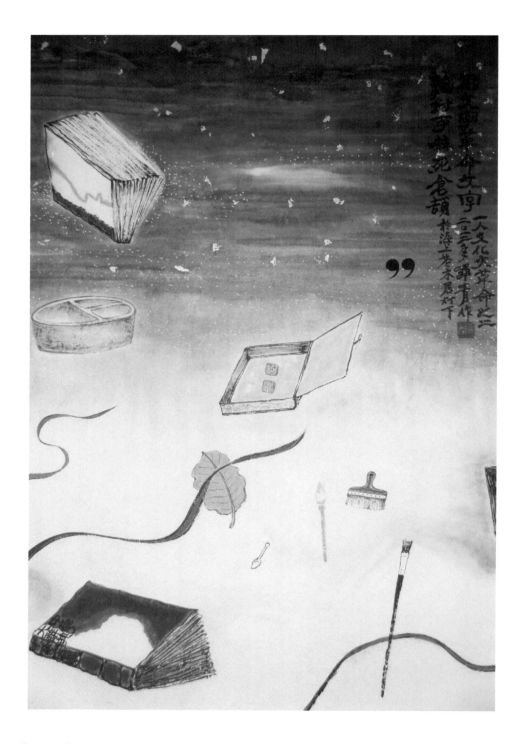

Figure 56. 空山文字鬥（局部二）/ Fighting of words (detail 2),
192 × 479 cm (2012)

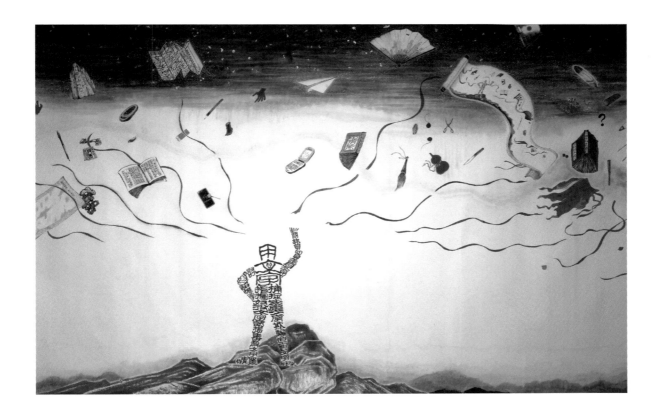

Figure 57. 空山文字鬥（局部三） / Fighting of words (detail 3),
192 × 479 cm (2012)

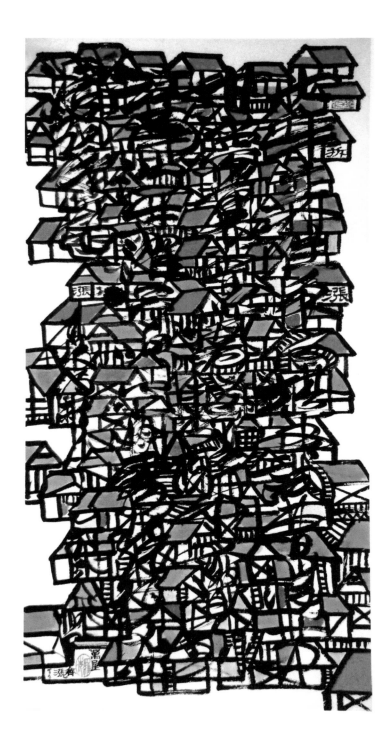

Figure 58. 萬屋齊漲（三聯屏之一） / Ten thousand real estates
(triptych, right), 137 × 69 cm (2012)

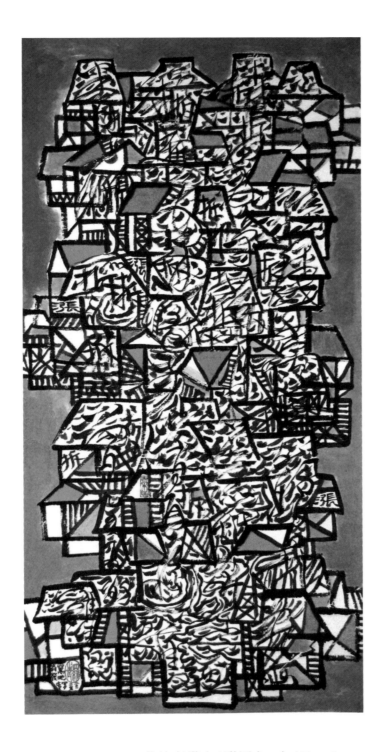

Figure 59. 萬地齊發（三聯屏之二）/ Ten thousand construction sites
(triptych, center), 137 × 69 cm (2012)

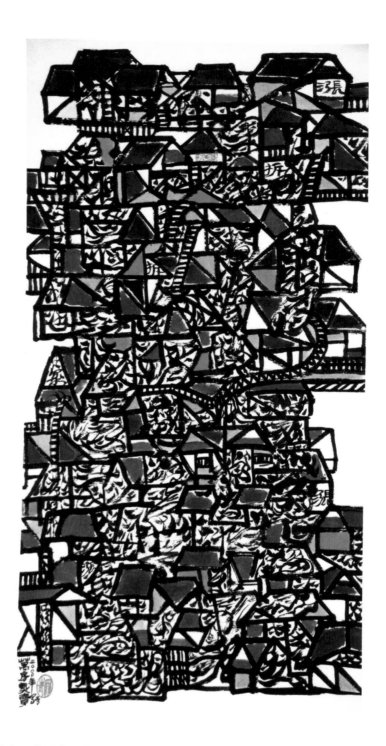

Figure 60. 萬房熱賣（三聯屏之三）/ Ten thousand houses for sale
(triptych, left), 137 × 69 cm (2012)

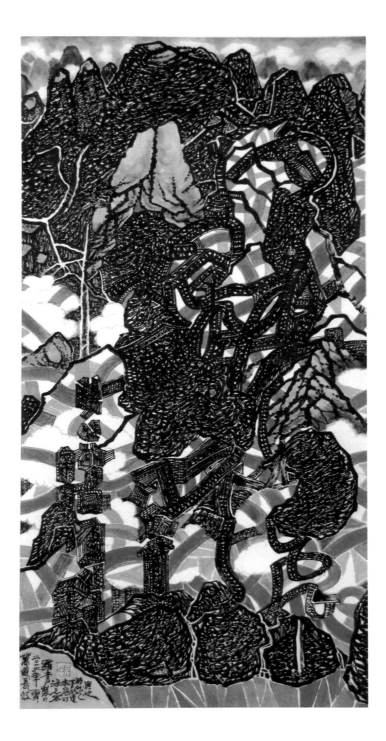

Figure 61. 萬道長虹 / Ten thousand rainbows,
137 × 69 cm (2012)

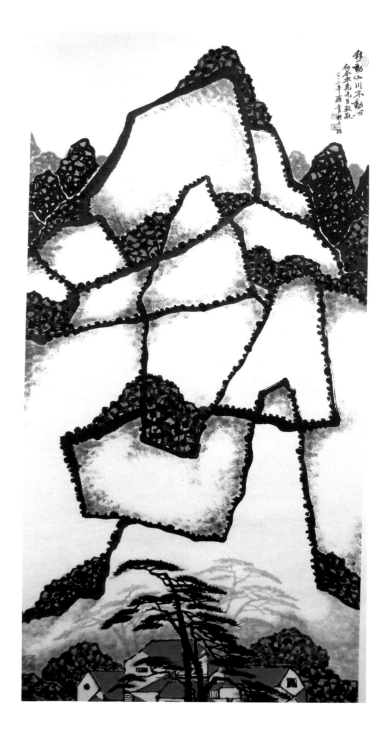

Figure 62. 移動山川 / The changing mountains in an unchanged heart,
137 × 69 cm (2012)

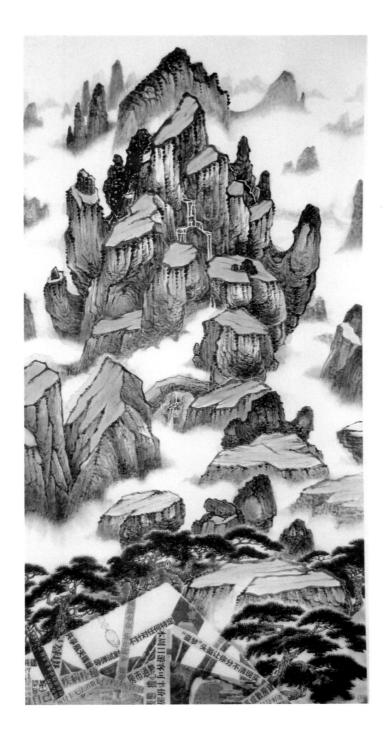

Figure 63. 萬山開發 ／ Ten thousand real estate developments,
137 × 69 cm (2013)

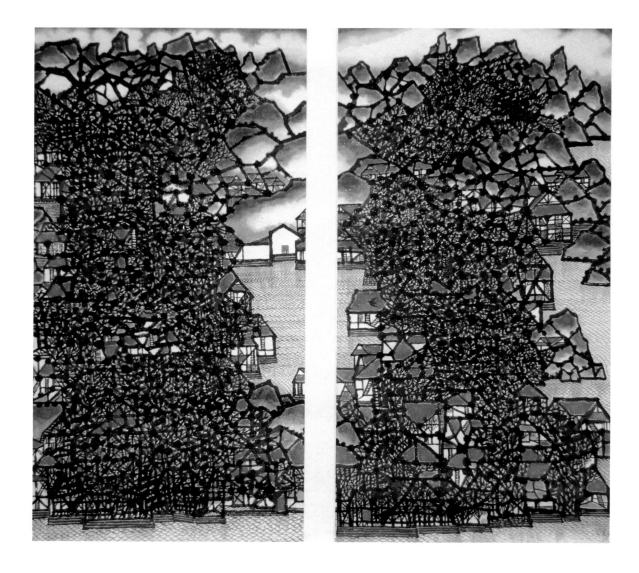

Figure 64. 萬屋投資（二聯屏）/ Ten thousand real estate investments
(diptych), 137 × 69 cm × 2 (2013)

The Postmodern Turn:
Windows Landscape Series

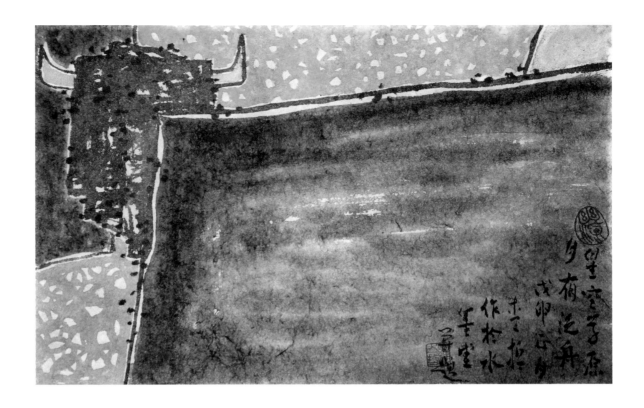

Figure 65. 星空草原月夜泛舟 / Starlit sky, meadows and
moonlight sailing, 28.5 × 43.5 cm (1968)

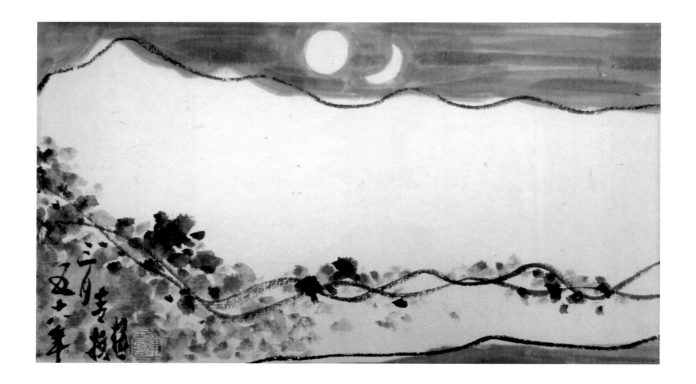

Figure 66. 月日橫挑不顧人 / The mountain that shoulderpoles
the sun and the moon, 25 × 43 cm (1969)

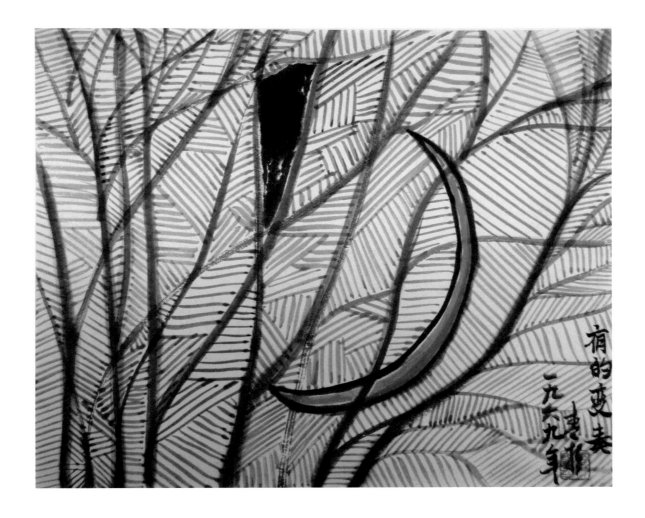

Figure 67. 夜的變奏 / Variations of the nocturnal song,
29 × 35 cm (1969)

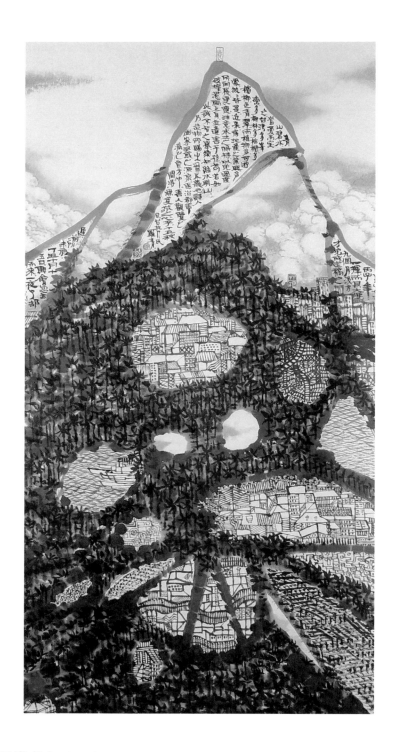

Figure 68. 為愛子孫護青山 / To love the green mountains is
to love our posterity, 137 × 69 cm (1997)

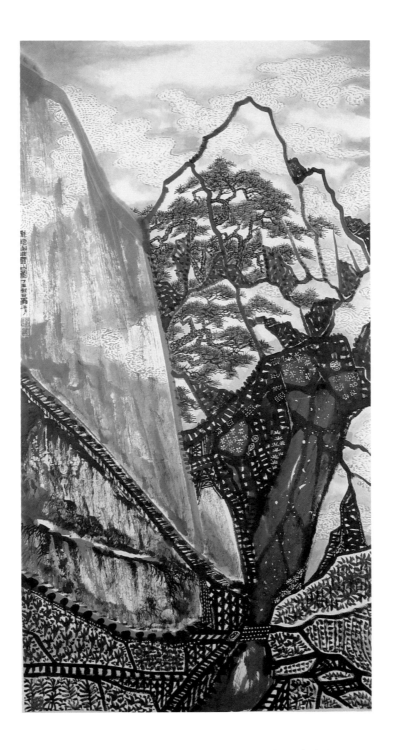

Figure 69. 鐵軌出岫圖 / Railway tracks stretching like mountain clouds, 137 × 69 cm (1997)

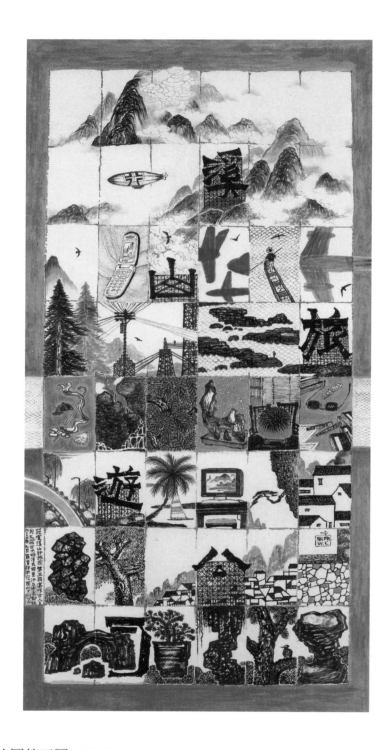

Figure 70. 溪山行旅圖第五圖 / Calling for Fan Kuan's
"Travelers amid Streams and Mountains" No. 5, 137 × 69 cm (2000)

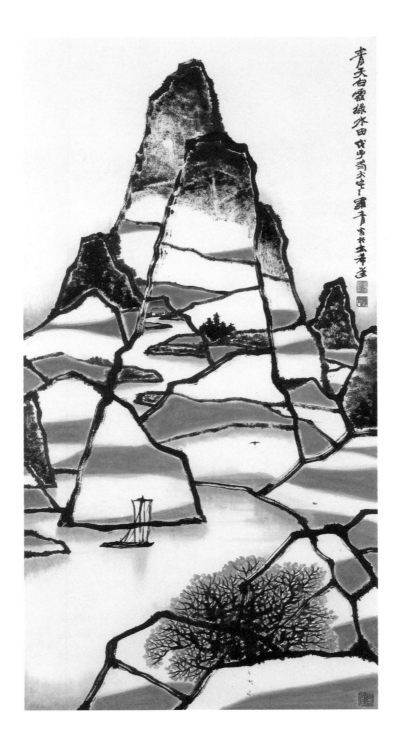

Figure 71. 青天白雲綠水田 / Blue sky, white cloud, and green rice field, 137 × 69 cm (2008)

126

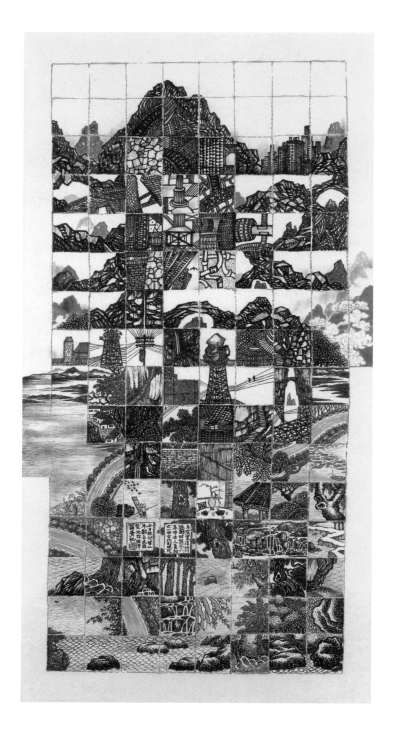

Figure 72. 溪山行旅圖第六圖 / Calling for Fan Kuan's
"Travelers amid Streams and Mountains" No. 6, 137 × 69 cm (2008)

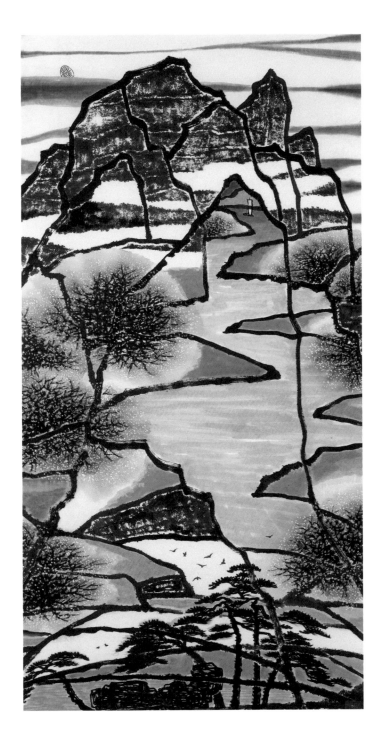

Figure 73. 夢中暗戀桃花源 / Dreaming of visiting Peach Blossom Spring,
137 × 69 cm (2008)

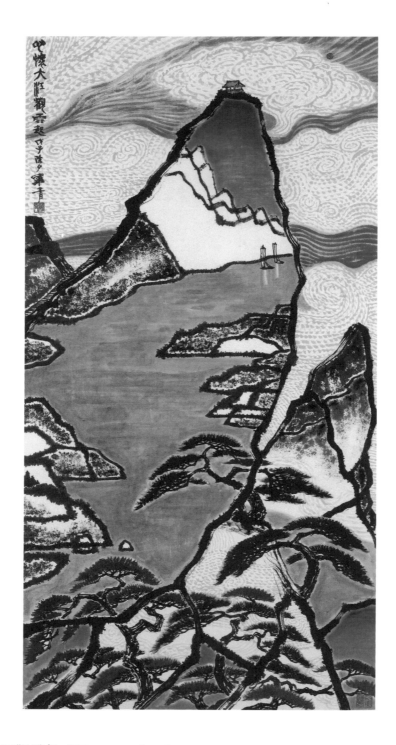

Figure 74. 心懷大江觀雲起 / Viewing clouds with a river in heart,
137 × 69 cm (2008)

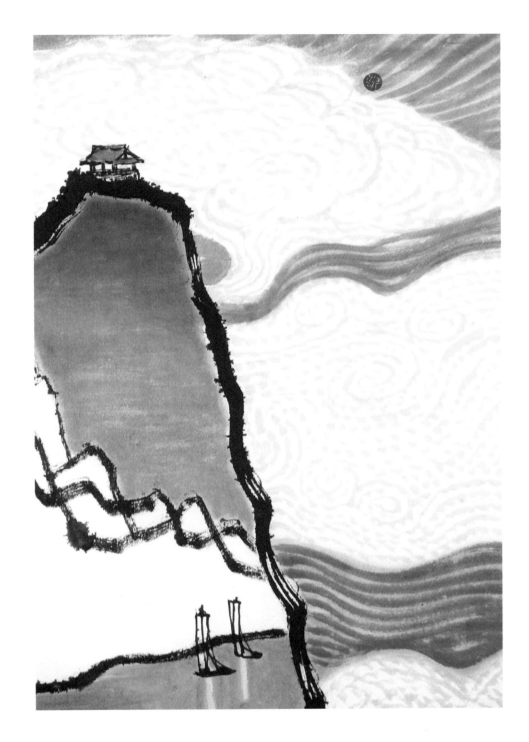

Figure 75. 心懷大江觀雲起（局部）/ Viewing clouds with a river in heart (detail), 137 × 69 cm (2008)

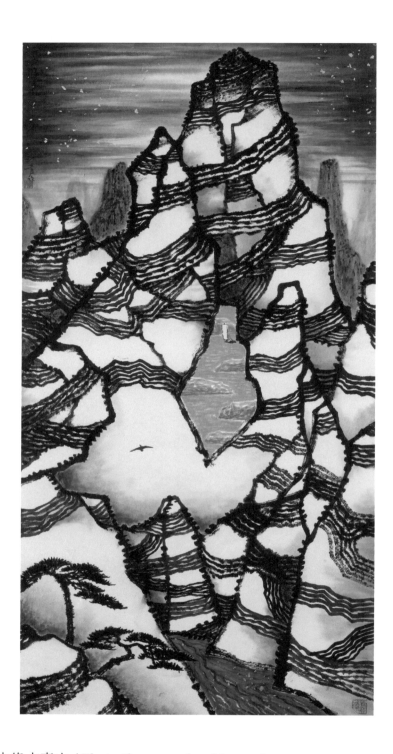

Figure 76. 飛向心中綠水青山 / Fly to the green land in my heart,
137 × 69 cm (2009)

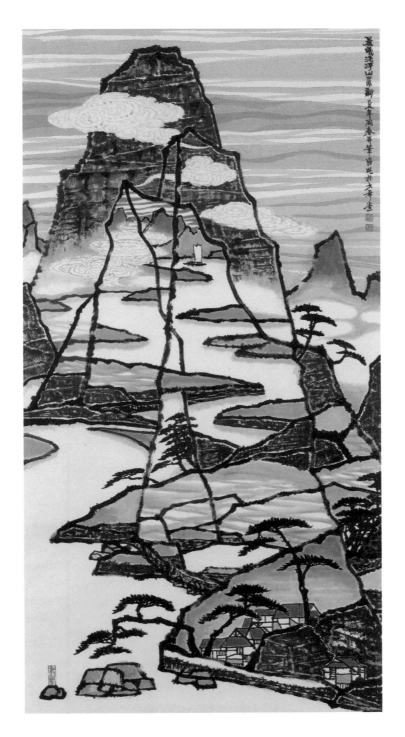

Figure 77. 晨曦洗淨山川新 / Mountains and streams refreshed
by the morning light, 137 × 69 cm (2009)

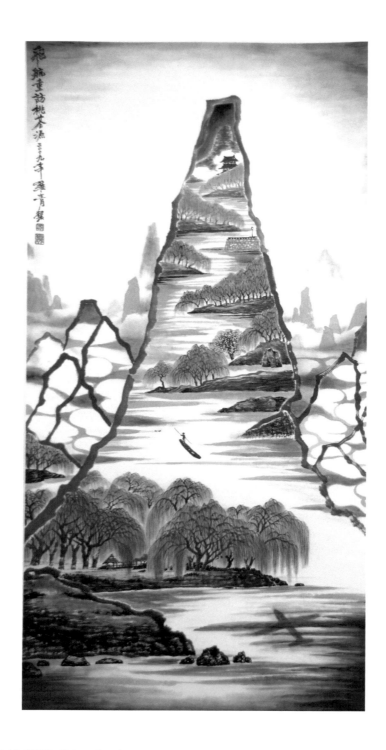

Figure 78. 飛航重訪桃花源 / Peach Blossom Spring revisited by flight, 137 × 69 cm (2009)

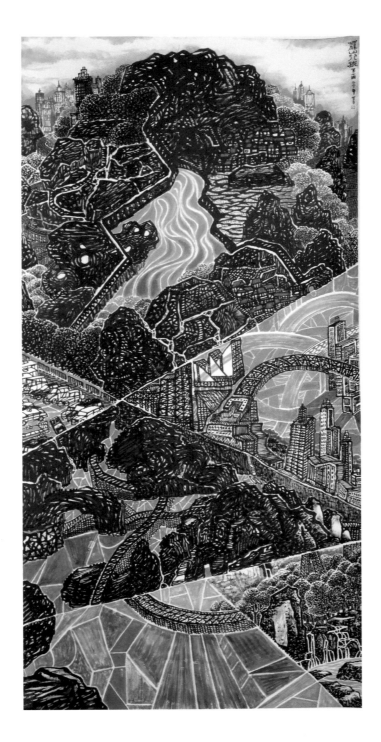

Figure 79. 溪山行旅圖第七圖 / Calling for Fan Kuan's
"Travelers amid Streams and Mountains" No. 7, 137 × 69 cm (2010)

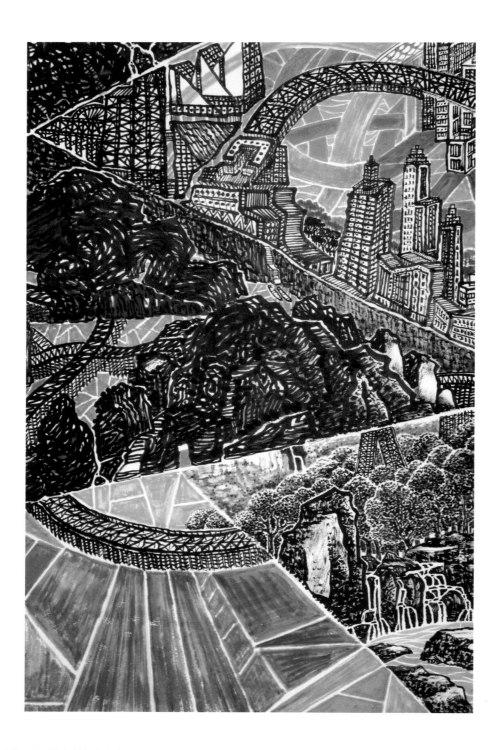

Figure 80. 溪山行旅圖第七圖（局部）/ Calling for Fan Kuan's
"Travelers amid Streams and Mountains" No. 7 (detail), 137 × 69 cm (2010)

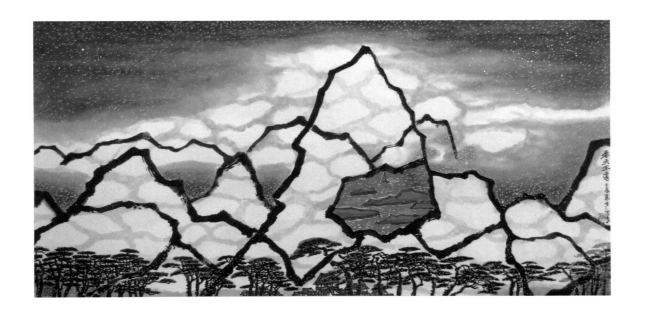

Figure 81. 春天不遠 / Can spring be far behind?,
169 × 37 cm (2012)

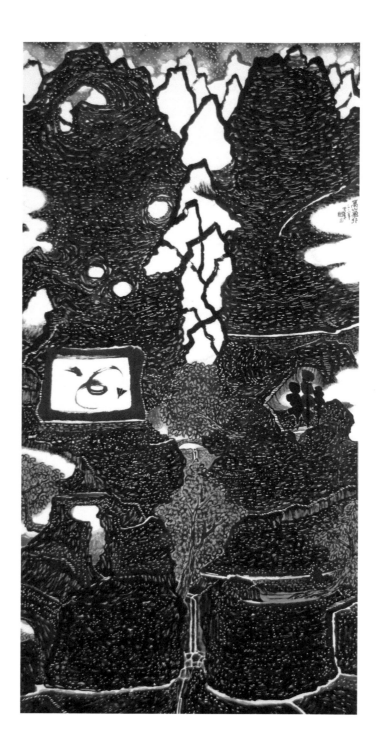

Figure 82. 萬山模擬飛行 / Flying with a flight simulator,
137 × 69 cm (2012)

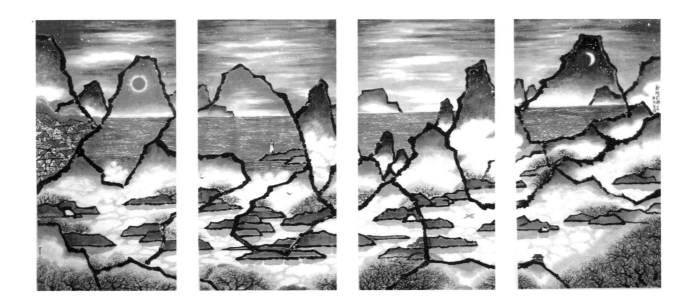

Figure 83. 新桃花源記（四聯屏）/ Peach Blossom Spring revisited
(quadriptych), 137 × 69 cm × 4 (2012)

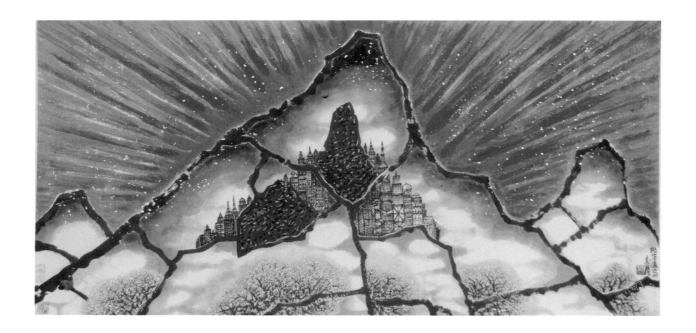

Figure 84. 發現桃花源之四 / Peach Blossom Spring rediscovered No. 4,
69 × 137 cm (2012)

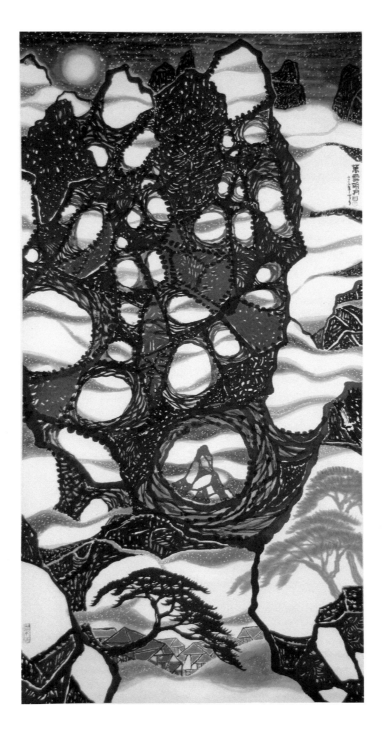

Figure 85. 萬雪明月 / Ten thousand moons reflected on the snow,
137 × 69 cm (2012)

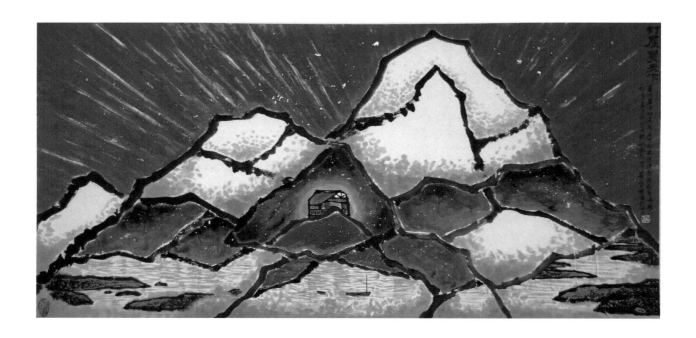

Figure 86. 燈屋照天下 / The Lamp House that lit up the world,
69 × 137 cm (2012)

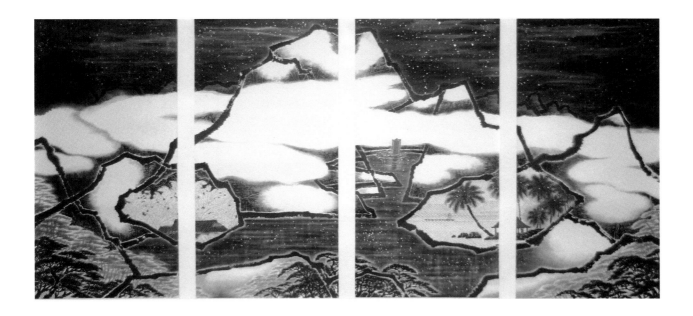

Figure 87. 地球暖化（四聯屏）/ Global warming (quadriptych),
137 × 69 cm × 4 (2013)

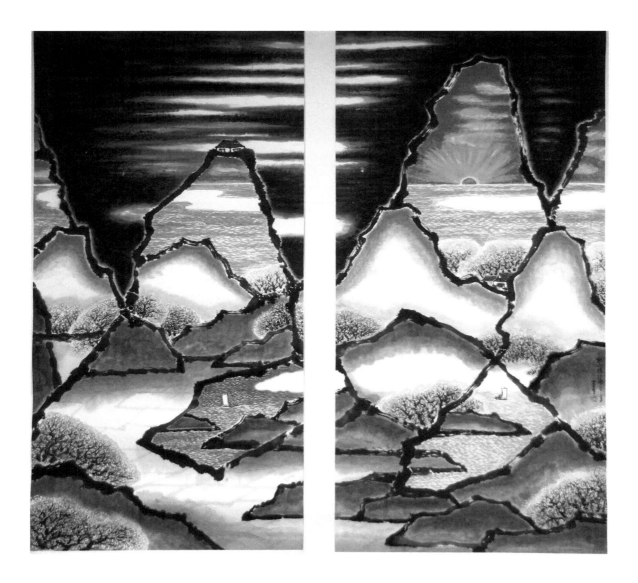

Figure 88. 能不憶江南（二聯屏）/ How can I forget the warm south?
(diptych), 137 × 69 cm × 2 (2013)

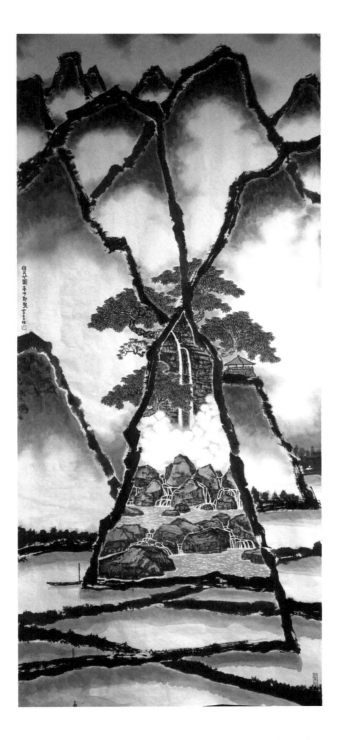

Figure 89. 幽谷圖—高呼郭熙 ／Calling for Kuo Hsi,
How green was the deep valley?, 215 × 96 cm (2014)

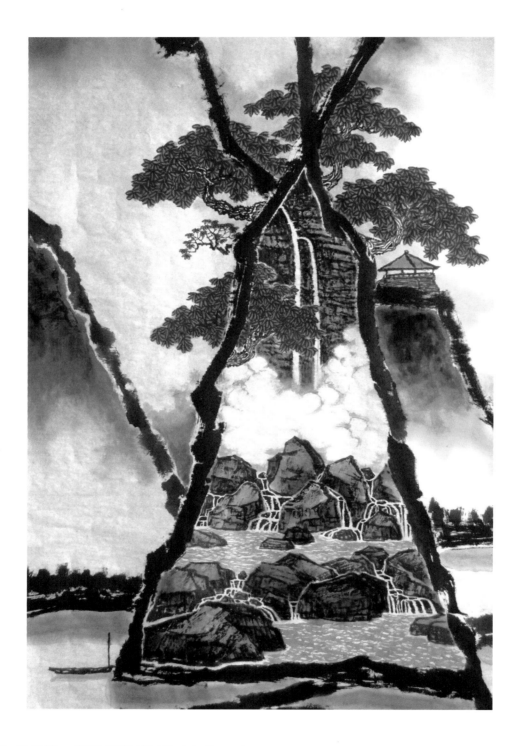

Figure 90. 幽谷圖—高呼郭熙（局部）/ Calling for Kuo Hsi,
How green was the deep valley? (detail), 215 × 96 cm (2014)

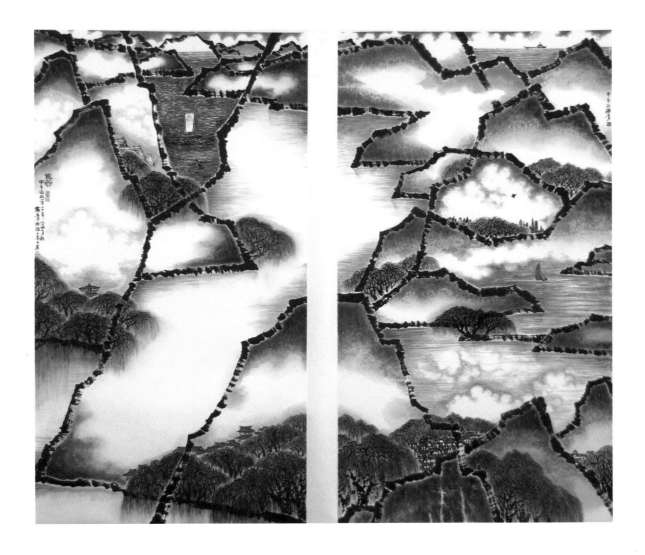

Figure 91. 風雲―甲午戰爭一百週年（二聯屏）/ In memory of the First Sino-Japanese War (diptych), 179 × 96 cm × 2 (2014)

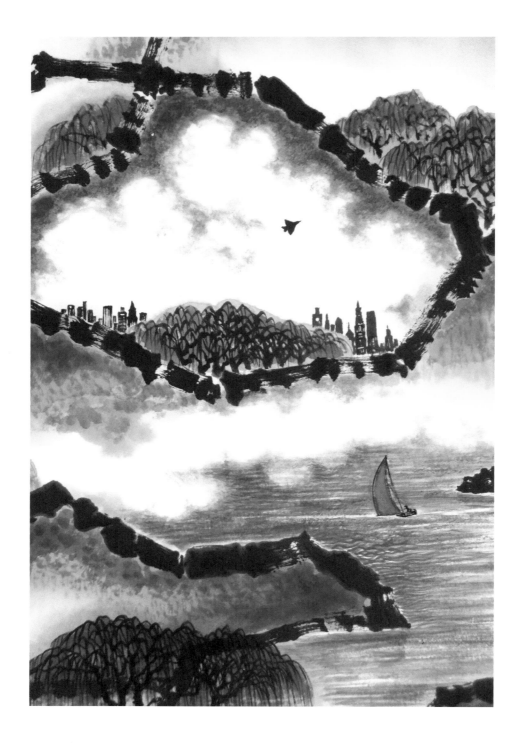

Figure 92. 風雲—甲午戰爭一百週年（局部一）/ In memory of the
First Sino-Japanese War (detail 1), 179 × 96 cm × 2 (2014)

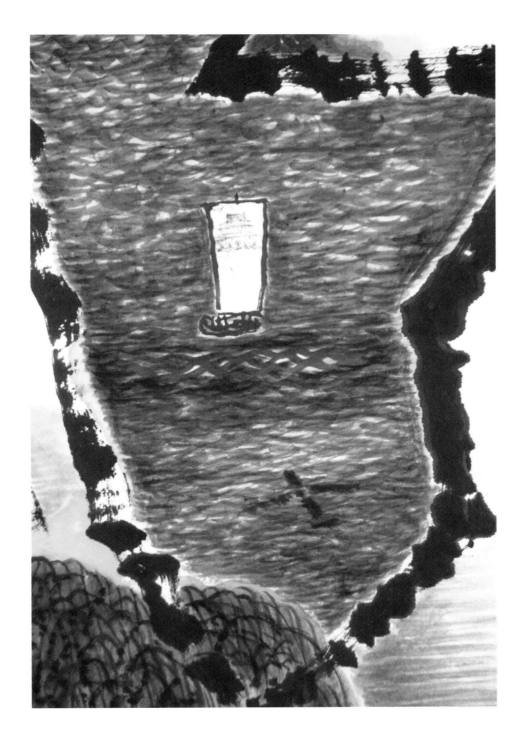

Figure 93. 風雲—甲午戰爭一百週年（局部二） / In memory of
the First Sino-Japanese War (detail 2), 179 × 96 cm × 2 (2014)

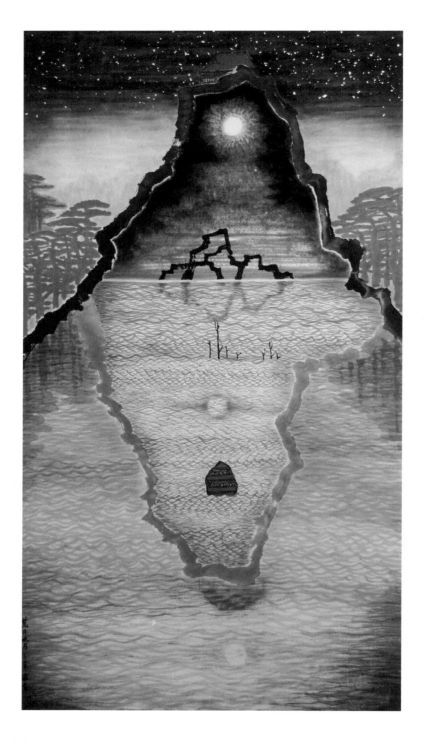

Figure 94. 萬片水月 / Ten thousand pieces of moon in waters,
179 × 96 cm (2014)

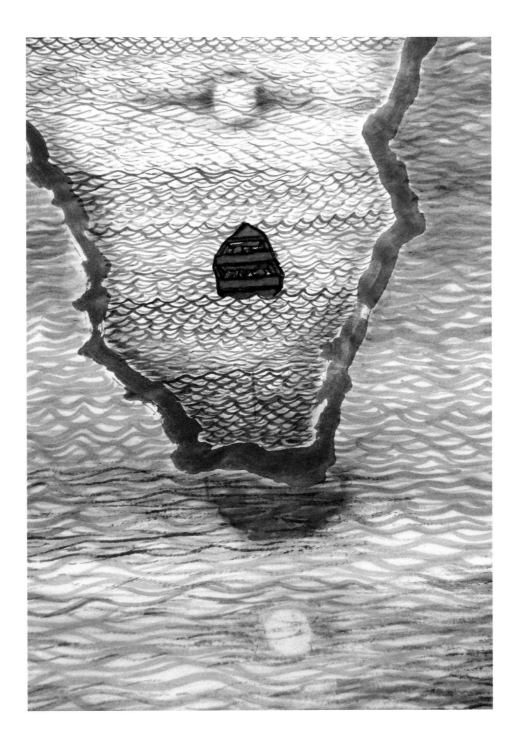

Figure 95. 萬片水月（局部）／ Ten thousand pieces of moon in waters
(detail), 179 × 96 cm (2014)

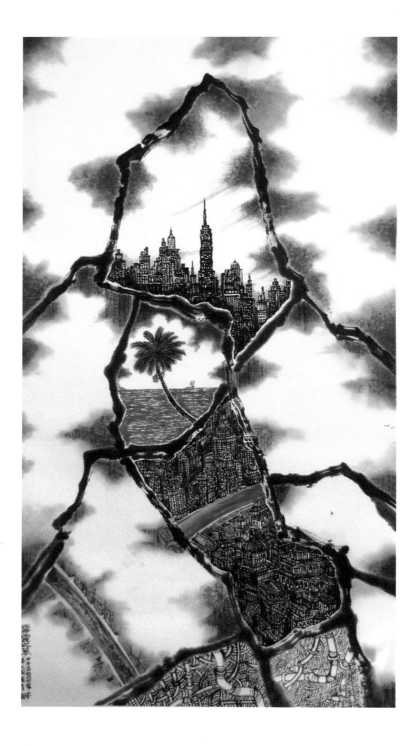

Figure 96. 霧霾中國夢 / The smoggy Chinese dream
179 × 96 cm (2014)

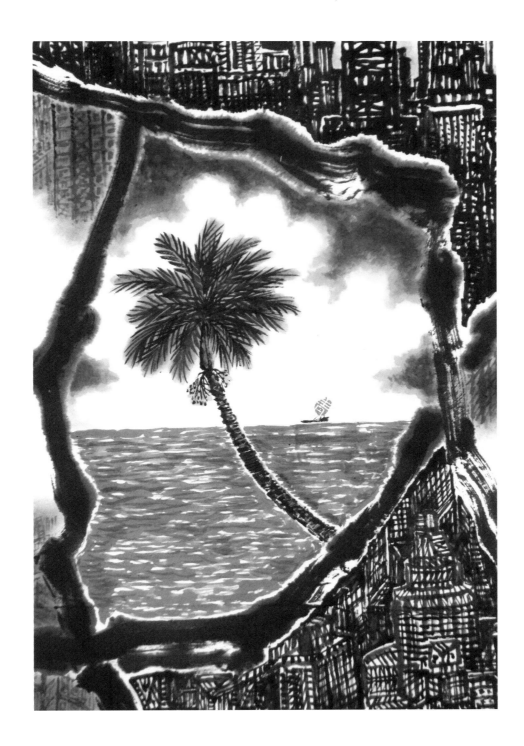

Figure 97. 霧霾中國夢（局部）/ The smoggy Chinese dream
(detail), 179 × 96 cm (2014)

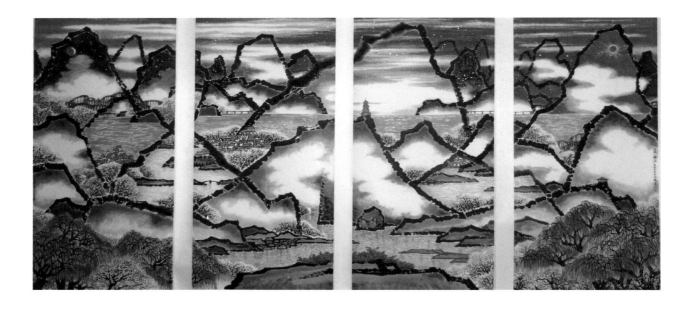

Figure 98. 日月照顧一朵小黃花（四聯屏） / The sun and the moon and a tiny yellow flower (quadriptych), 137 × 69 cm × 4 (2014)

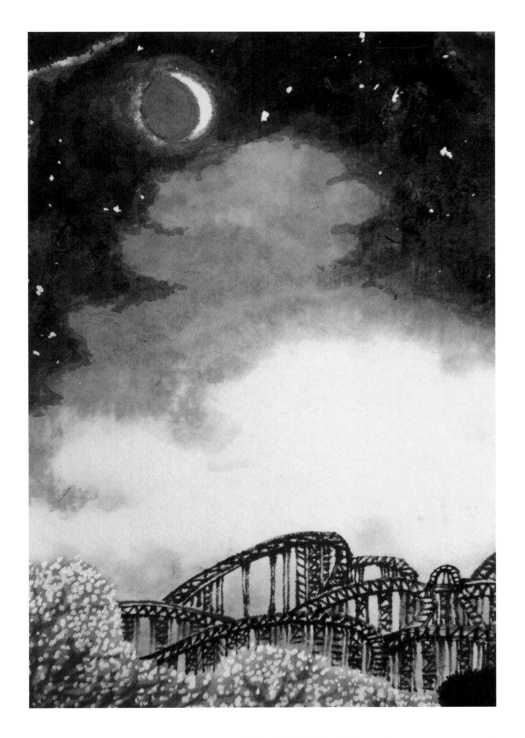

Figure 99. 日月照顧一朵小黃花（局部一）/ The sun and the moon and a tiny yellow flower (detail 1), 137 × 69 cm × 4 (2014)

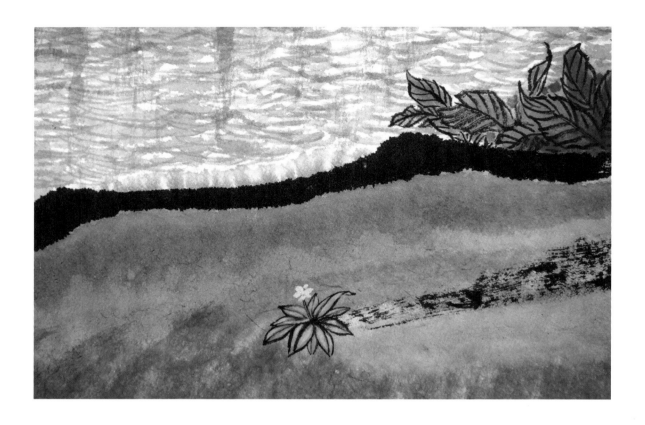

Figure 100. 日月照顧一朵小黃花（局部二）/ The sun and the moon and
a tiny yellow flower (detail 2), 137 × 69 cm × 4 (2014)

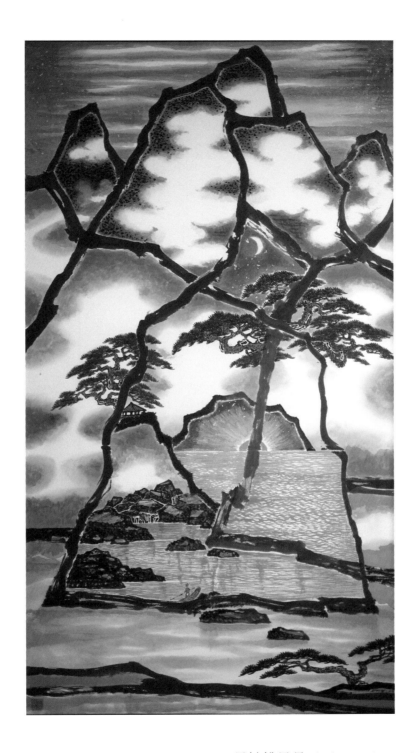

Figure 101. 長松挑日月 / The ancient pines shoulderpole the sun and the moon, 179 × 96 cm (2015)

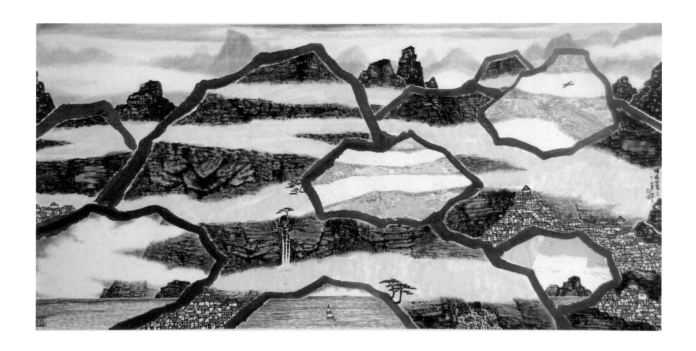

Figure 102. 環遊世界 / Around the world in no time,
69 × 137 cm (2015)

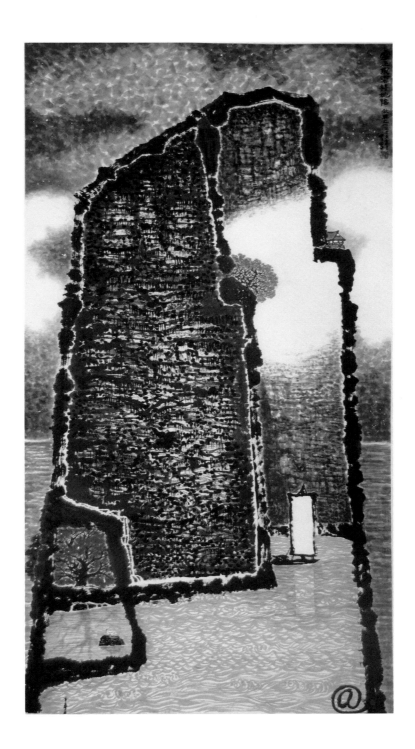

Figure 103. 塞上風雲接地陰 / Clouds and winds lock
the mountain gorge pass, 179 × 96 cm (2015)

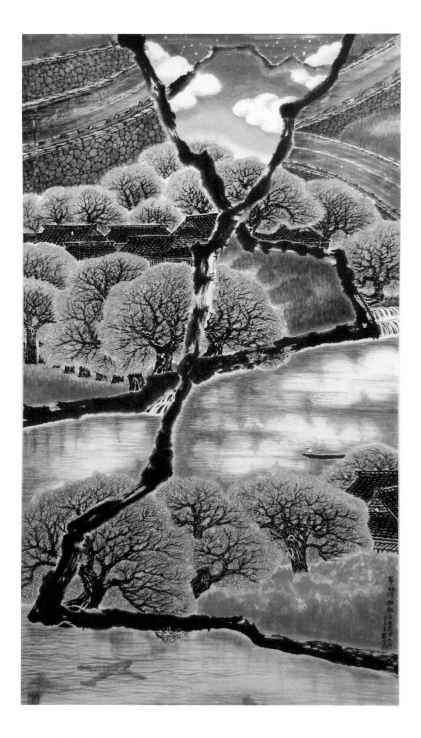

Figure 104. 夢的滑翔機 / The dream glider,
179 × 96 cm (2015)

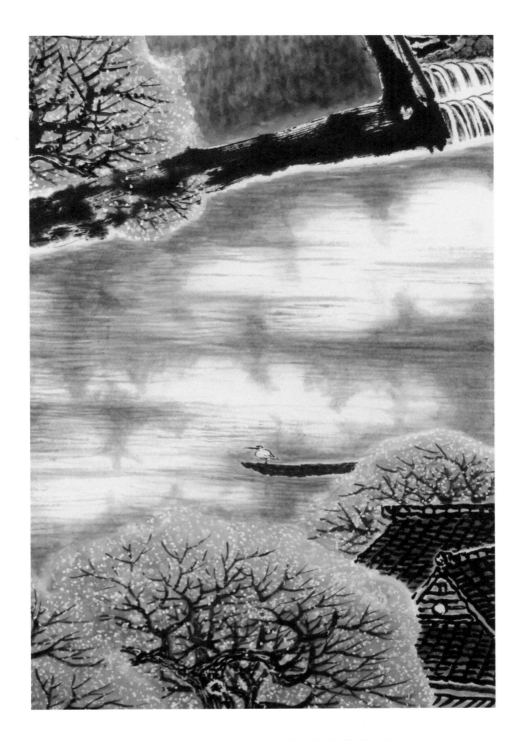

Figure 105. 夢的滑翔機（局部）/ The dream glider (detail),
179 × 96 cm (2015)

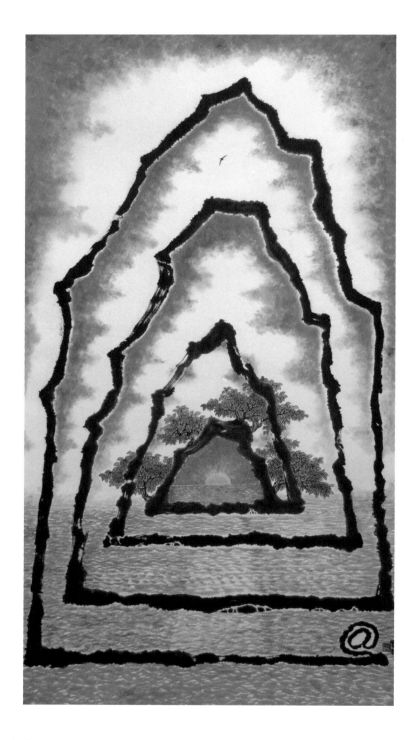

Figure 106. 電郵@山水 / Email@Landscape,
179 × 96 cm (2015)

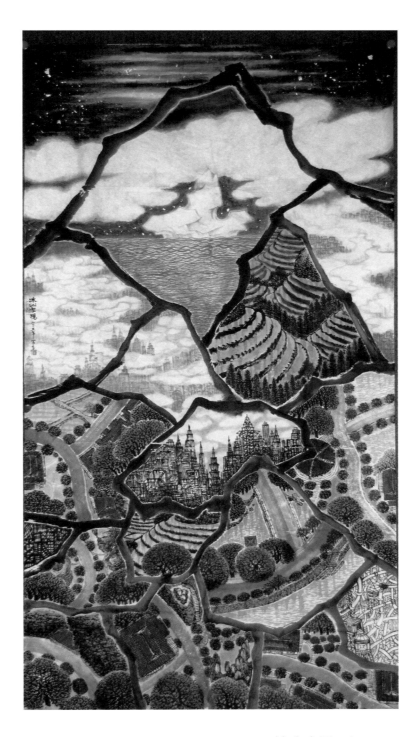

Figure 107. 冰山來了II / Here comes the iceberg II,
179 × 96 cm (2015)

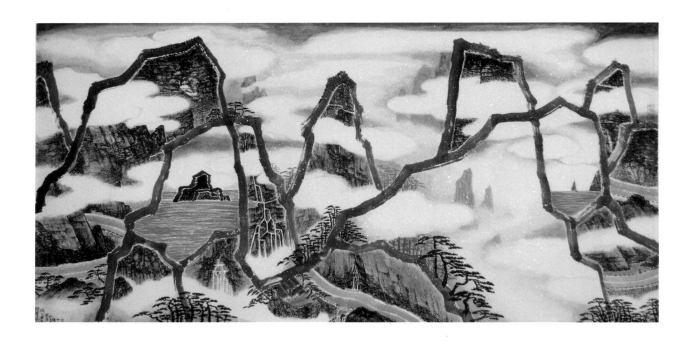

Figure 108. 千巖競秀 / Thousands of peaks thrive,
69 × 137 cm (2015)

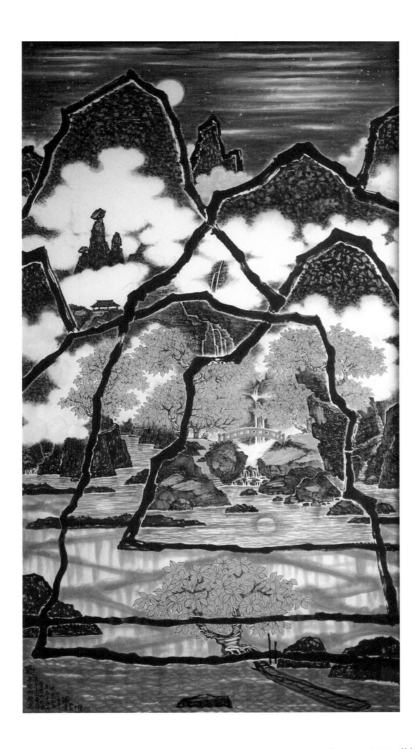

Figure 109. 戀 / In love with…,
179 × 96 cm (2015)

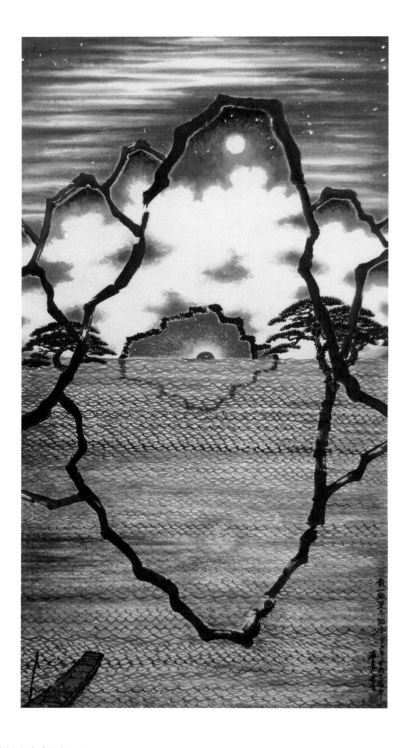

Figure 110. 載一船星光歸去 / Row a boatful of starlight home,
179 × 96 cm (2015)

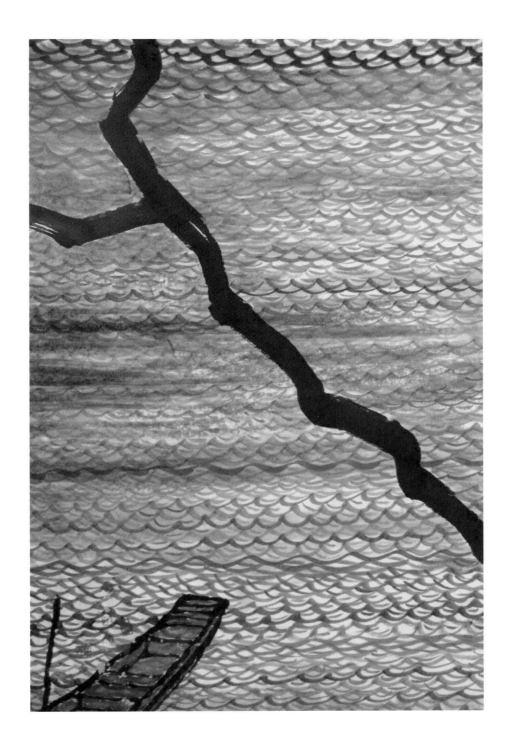

Figure 111. 載一船星光歸去（局部）/ Row a boatful of starlight home (detail), 179 × 96 cm (2015)

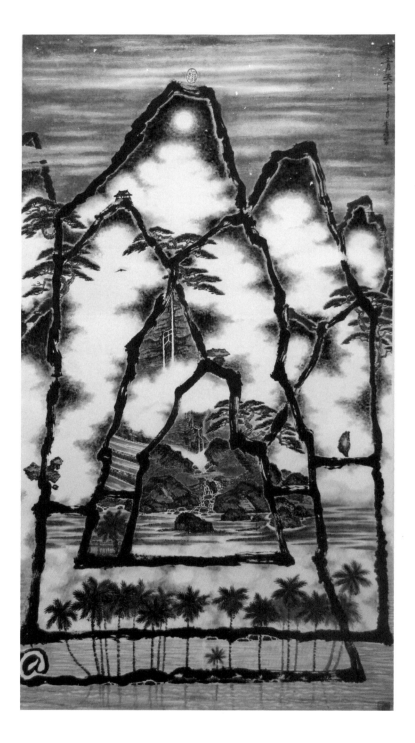

Figure 112. 羅青天下 / The art world of Lo Ch'ing,
179 × 96 cm (2015)

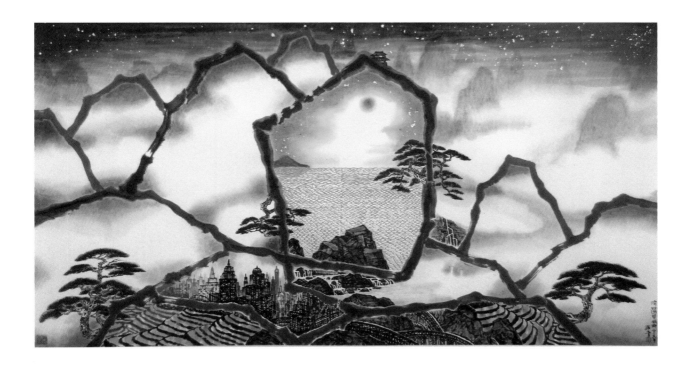

Figure 113. 溶溶日出桃花源 / The morning sun of Peach Blossom Spring,
96 × 197 cm (2015)

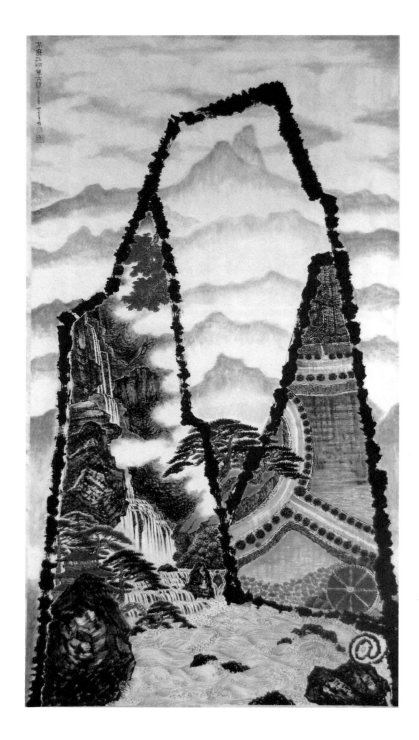

Figure 114. 不廢江河萬古流 / The present could never pass the past,
179 × 96 cm (2015)

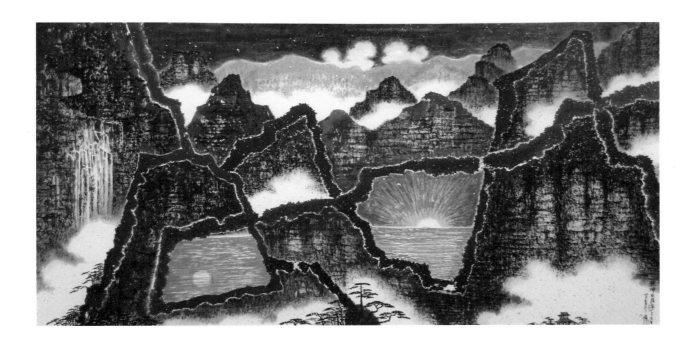

Figure 115. 乾坤日月浮 / The sun and the moon floating
and circling with the universe, 69 × 137 cm (2015)

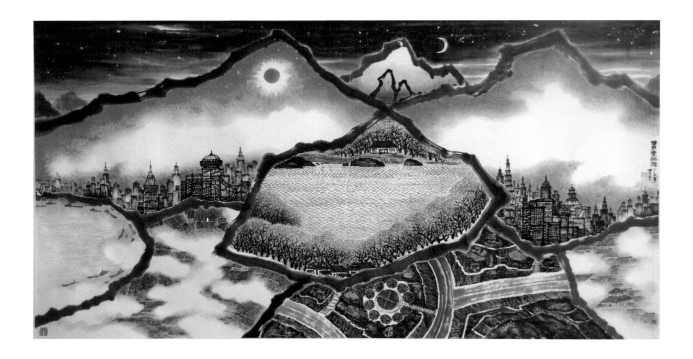

Figure 116. 日月東西跳 / The sun and the moon
jumping from the East to the West, 179 × 96 cm (2015)

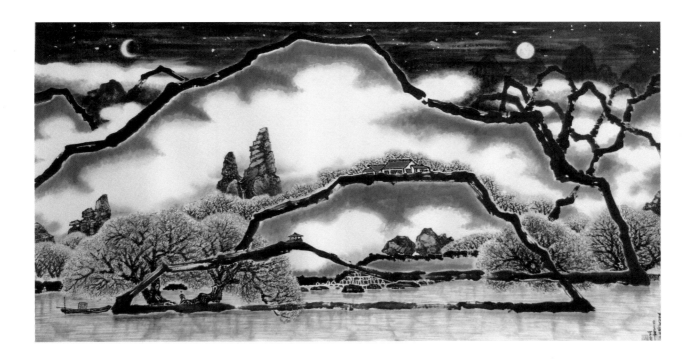

Figure 117. 日居月諸桃花源 / The sun and the moon of
Peach Blossom Spring, 179 × 96 cm (2015)

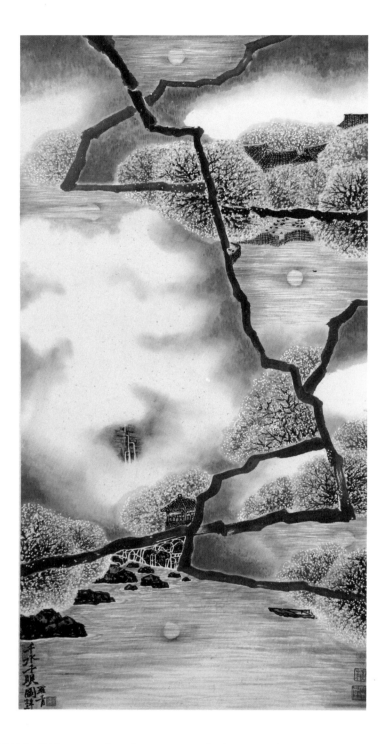

Figure 118. 千水千眼圖 / Thousands of waters with thousands of eyes,
179 × 96 cm (2015)

Modernism Revised:
Asphalt Road Series

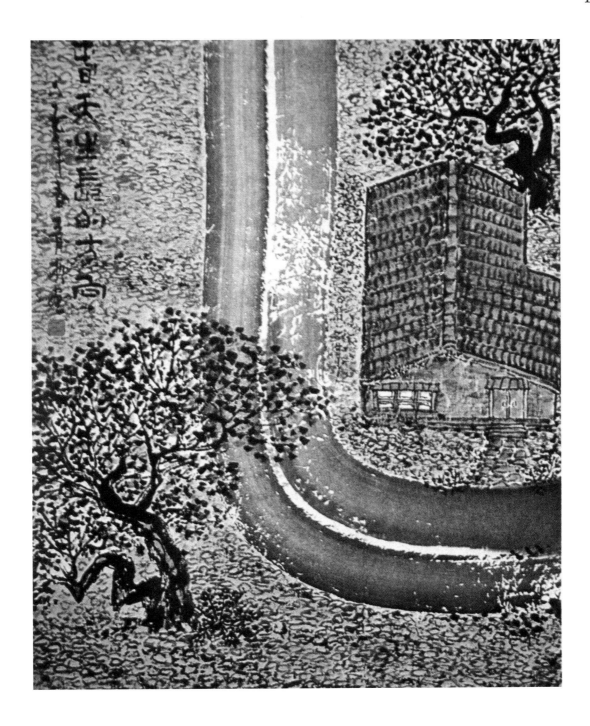

Figure 119. 春天生長的方向 / Spring's growing direction,
69 × 69 cm (1980)

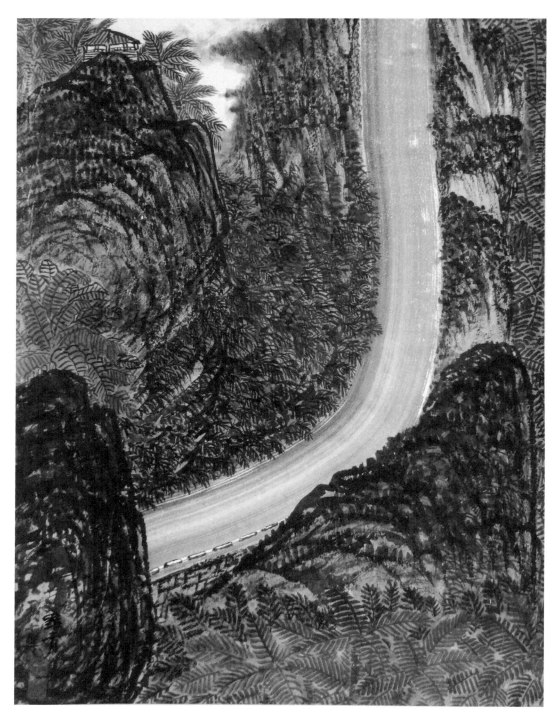

Figure 120. 上坡路 / Uphill road,
69 × 69 cm (1984)

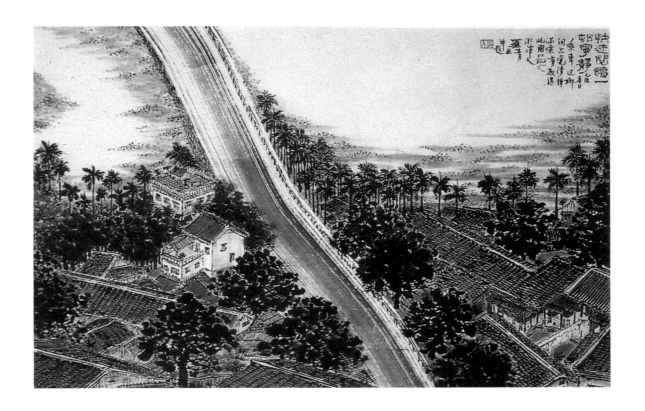

Figure 121. 快速閱讀一村寧靜 / Browsing a piece of village tranquility,
69 × 103 cm (1985)

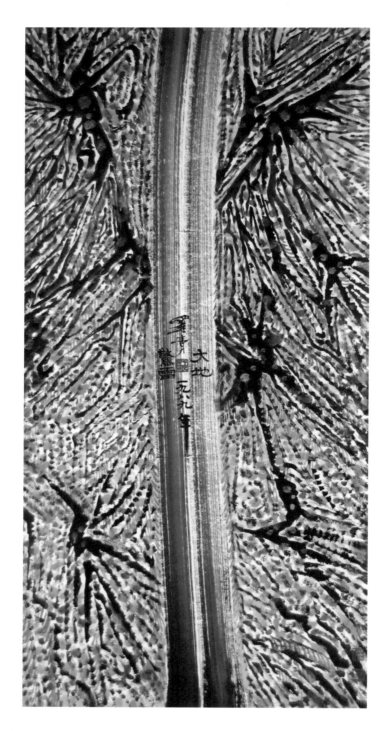

Figure 122. 大地驚雷 / A crash of thunder, 1989,
137 × 69 cm (1989)

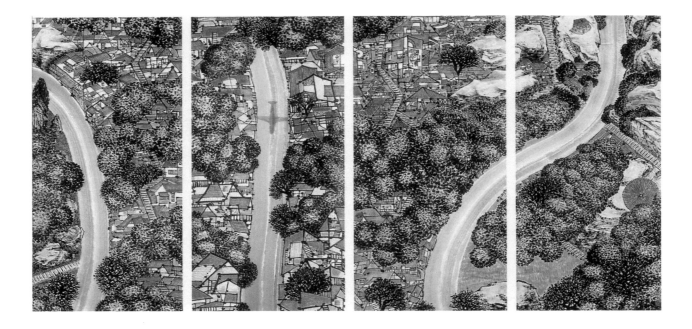

Figure 123. 感覺飛行 / Flying with intuition,
137 × 69 cm × 4 (1992)

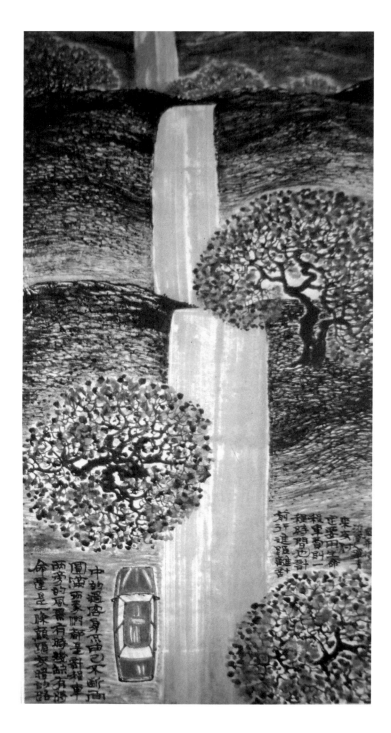

Figure 124. 計程人生 / Life, a taxi ride,
137 × 69 cm (1992)

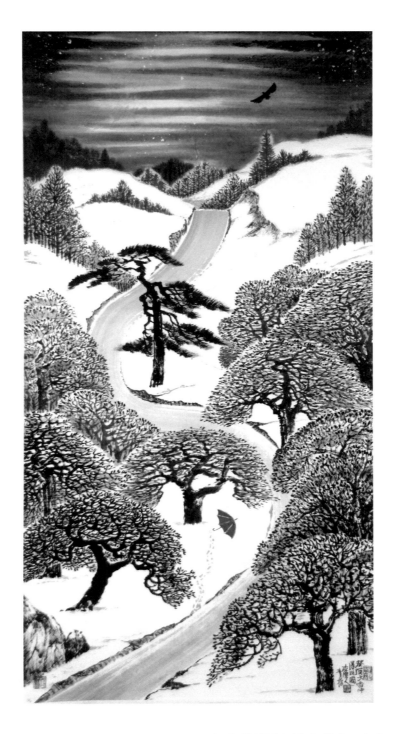

Figure 125. 紅傘飛鷹（女性主義之一）/ A red umbrella and
a flying eagle—a feminist view, 137 × 69 cm (1993)

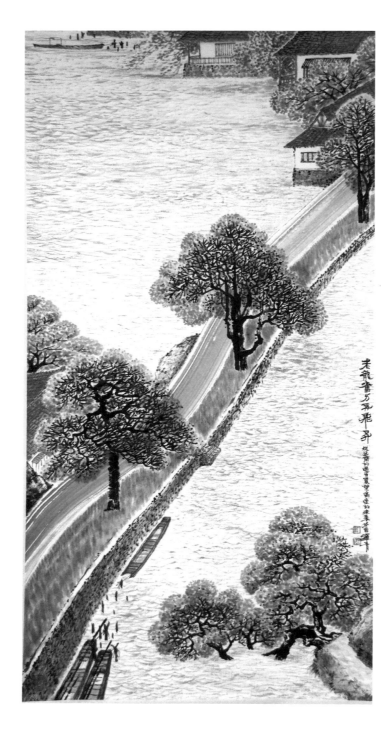

Figure 126. 老龍落水思奮飛 / An old tree trying to reestablish himself
from the muddy path, 137 × 69 cm (1993)

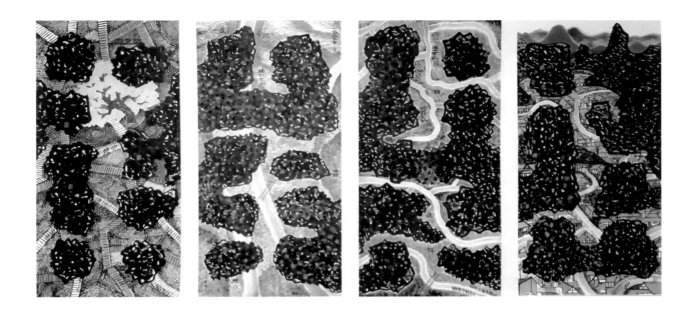

Figure 127. 中國現代化的道路（四聯屏）/ Road to modernization
(quadriptych), 138 × 69 cm × 4 (1993)

184

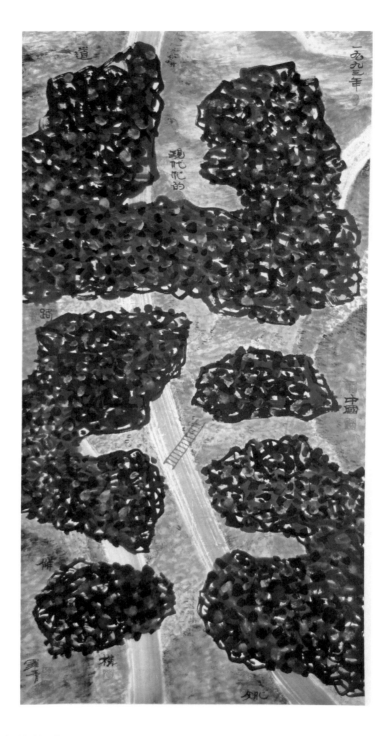

Figure 128. 中國現代化的道路（四屏之一）/ Road to modernization
(panel 1), 138 × 69 cm (1993)

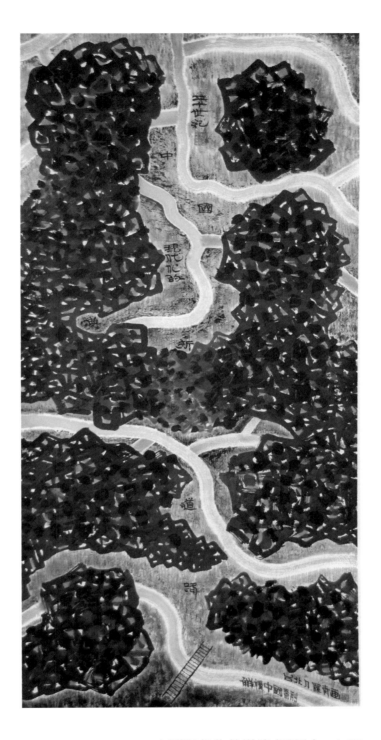

Figure 129. 中國現代化的道路（四屏之二）/ Road to modernization
(panel 2), 138 × 69 cm (1993)

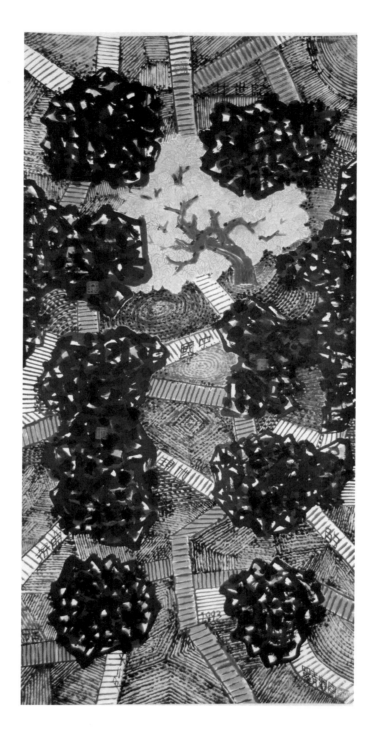

Figure 130. 中國現代化的道路（四屏之三）/ Road to modernization
(panel 3), 138 × 69 cm (1993)

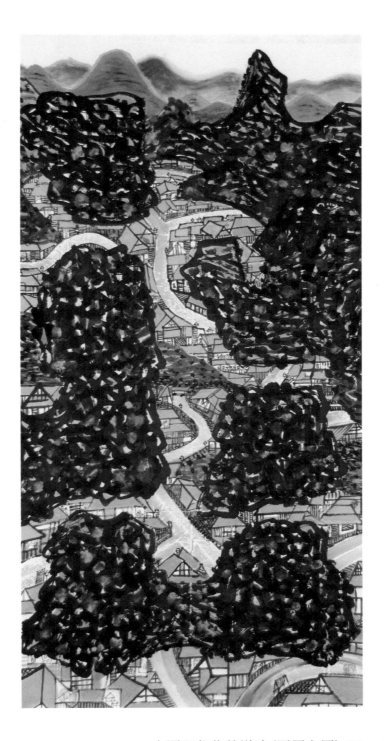

Figure 131. 中國現代化的道路（四屏之四）/ Road to modernization
(panel 4), 138 × 69 cm (1993)

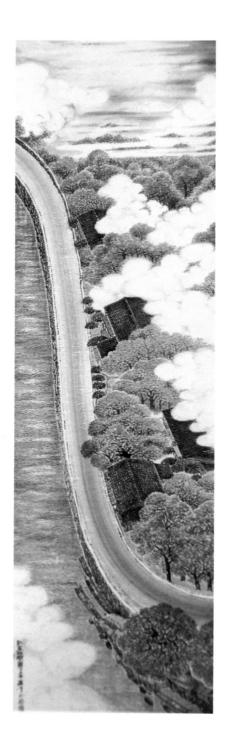

Figure 132. 紅屋白雲 / Red roofs and white clouds,
213 × 62.5 cm (1997)

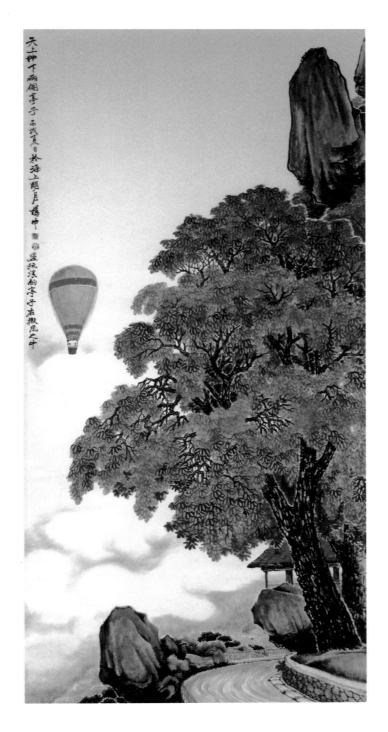

Figure 133. 兩個亭子 / Two pavilions,
137 × 69 cm (2006)

Modernism Revised:
Flying Series

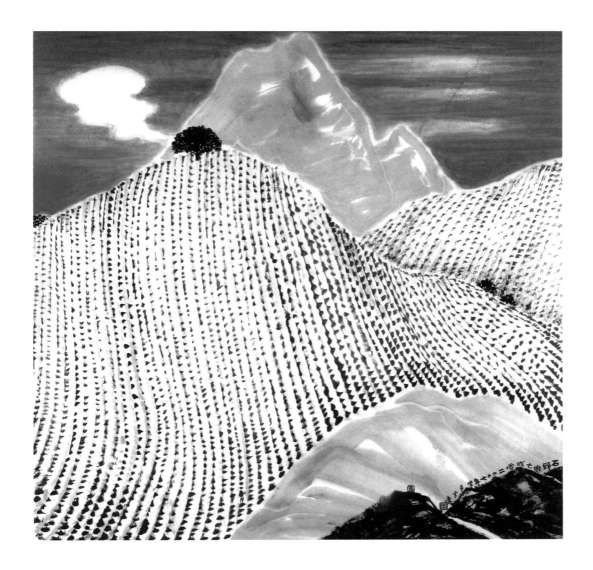

Figure 134. 石頭逃亡成雲 / Stone escapes into cloud,
69 × 69 cm (2007)

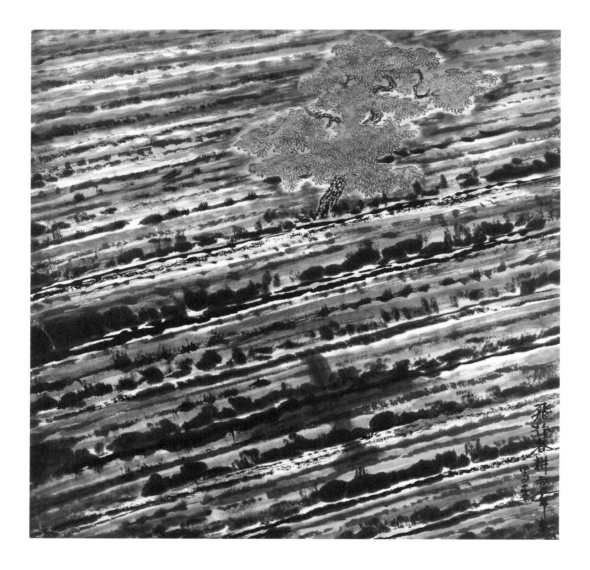

Figure 135. 飛行者春耕 / Flying spring plowing,
69 × 69 cm (2007)

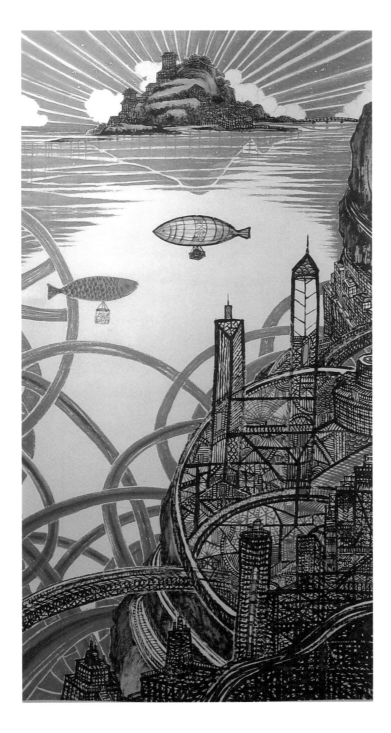

Figure 136. 萬丈金光 / Ten thousand rays of light,
137 × 69 cm (2007)

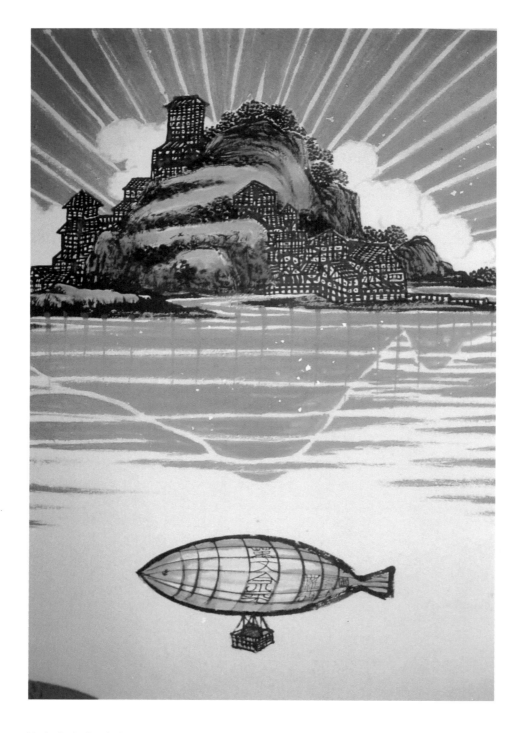

Figure 137. 萬丈金光（局部）/ Ten thousand rays of light (detail),
137 × 69 cm (2007)

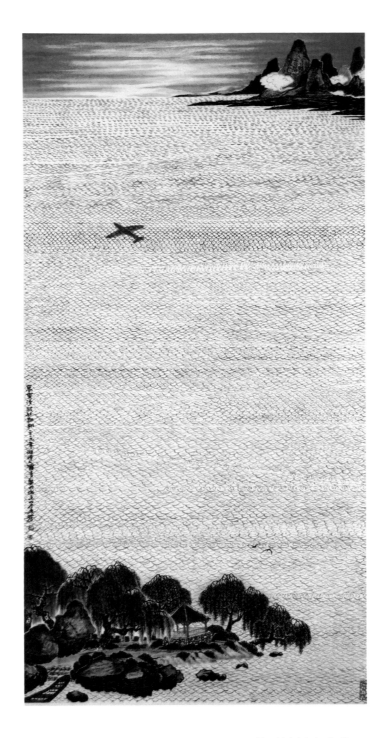

Figure 138. 萬重清波任翱翔 / Ten thousand ripples,
137 × 69 cm (2009)

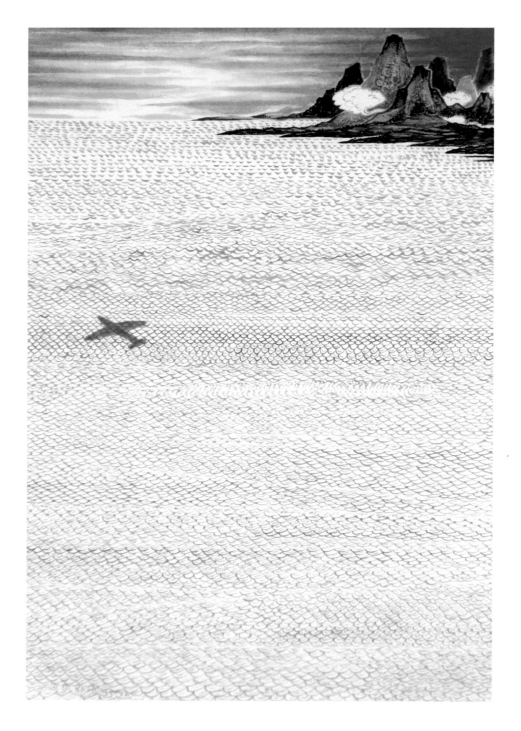

Figure 139. 萬重清波任翶翔（局部）/ Ten thousand ripples
(detail), 137 × 69 cm (2009)

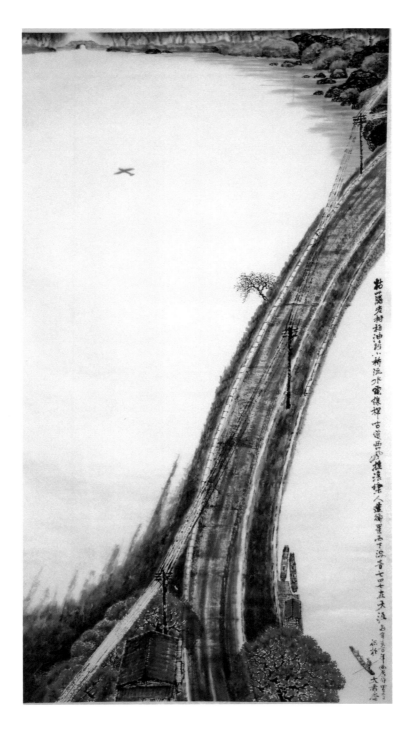

Figure 140. 枯藤老樹柏油路 / Dry vines, old trees and asphalt road, 179 × 96 cm (2011)

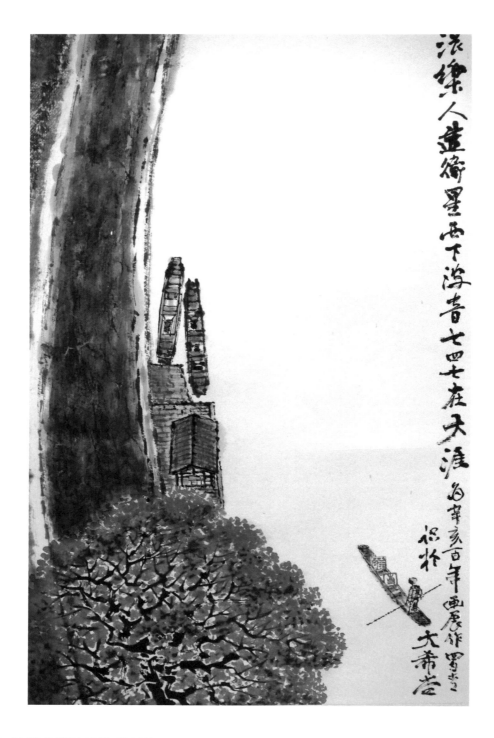

Figure 141. 枯藤老樹柏油路（局部）/ Dry vines, old trees and asphalt road
 (detail), 179 × 96 cm (2011)

Modernism Revised: Nocturnal Scene Series

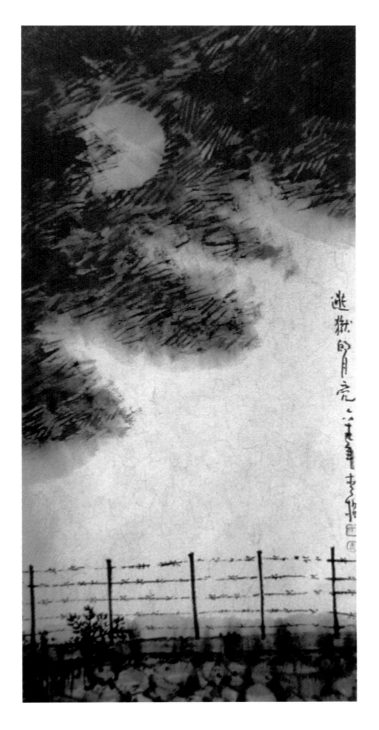

Figure 142. 逃獄的月亮 / The escaping moon,
69 × 30.5 cm (1980)

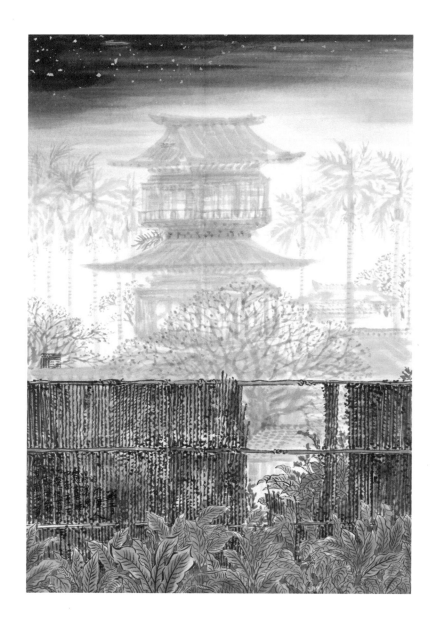

Figure 143. 曉星晨霧 / Morning stars,
69 × 45.5 cm (1986)

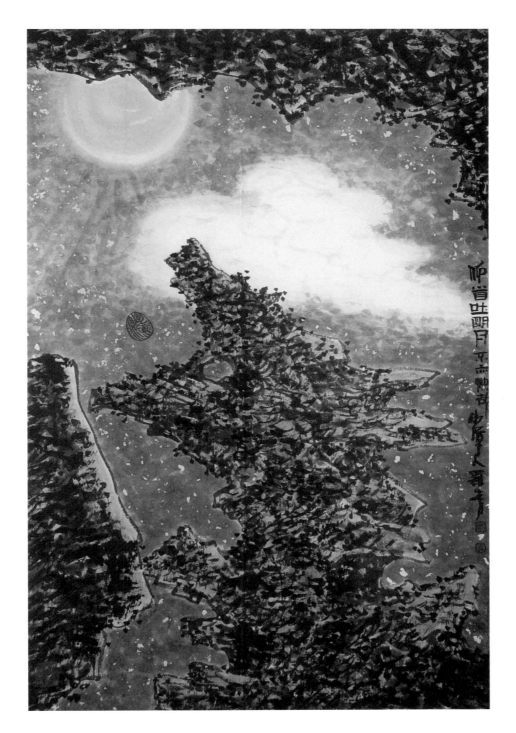

Figure 144. 蒼龍吐月 / The dragon that breathes out the moon,
69 × 45 cm (1986)

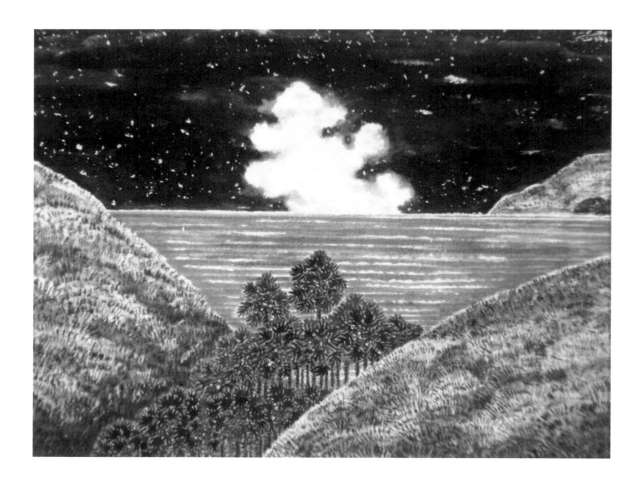

Figure 145. 加州卡通雲 / Cartoonic cloud in California,
69 × 103 cm (1987)

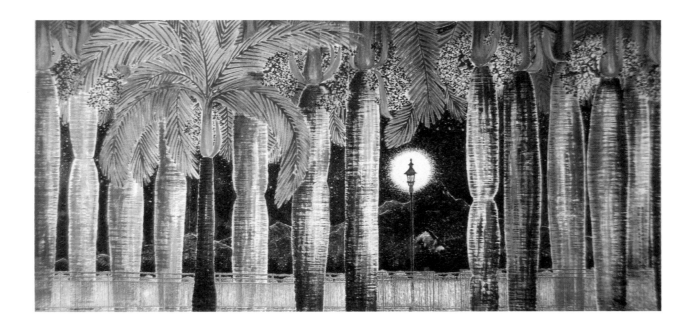

Figure 146. 對黑暗講解光明 / Explaining brightness to the darkness,
137 × 280 cm (1987)

208

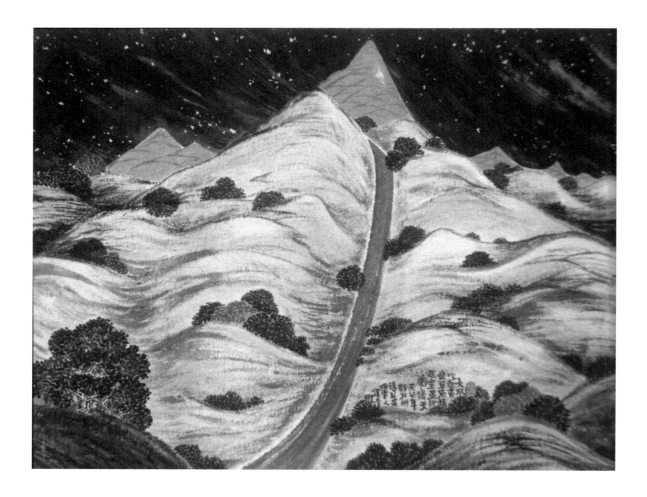

Figure 147. 行過加州 / Passing through California,
69 × 103 cm (1987)

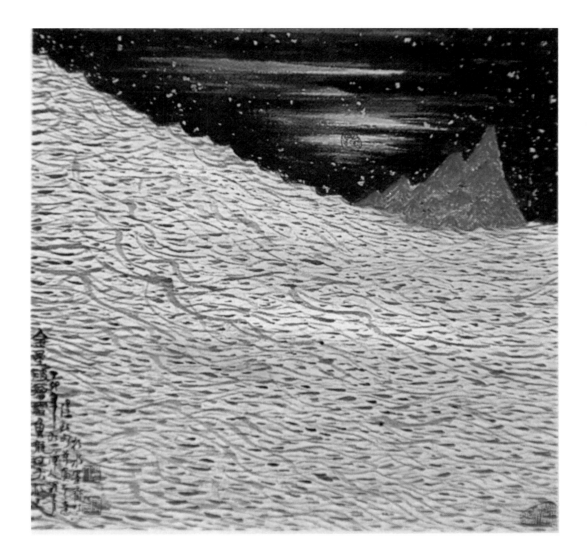

Figure 148. 百萬魚龍過大江 / Swarms of fishes crossing the giant river, 69 × 69 cm (1987)

Figure 149. 月出驚山鳥 / The rising moon startles a mountain bird,
69 × 69 cm (1987)

211

Figure 150. 松間紅樹舞秋風 / Red tree dancing with
the autumn wind, 69 × 69 cm (1988)

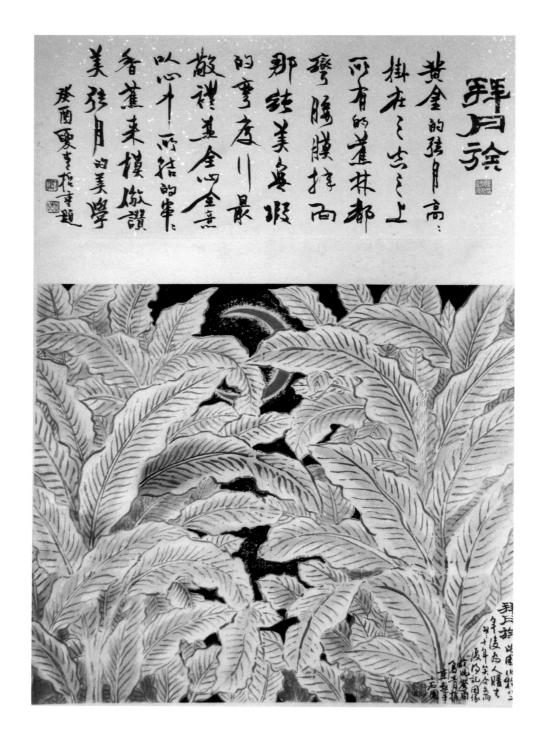

Figure 151. 拜月族 / Moon worshippers,
69 × 69 cm (1993)

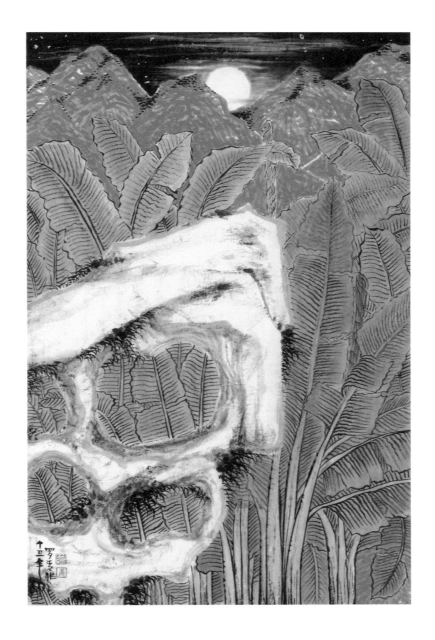

Figure 152. 蕉園月夜 / The moon shining snow on the bananas,
71 × 44 cm (1997)

214

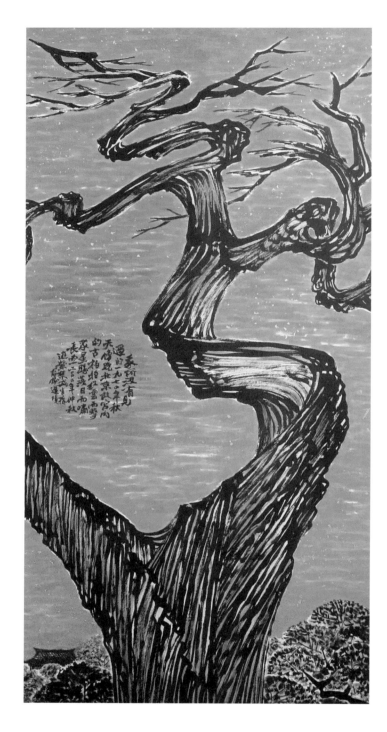

Figure 153. 我所沒有見過的1970年代故宮古柏 / Palace cypress in the 1970s that I've never seen, 137 × 69 cm (2000)

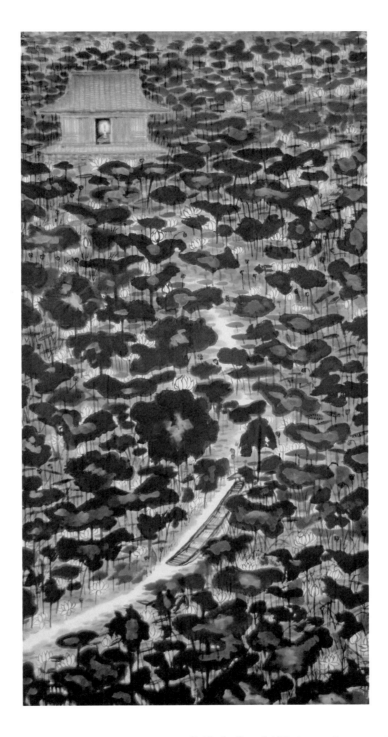

Figure 154. 萬點白荷一紅燭 / Ten thousand white lotuses and one red candle, 137 × 69 cm (2002)

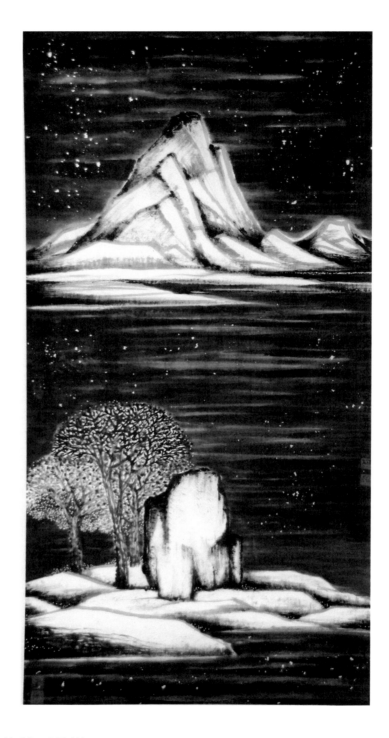

Figure 155. 江渚楓林（高呼雲林） / Sand bars with maple trees
(Calling for Yun-lin [Ni Tsan]), 137 × 69 cm (2002)

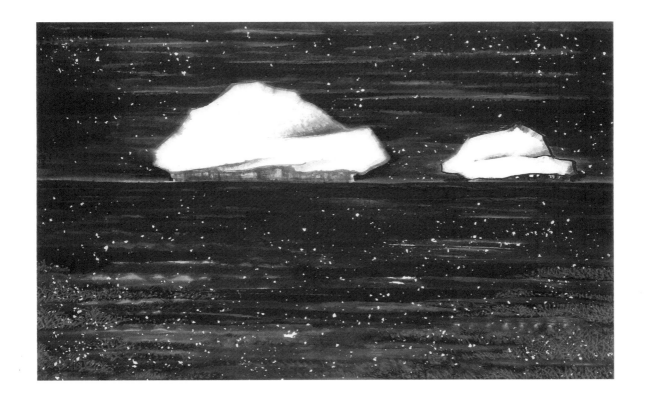

Figure 156. 冰山來了I / Here comes the iceberg, I,
67 × 130 cm (2006)

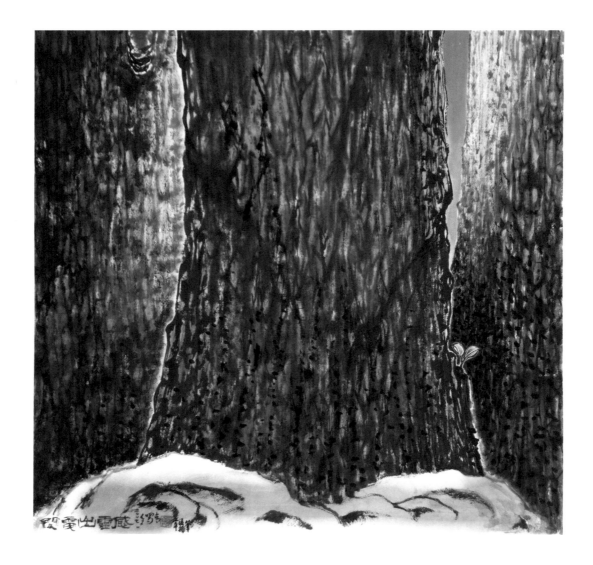

Figure 157. 閃電出靈感 / A stroke of lightning: green inspiration,
69 × 69 cm (2007)

Modernism Revised:
Iron-and-Steel Landscape Series

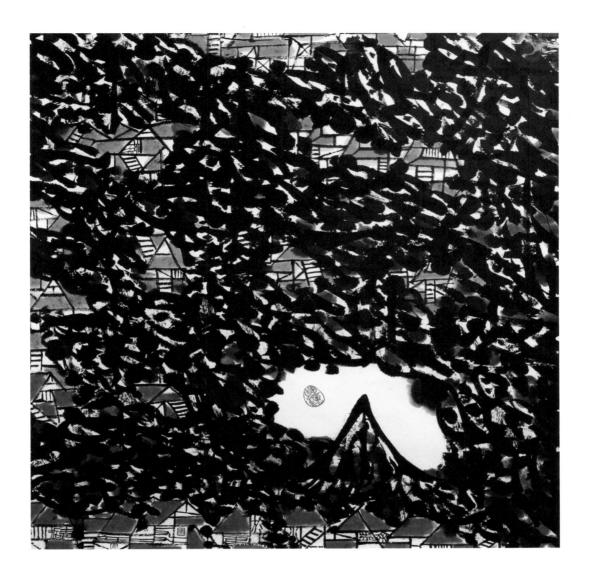

Figure 158. 別有洞天 / A different world out of the cave,
69 × 69 cm (1992)

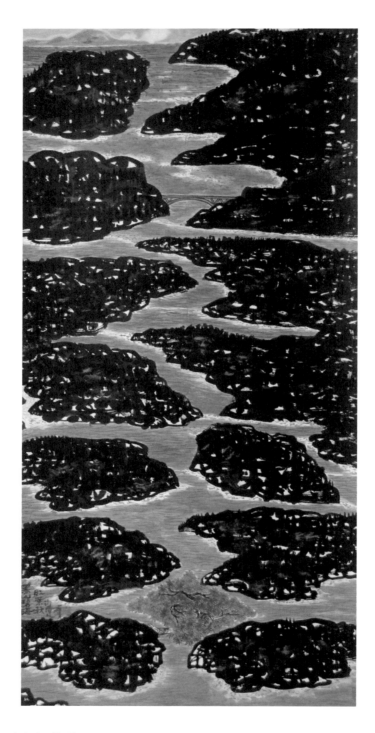

Figure 159. 黑山碧海紅葉秋 / Dark mountain, blue sea
and red leaf autumn, 137 × 69 cm (1993)

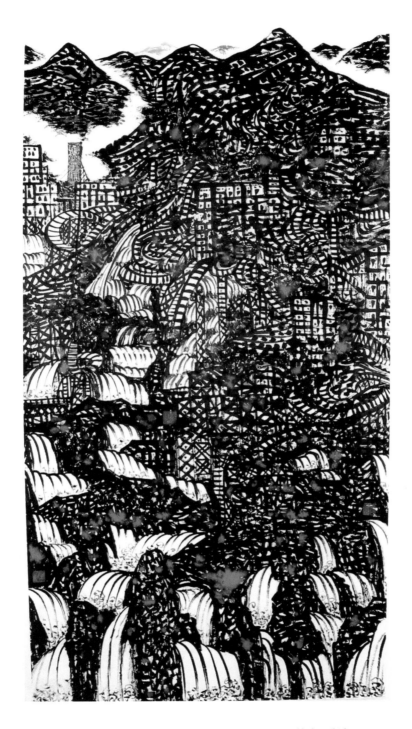

Figure 160. 萬壑爭流 / Ten thousand cataracts,
137 × 69 cm (1994)

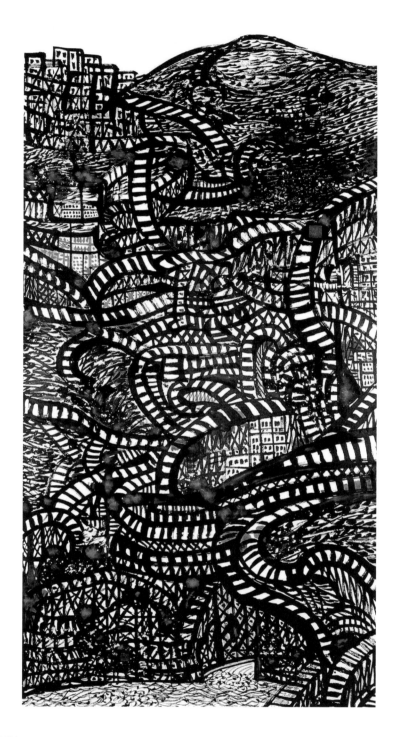

Figure 161. 萬條軌道 / Ten thousand railways,
137 × 69 cm (1994)

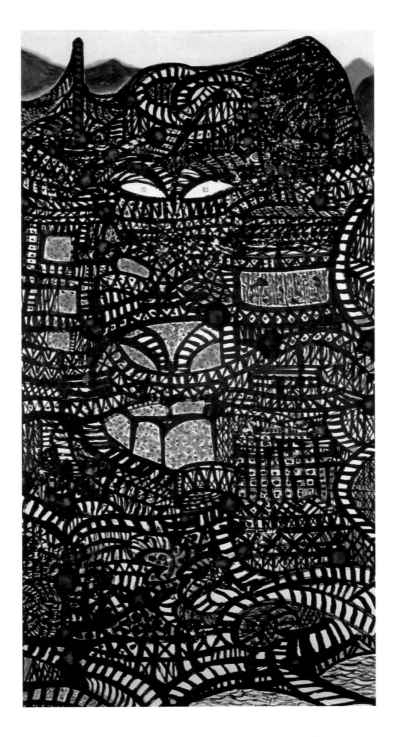

Figure 162. 萬重鋼架 / Ten thousand steel frames,
136 × 70 cm (1994)

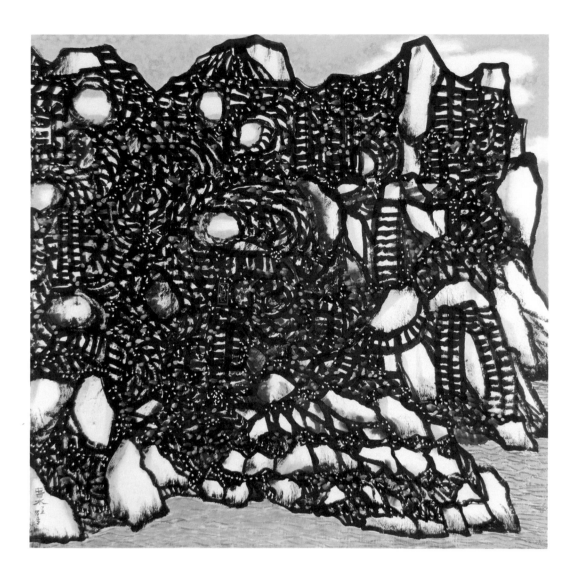

Figure 163. 春水幾多深 / How deep is the spring water?,
69 × 69 cm (1997)

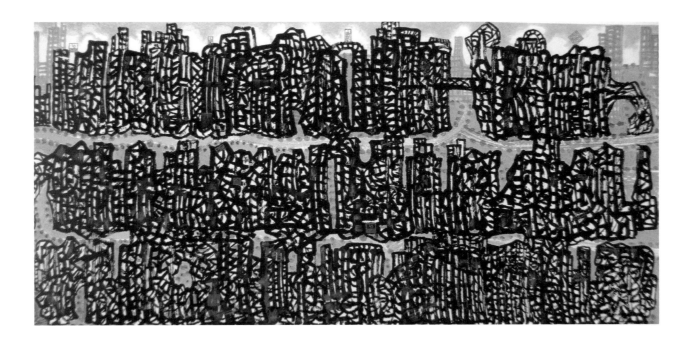

Figure 164. 石壁城 / Rock wall city,
69 × 137 cm (1998)

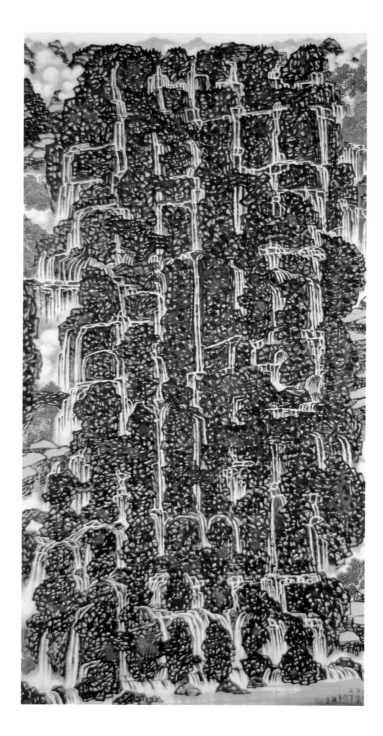

Figure 165. 萬脈爭流 / Ten thousand waterfalls, 137 × 69 cm (1998)

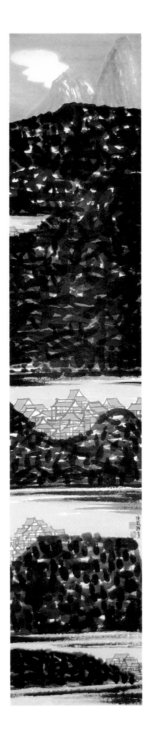

Figure 166. 青山碧海紅房子 / The red houses against the blue sea,
137 × 34 cm (2000)

Classical Renovation:
Birds and Flowers

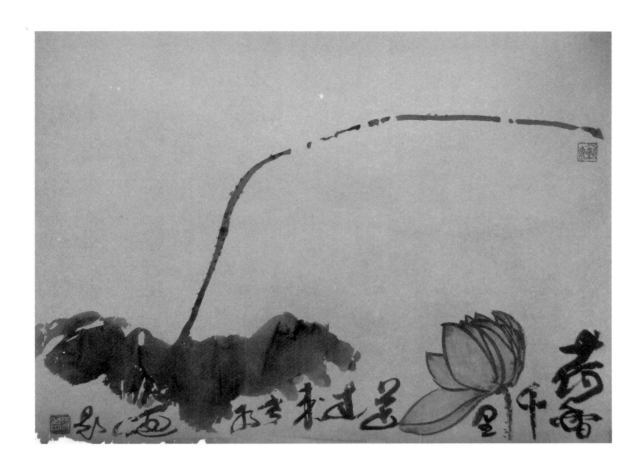

Figure 167. 千里送荷香 / Lotus fragrance travels thousands of miles,
53 × 71 cm (1976)

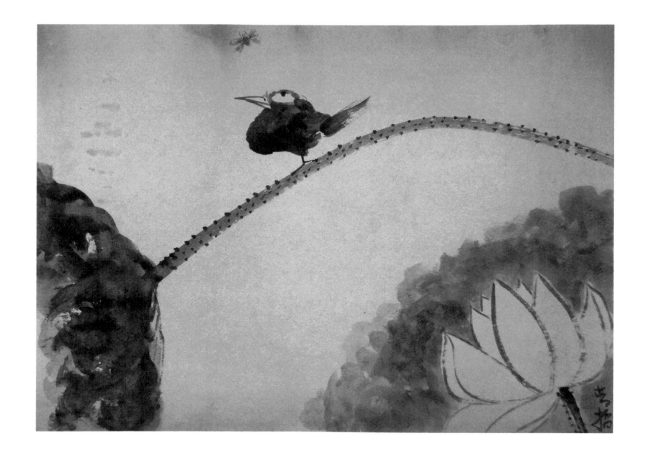

Figure 168. 誘惑 / Temptation, 45 × 62 cm (1976)

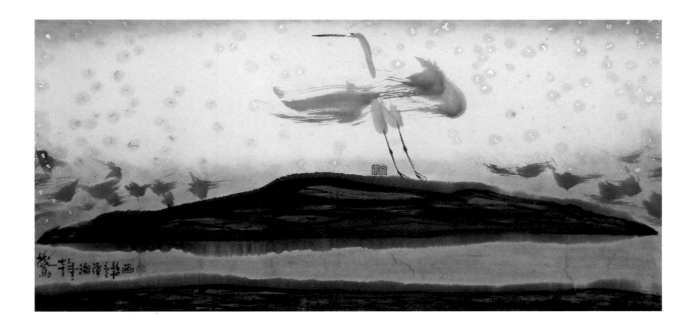

Figure 169. 驚 / Startled, 34 × 69 cm (1981)

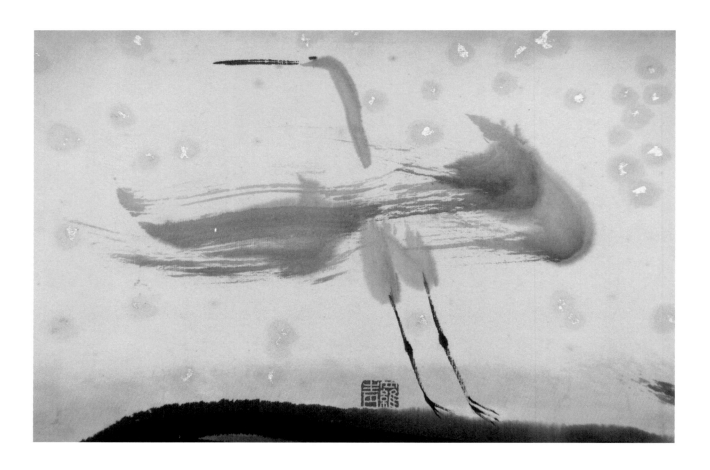

Figure 170. 驚（局部）/ Startled (detail),
34 × 69 cm (1981)

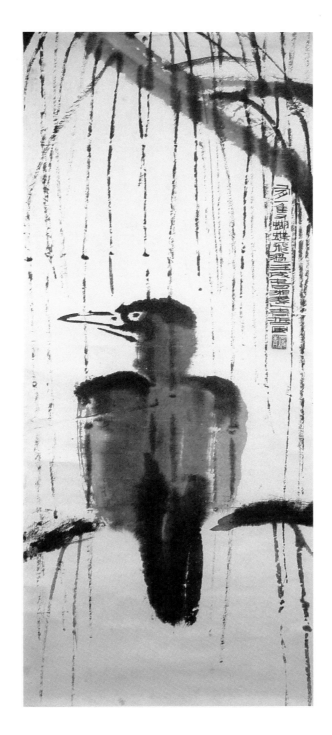

Figure 171. 一隻蝴蝶飛過 / Passing by a butterfly,
137 × 69 cm (1982)

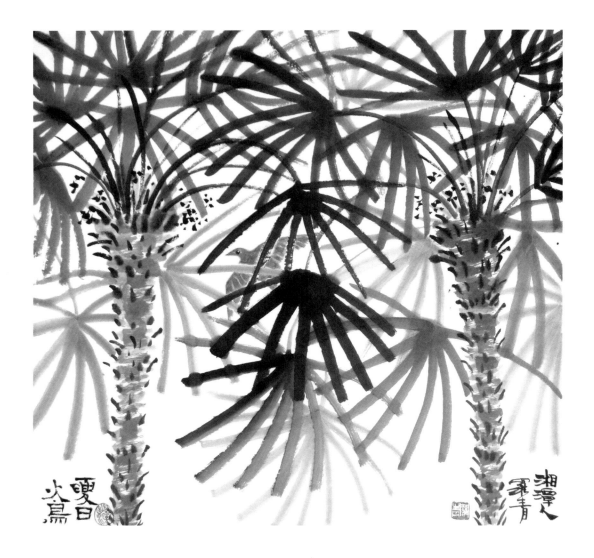

Figure 172. 高呼齊白石—夏日火鳥 / Fire bird of summer
(Calling for Ch'i Pai-shih), 69 × 69 cm (1985)

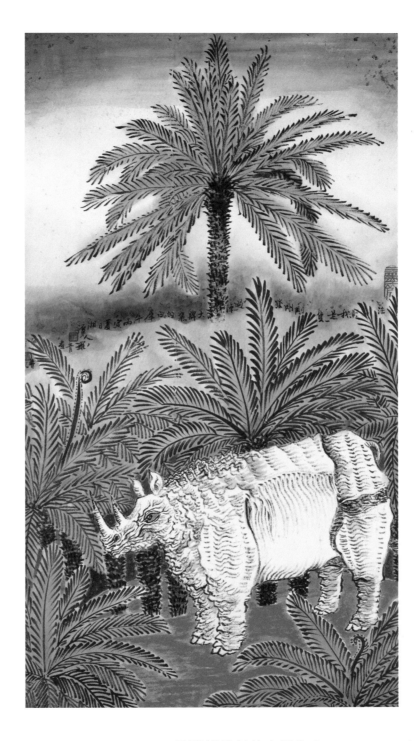

Figure 173. 剛發過脾氣的白犀牛 / A jumpy grudging white rhino,
79 × 44 cm (1986)

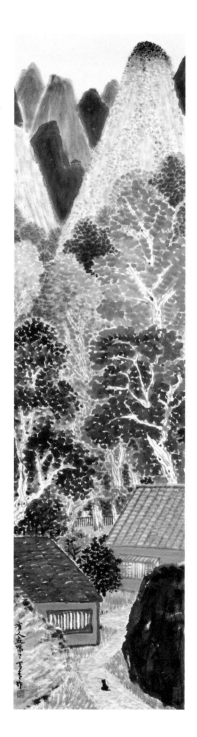

Figure 174. 有人在家嗎 / Anybody home?,
140 × 35 cm (1997)

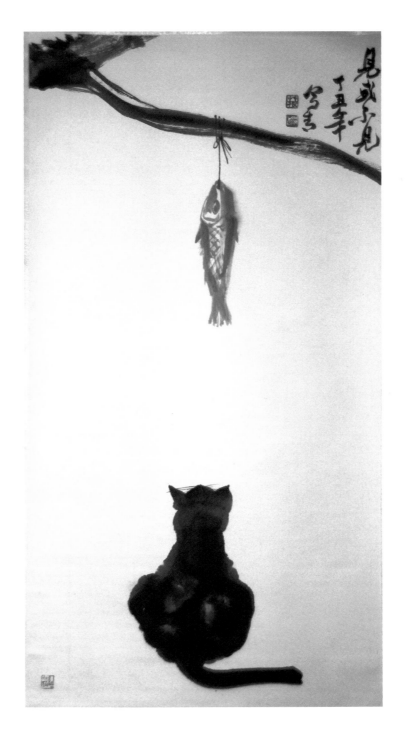

Figure 175. 見或不見 / Now you see it, now you don't,
137 × 69 cm (1997)

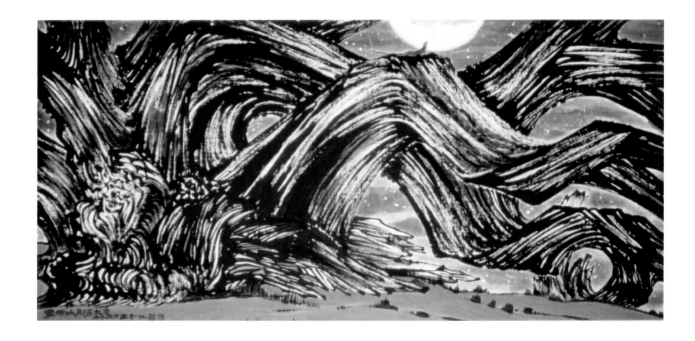

Figure 176. 攀蜥吐月圖 / The lizard breathing a new born moon,
69 × 137 cm (1997)

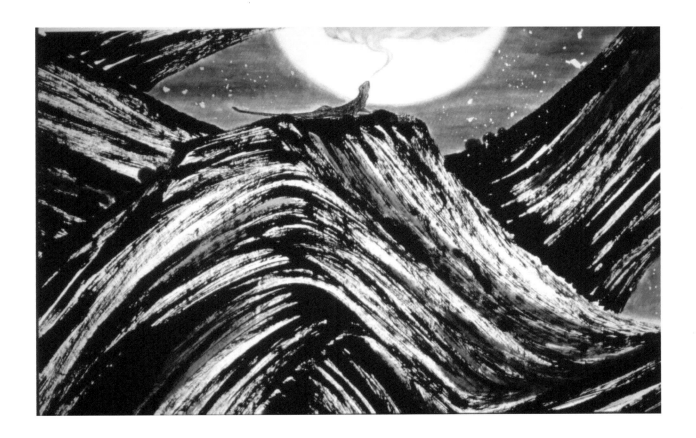

Figure 177. 攀蜥吐月圖（局部）/ The lizard breathing a new born moon
(detail), 69 × 137 cm (1997)

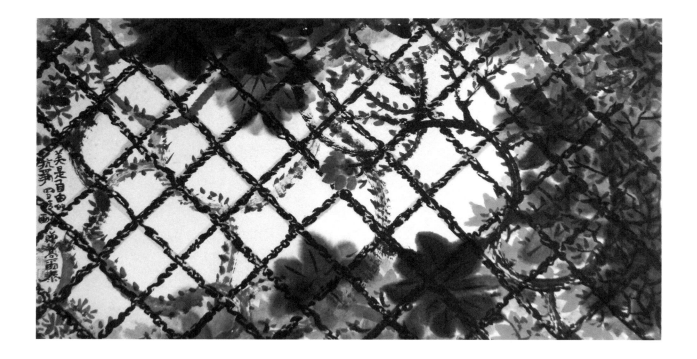

Figure 178. 美是自由的抗爭 / Beauty, the struggle of freedom,
69 × 137 cm (1999)

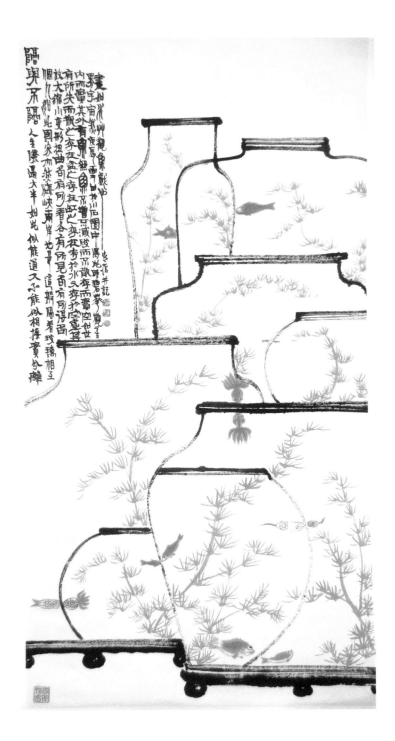

Figure 179. 隔與不隔 / Separated yet not separated,
137 × 69 cm (2000)

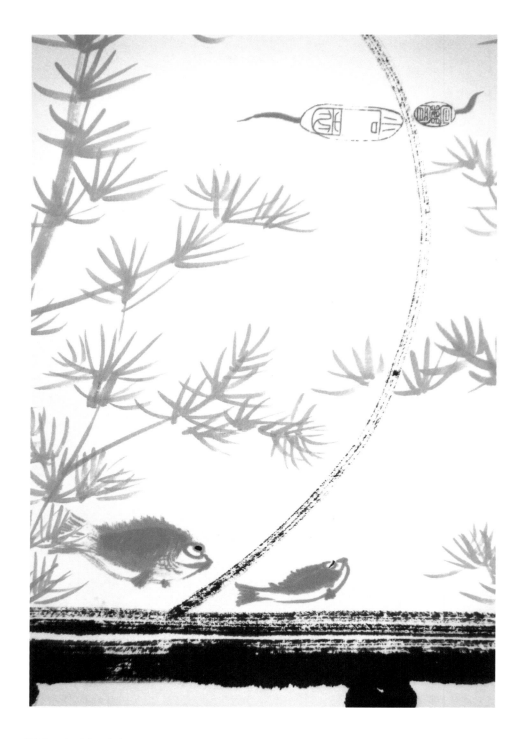

Figure 180. 隔與不隔（局部）/ Separated yet not separated
(detail), 137 × 69 cm (2000)

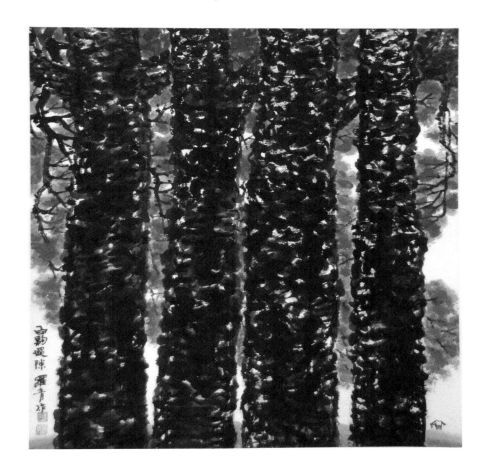

Figure 181. 白馬紅樹碧草肥 / White horse, red trees and green grass, 69 × 69 cm (2000)

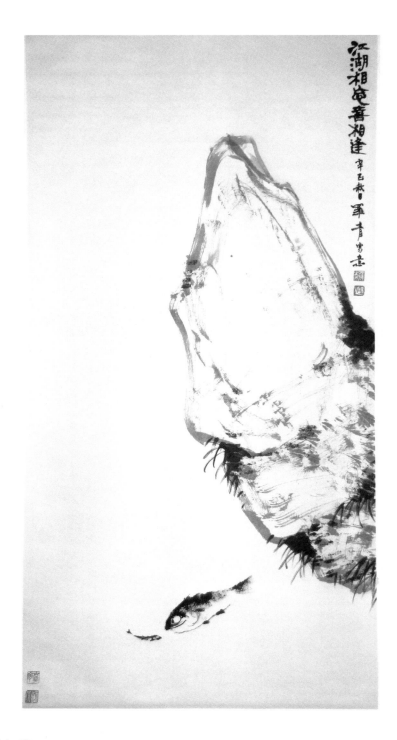

Figure 182. 相忘於江湖 / Forgetting each other in the waters,
137 × 69 cm (2001)

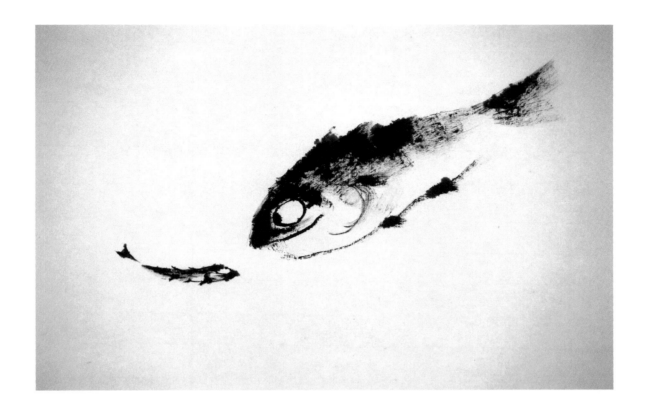

Figure 183. 相忘於江湖（局部）/ Forgetting each other in the waters (detail), 137 × 69 (2001)

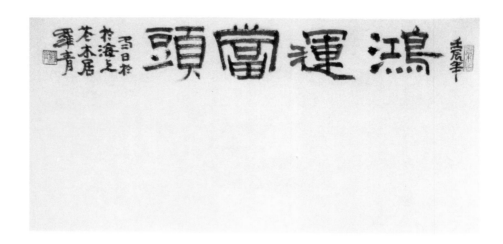

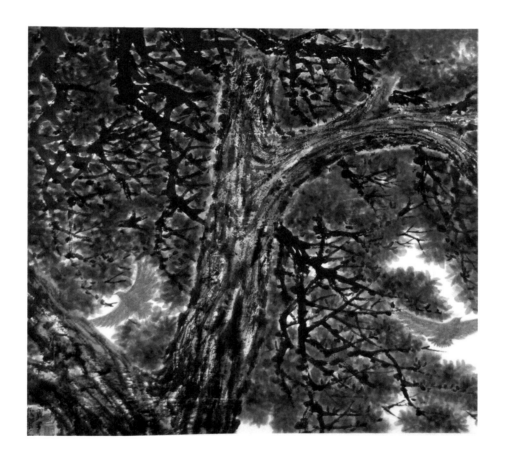

Figure 184. 鴻運當頭 / Good fortune shines above you,
69 × 69 cm (2002)

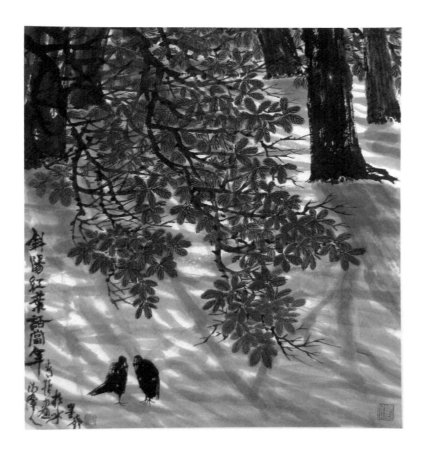

Figure 185. 起舞影凌亂 / Unkempt dancing shadows,
69 × 69 cm (2006)

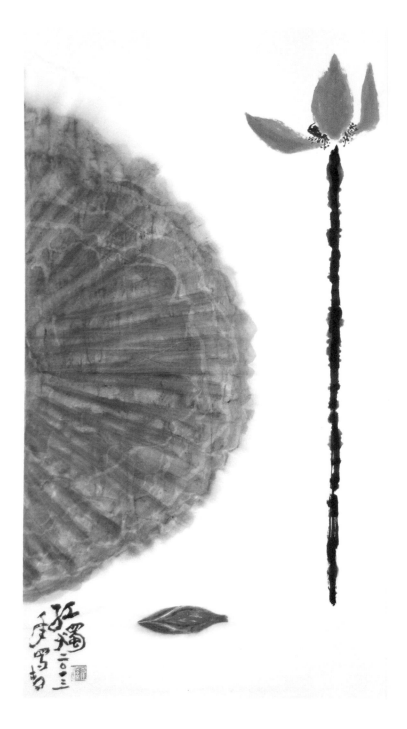

Figure 186. 紅燭 / The little red candle,
137 × 69 cm (2013)

Classical Renovation:
Extraordinary Arhats Series

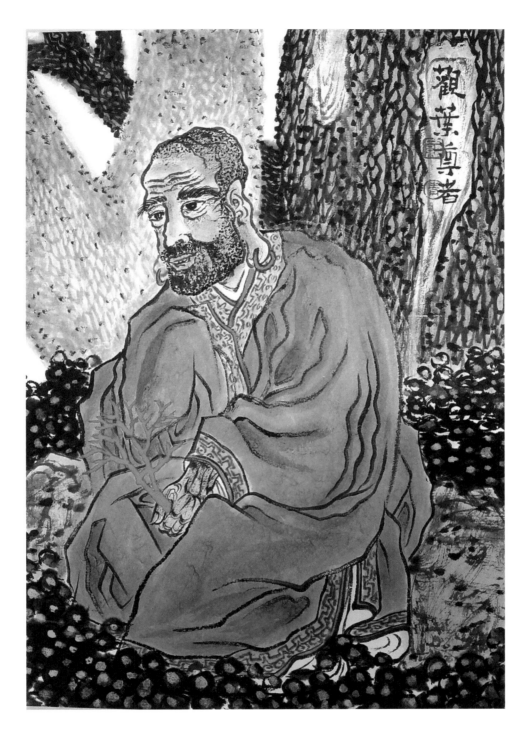

Figure 187. 觀葉尊者 / Leaf-reading arhat,
28 × 20 cm (1980)

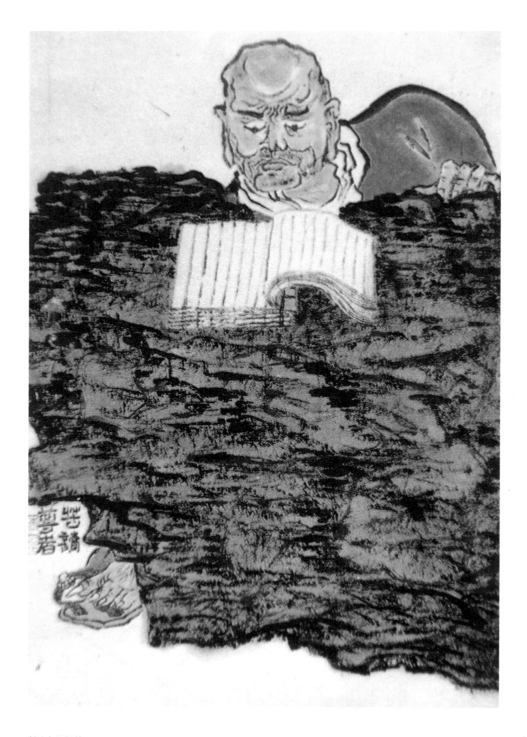

Figure 188. 苦讀羅漢 / Studious arhat,
28 × 20 cm (1985)

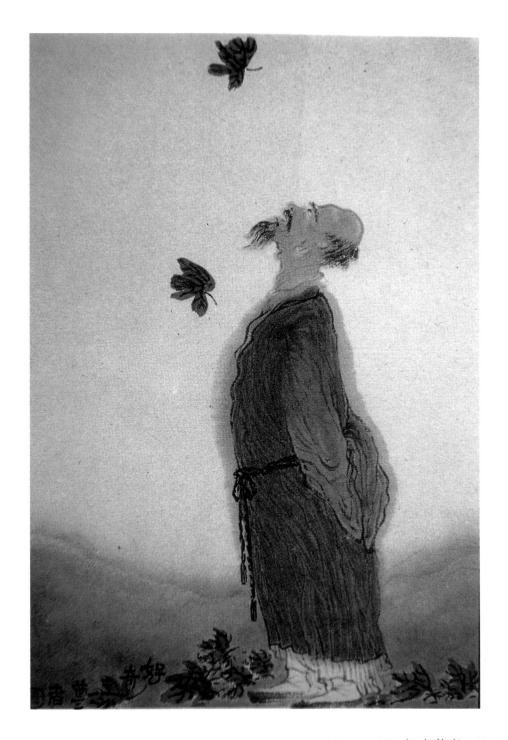

Figure 189. 好奇尊者 / Curious arhat,
28 × 20 cm (1985)

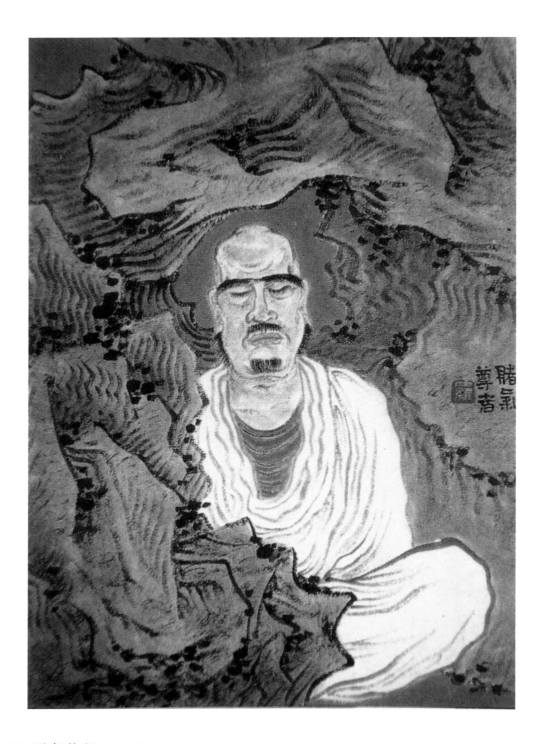

Figure 190. 賭氣尊者 / Grudging arhat,
28 × 20 cm (1985)

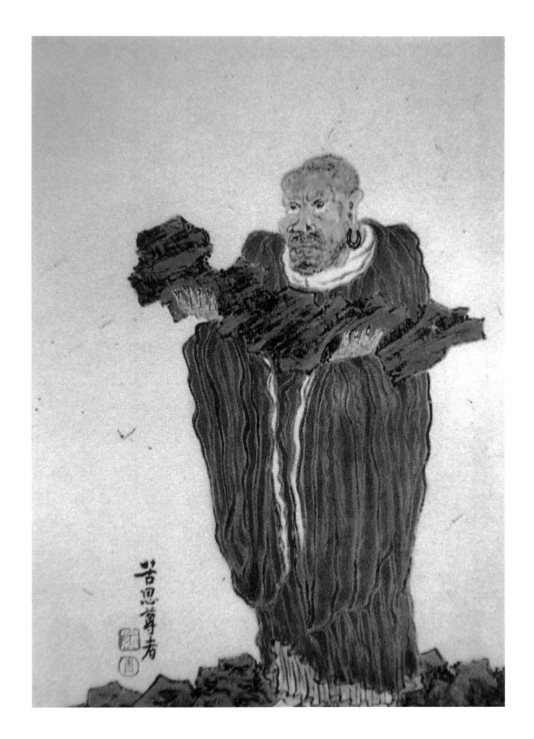

Figure 191. 苦思尊者 / Musing arhat,
28 × 20 cm (1985)

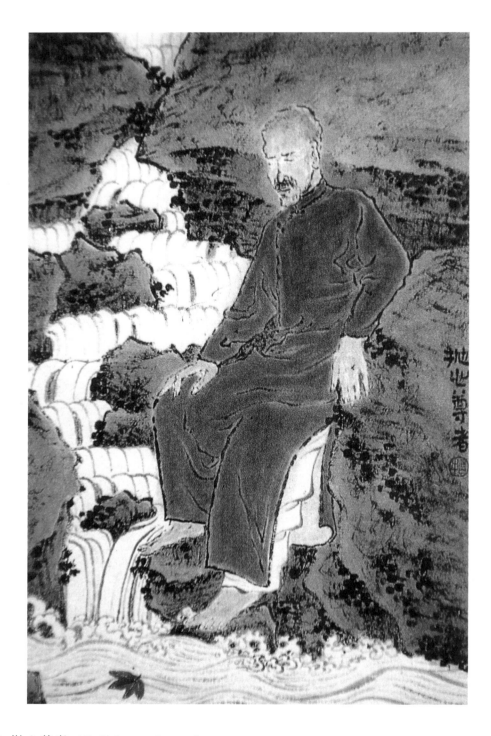

Figure 192. 抛心尊者 / Self-forgetting arhat,
28 × 20 cm (1985)

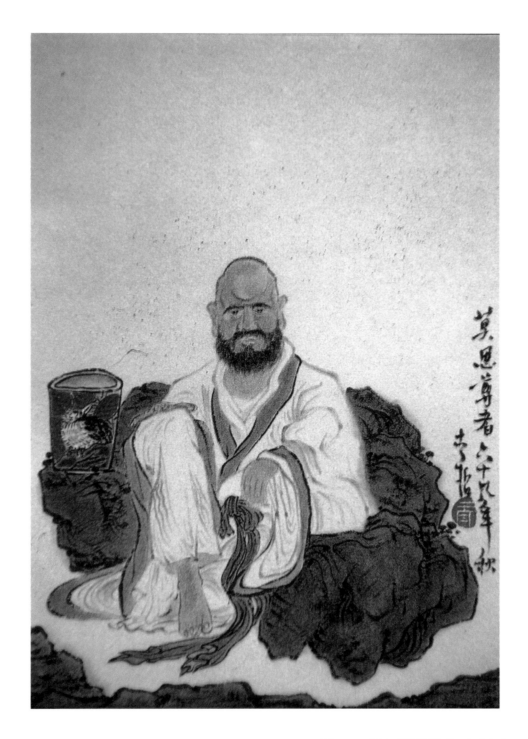

Figure 193. 莫思尊者 / Think-not arhat,
28 × 20 cm (1985)

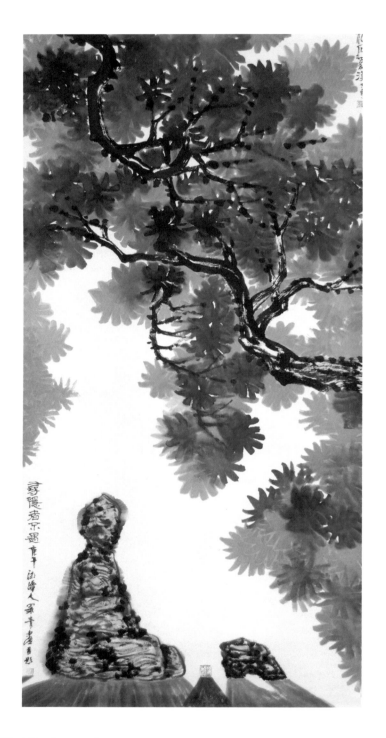

Figure 194. 化石羅漢 / Recluse arhat,
137 × 69 cm (1990)

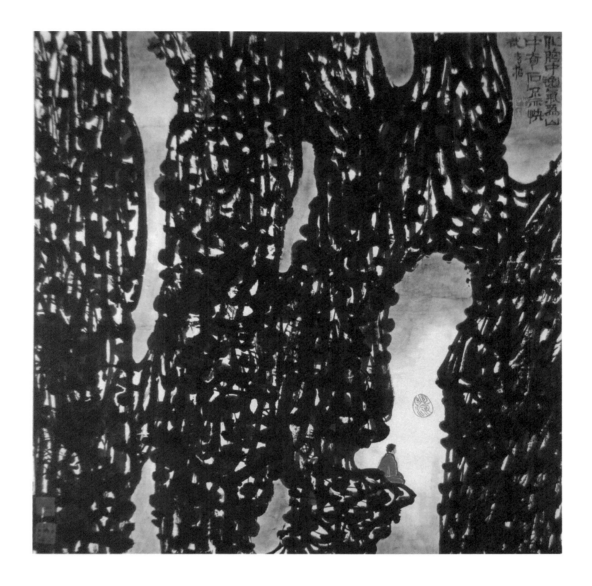

Figure 195. 胸中逸氣化山石 / Turning the grudges into rock formations,
69 × 69 cm (1992)

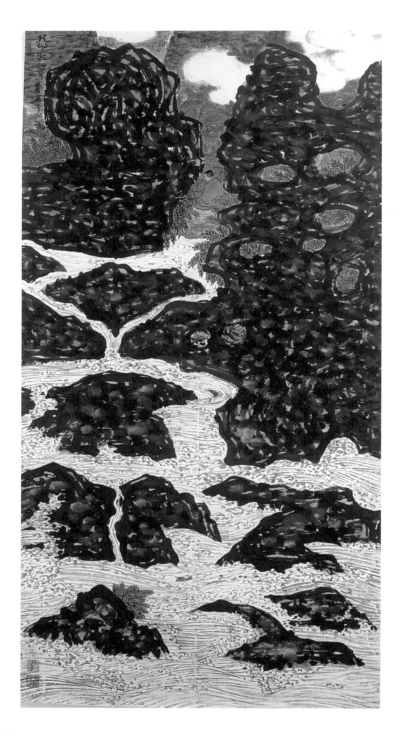

Figure 196. 紅葉羅漢 / Red leaf arhat,
137 × 69 cm (1994)

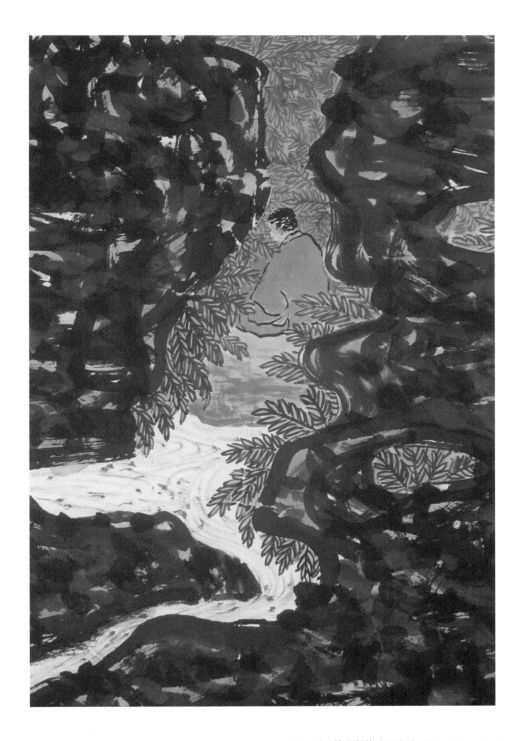

Figure 197. 紅葉羅漢（局部）/ Red leaf arhat (detail),
137 × 69 cm (1994)

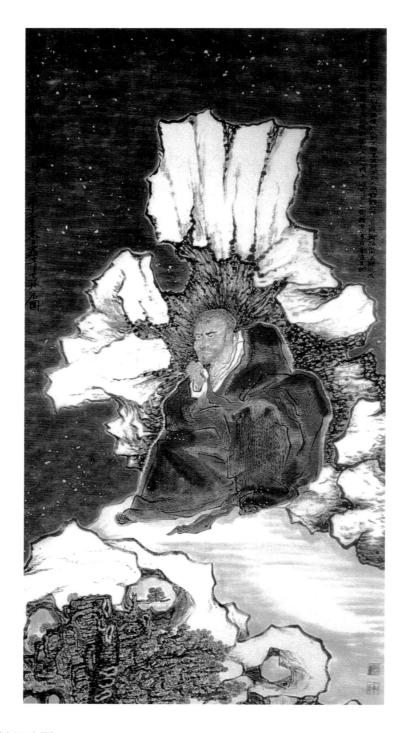

Figure 198. 如何刺殺時間 / How to assassinate time,
137 × 69 cm (1996)

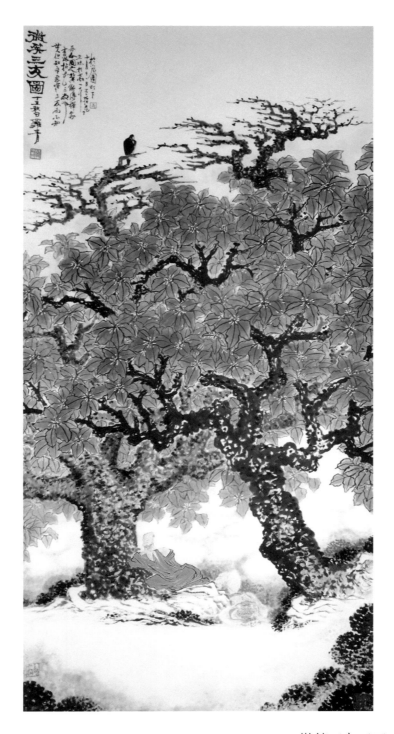

Figure 199. 微笑三友 / Three smiling arhats,
137 × 69 cm (1997)

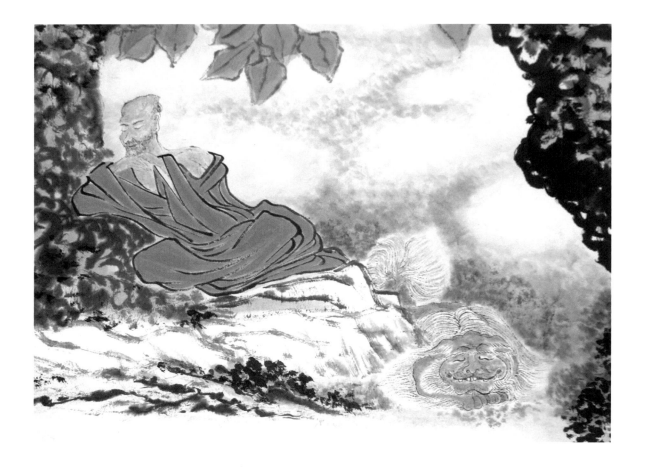

Figure 200. 微笑三友（局部）/ Three smiling arhats
(detail), 137 × 69 cm (1997)

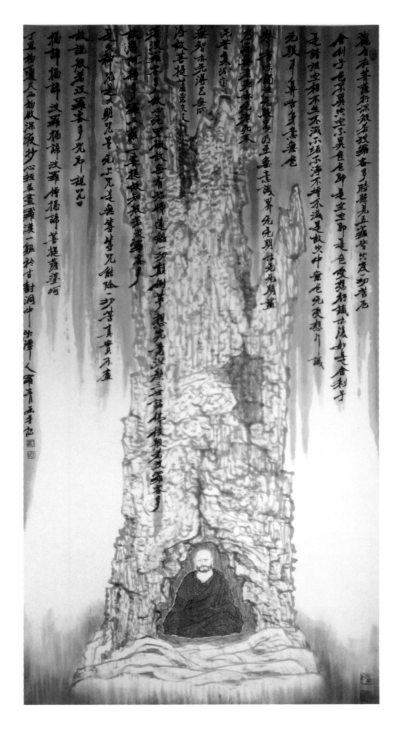

Figure 201. 柳蔭心經木羅漢 / Wood arhat among sutra willows,
137 × 70 cm (1997)

270

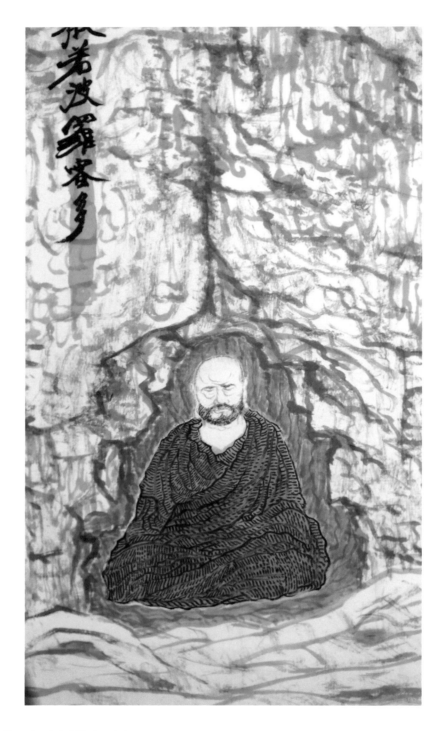

Figure 202. 柳蔭心經木羅漢（局部）/ Wood arhat among sutra willows (detail), 137 × 70 cm (1997)

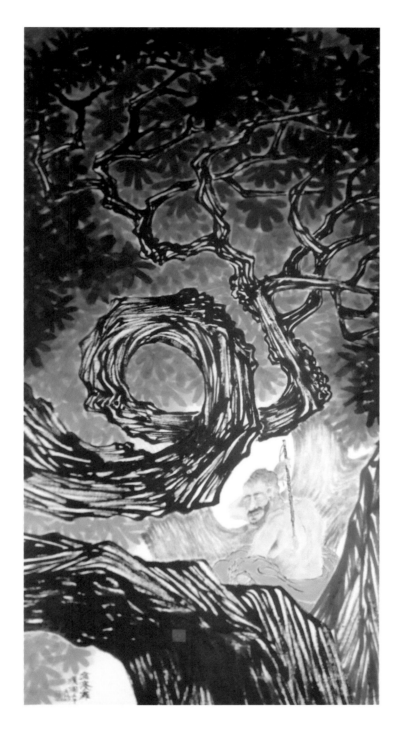

Figure 203. 痛癢羅漢 / Scratching arhat,
137 × 69 cm (2002)

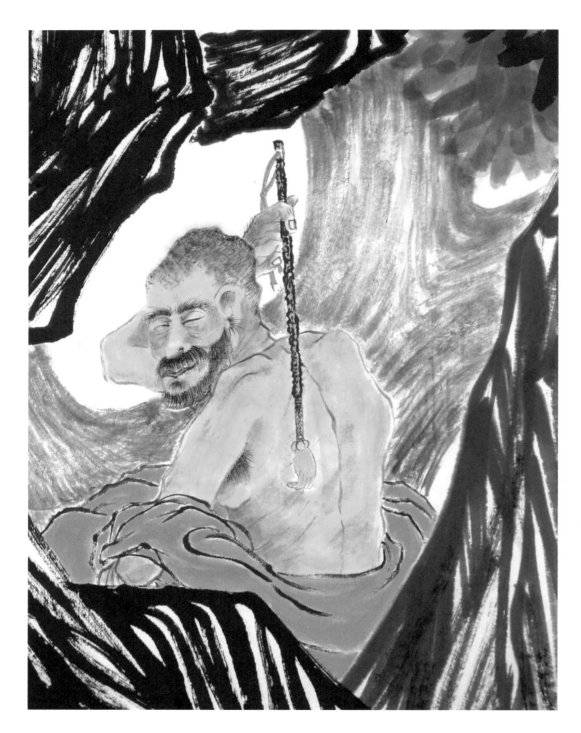

Figure 204. 痛癢羅漢（局部）/ Scratching arhat
(detail), 137 × 69 cm (2002)

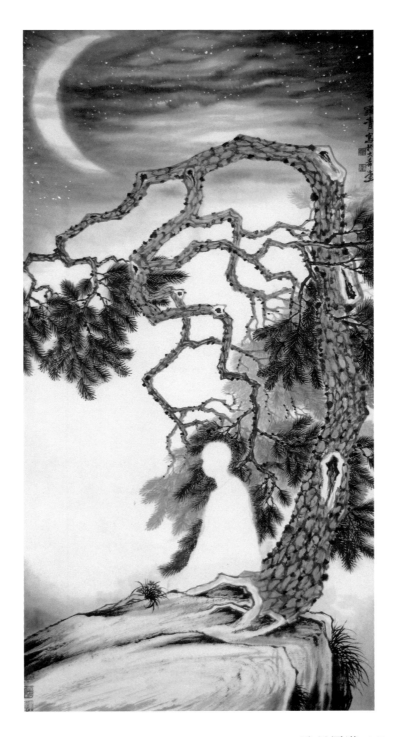

Figure 205. 弦月羅漢 / Crescent moon arhat,
137 × 69 cm (2008)

274

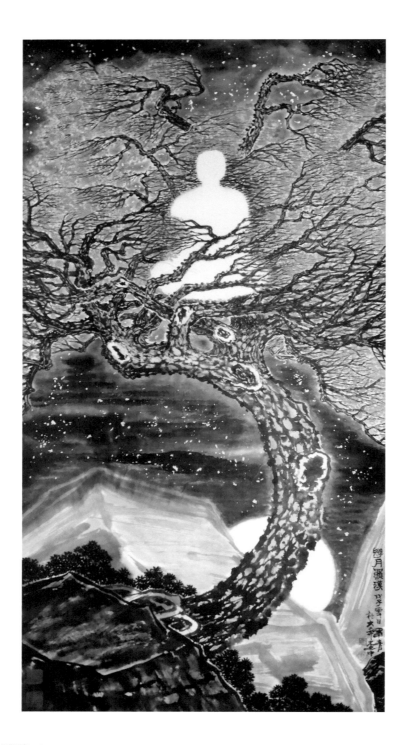

Figure 206. 孵月羅漢 / Moon-brooding arhat,
137 × 69 cm (2008)

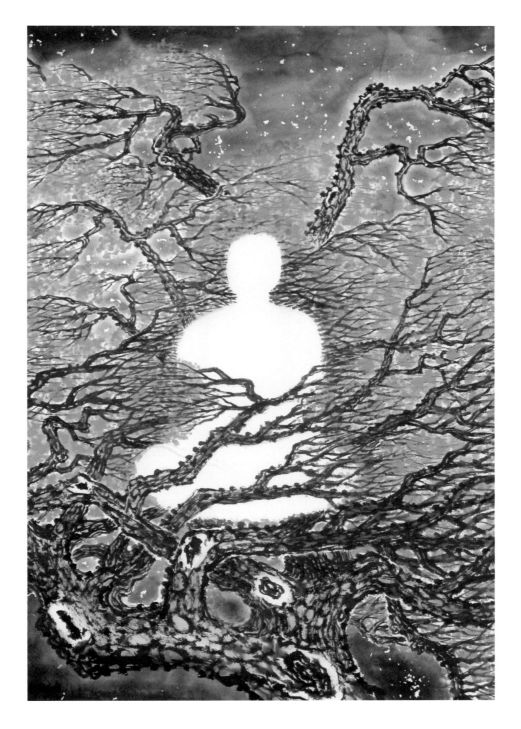

Figure 207. 孵月羅漢（局部）/ Moon-brooding arhat (detail),
137 × 69 cm (2008)

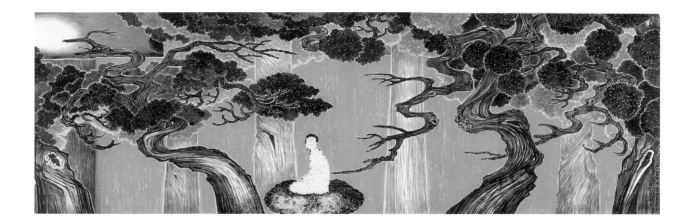

Figure 208. 空山龍虎鬥 / Struggle between dragons and tigers
(One Man's Cultural Revolution), 192 × 497 cm (2008)

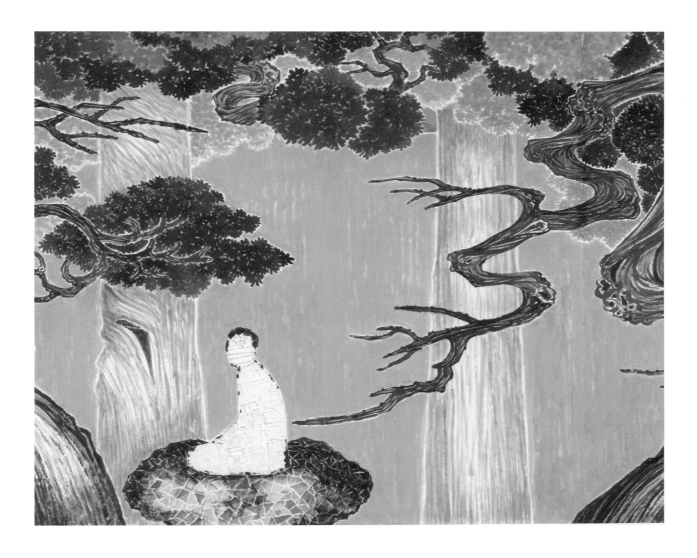

Figure 209. 空山龍虎鬥（局部）/ Struggle between dragons and tigers
(One Man's Cultural Revolution) (detail), 192 × 497 cm (2008)

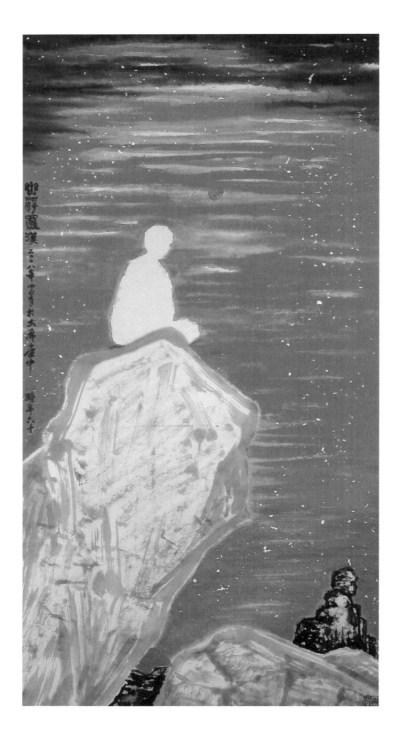

Figure 210. 幽浮羅漢 / UFO arhat,
137 × 69 cm (2008)

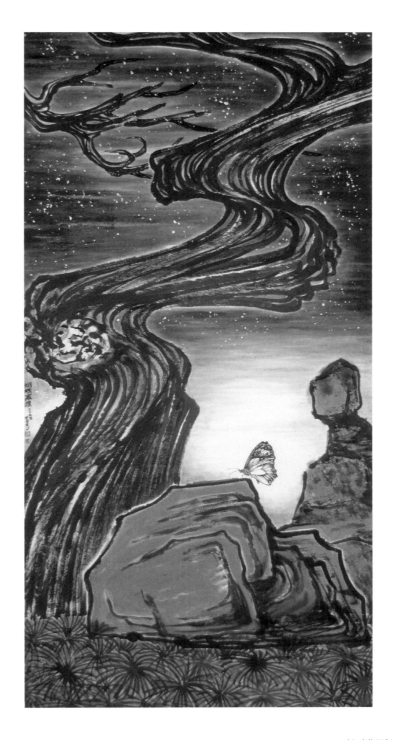

Figure 211. 蝴蝶羅漢 / Butterfly arhat,
137 × 69 cm (2009)

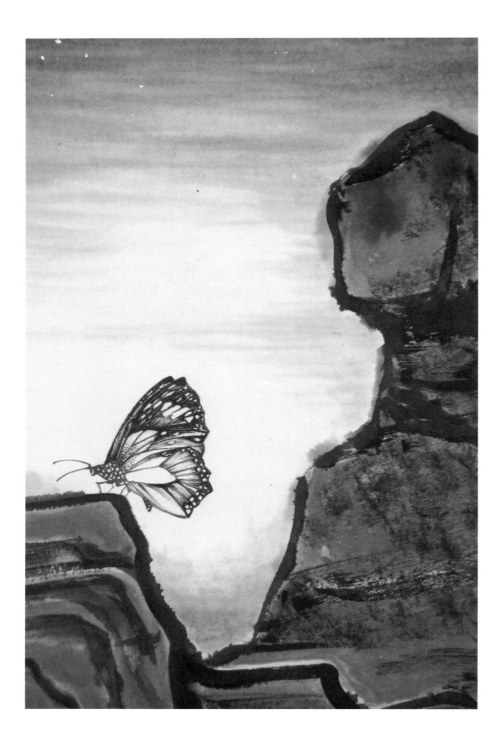

Figure 212. 蝴蝶羅漢（局部） / Butterfly arhat
(detail), 137 × 69 cm (2009)

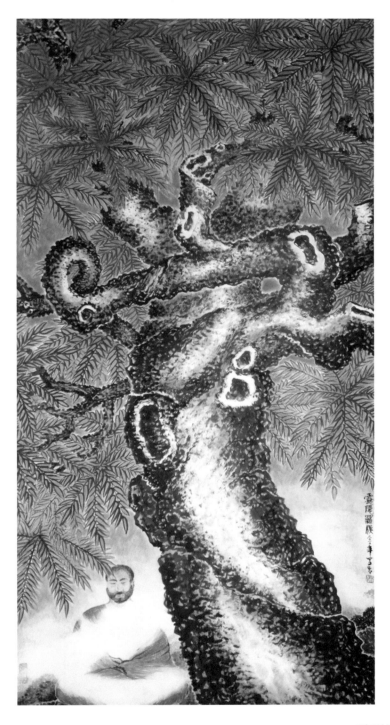

Figure 213. 霧隱羅漢 / Misty arhat,
137 × 69 cm (2010)

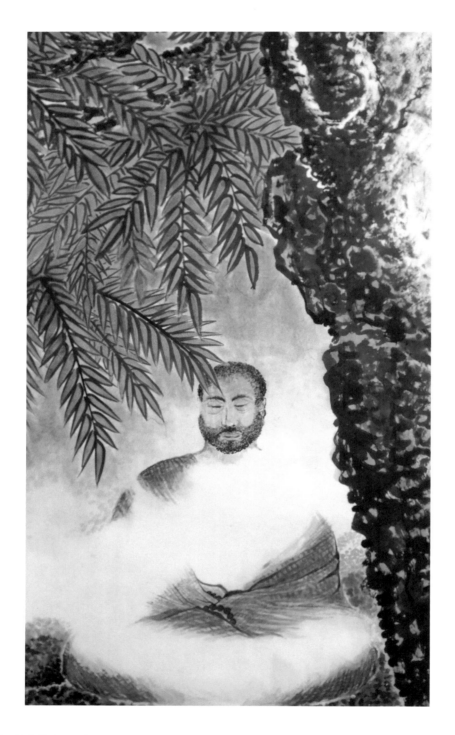

Figure 214. 霧隱羅漢（局部）/ Misty arhat
(detail), 137 × 69 cm (2010)

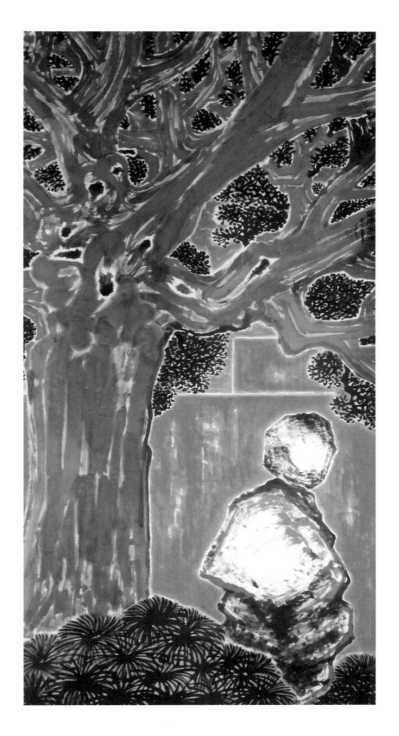

Figure 215. 面壁羅漢 / Wall-meditating arhat,
137 × 69 cm (2010)

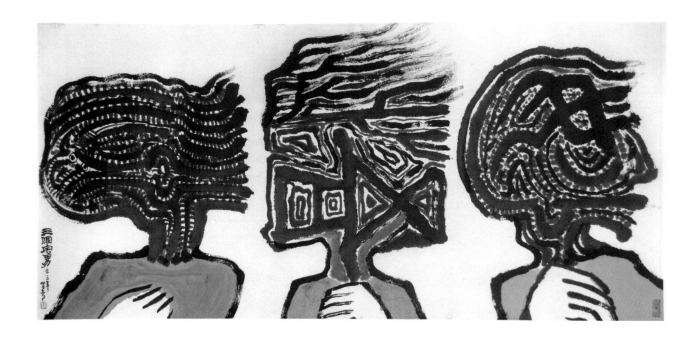

Figure 216. 宅男羅漢 / Indoorsy arhat,
69 × 137 cm (2012)

Classical Renovation:
Calling for the Ancients Series

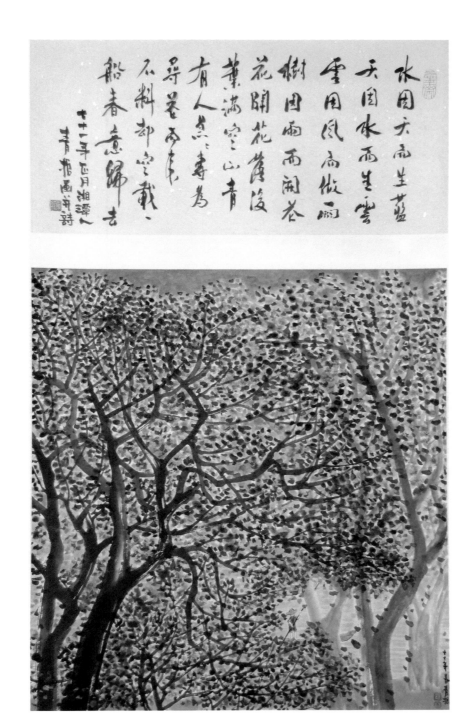

Figure 217. 高呼石田：載得春意歸 / Calling for Shen Chou,
Row the spring back home, 69 × 69 cm (1982)

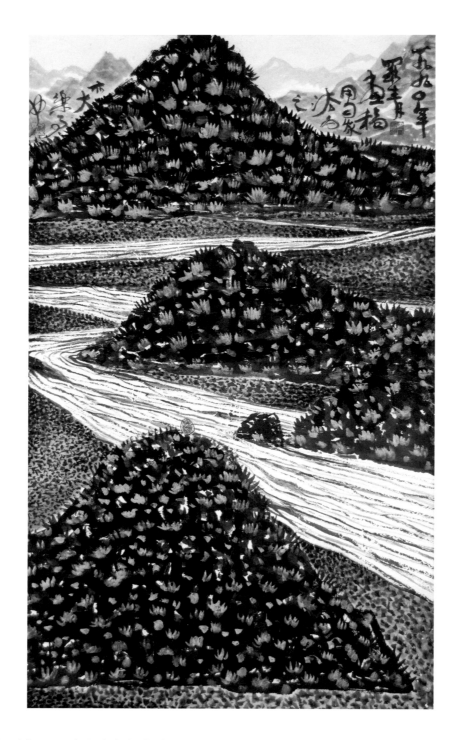

Figure 218. 高呼白石：碧山流水如白練 / Calling for Ch'i Pai-shih,
White river like white silk ribbon, 124 × 73 cm (1990)

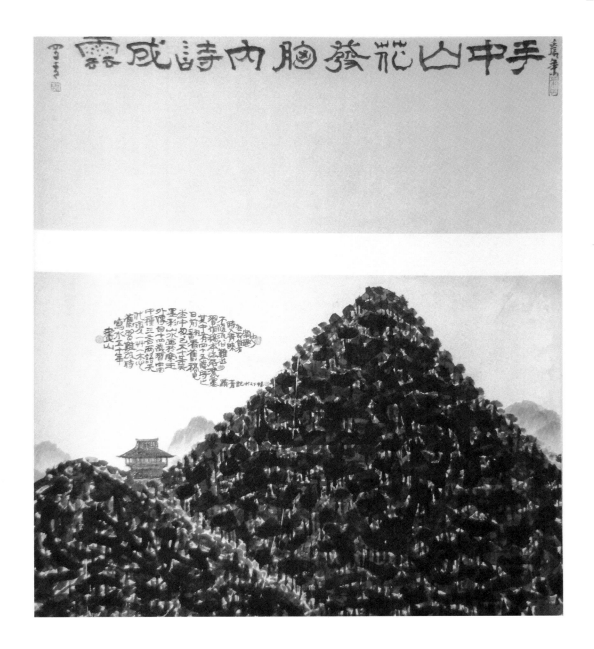

Figure 219. 高呼冬心：胸內詩成雲 / Calling for Chin Nung,
Verse voiced into clouds, 59.5 × 87.5 cm (1993)

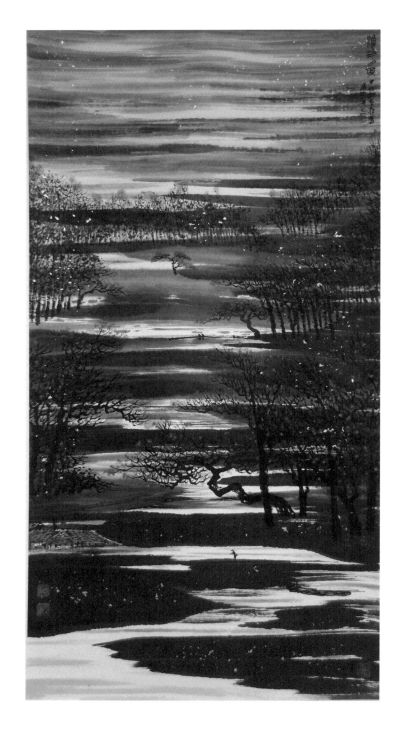

Figure 220. 瀟湘八景之一　漁村夕照　/ Eight views of Hsiao-hsiang,
Evening village, 137 × 69 cm (1994)

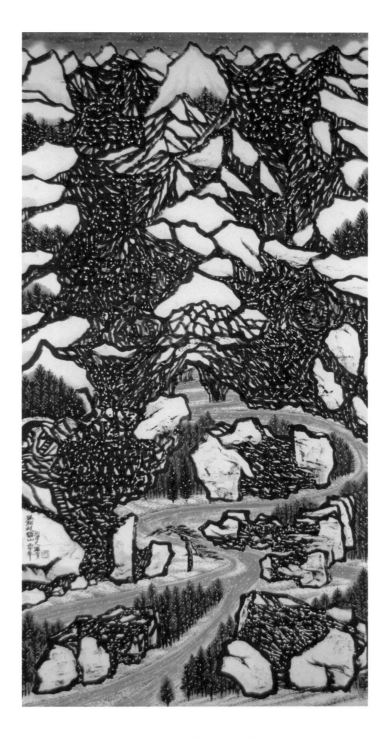

Figure 221. 高呼王維之一 孤松戰雪山 / Calling for Wang Wei No. 1,
A lonely pine among snowy mountains, 137 × 69 cm (1996)

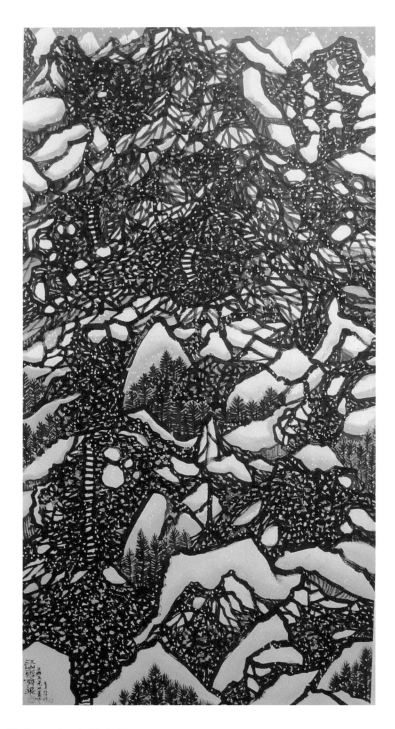

Figure 222. 高呼王維之二 江山雪齊飛 / Calling for Wang Wei No. 2, Snowflakes flying among mountains, 137 × 69 cm (1996)

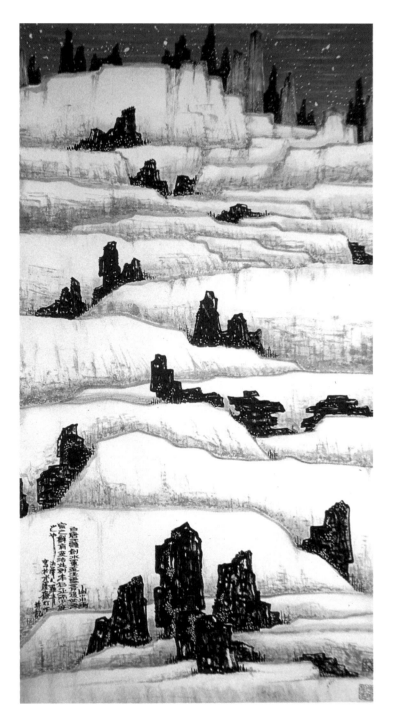

Figure 223. 高呼王維之三　夕陽映雪白　/ Calling for Wang Wei No. 3,
Snowy evening, 136.5 × 70 cm (1997)

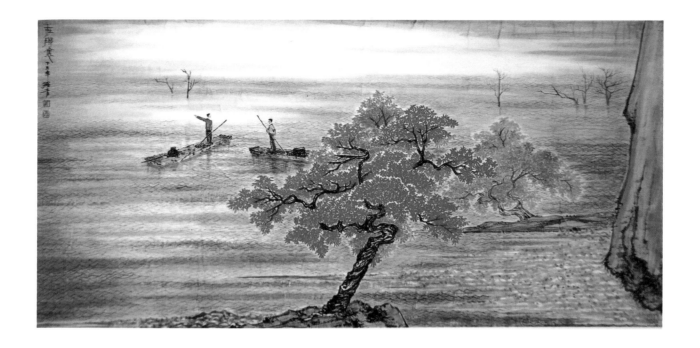

Figure 224. 高呼張崟：在那裡 / Calling for Chang Yin,
Over there, 69 × 137 cm (1997)

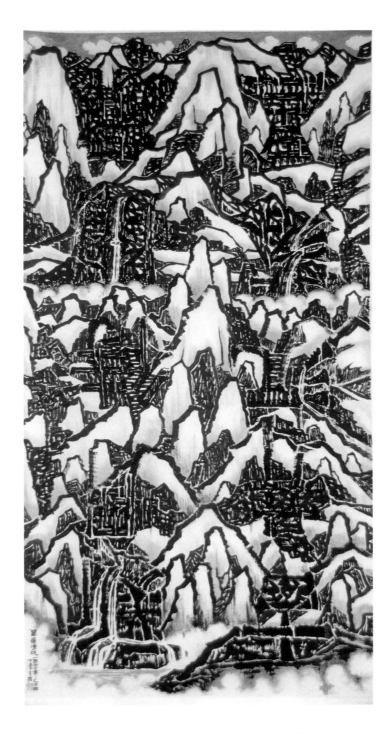

Figure 225. 高呼任熊之一 萬株寒林 / Calling for Jen Hsiung No. 1,
Ten thousand snowy woods, 137 × 69 cm (1997)

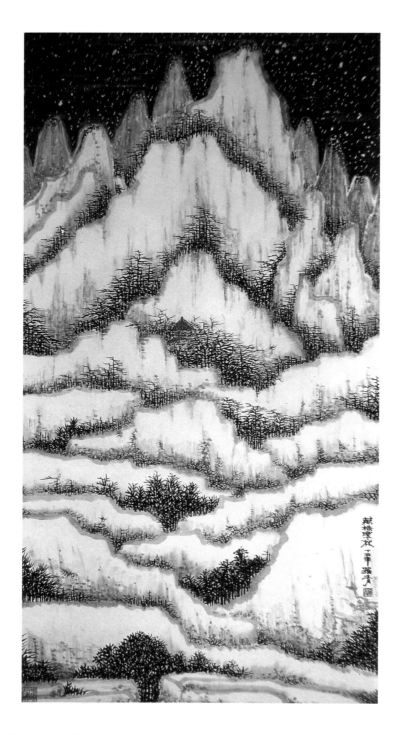

Figure 226. 高呼任熊之二　萬道凍流　/ Calling for Jen Hsiung No. 2,
Ten thousand frozen waterfalls, 137 × 69 cm (1997)

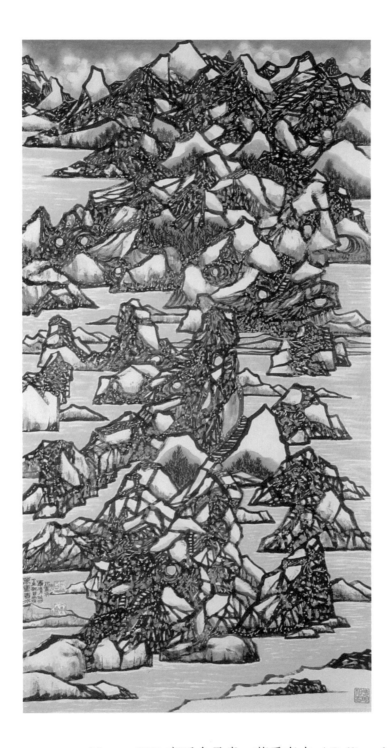

Figure 227. 高呼余承堯：萬重春水 / Calling for Yu Ch'eng-yao,
Ten thousand spring waves, 137 × 69 cm (1997)

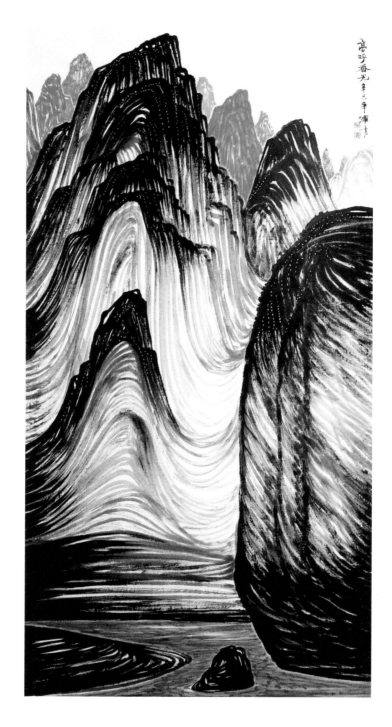

Figure 228. 高呼董其昌之一 / Calling for Tung Ch'i-ch'ang No. 1,
Pastoral landscape, 137 × 69 cm (2001)

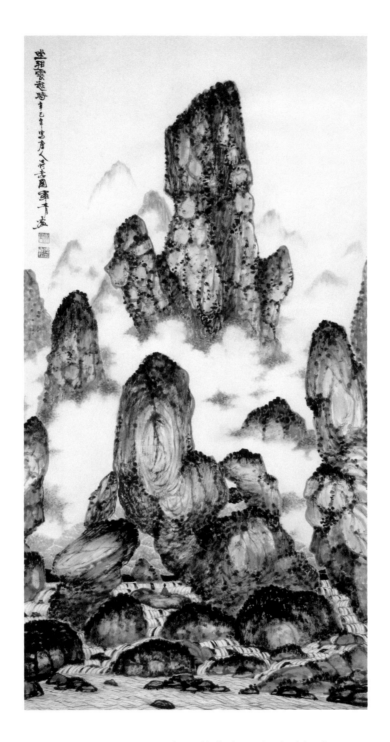

Figure 229. 高呼戴本孝: 坐看雲起時 / Calling for Tai Pen-hsiao,
Where the river ends, clouds emerge, 137 × 69 cm (2001)

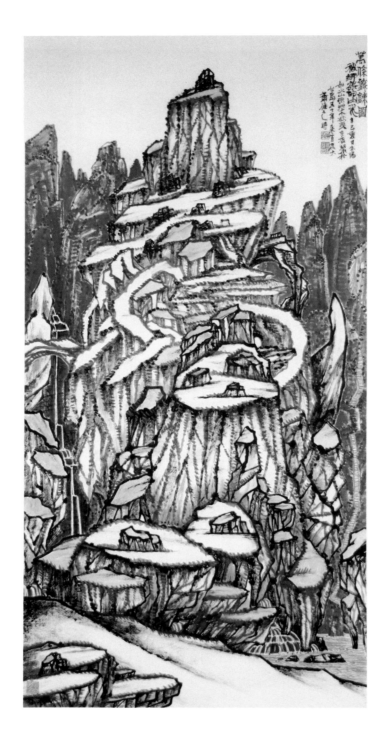

Figure 230. 高呼蘇仁山：萬條鐵鍊 / Calling for Su Jen-shan,
Ten thousand iron chains, 137 × 69 cm (2001)

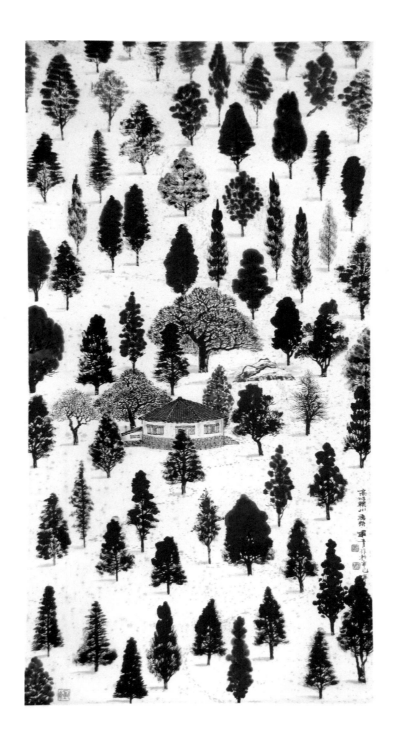

Figure 231. 高呼王維之四 鹿柴 / Calling for Wang Wei No. 4, Deer groves, 137 × 69 cm (2001)

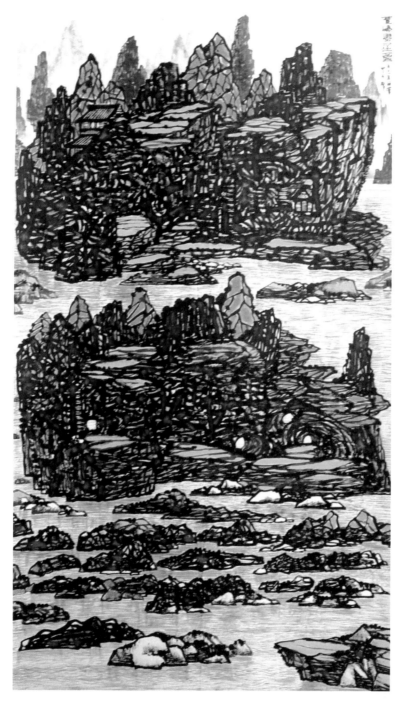

302

Figure 232. 高呼文伯仁－圓嶠書屋圖 / Calling for Wen Po-jen,
The studio of the divine Yuan-ch'iao mountain, 137 × 69 cm (2001)

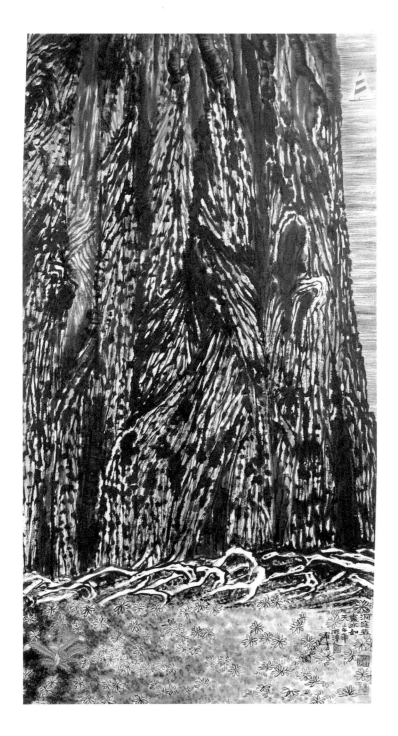

Figure 233.高呼陸曄：洞庭水如天 / Calling for Lu Hui,
The water and sky are one, 137 × 69 cm (2002)

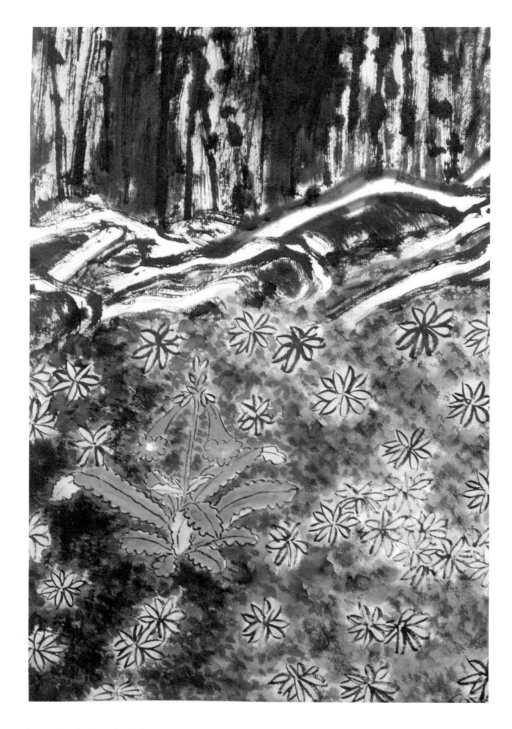

Figure 234. 高呼陸曎: 洞庭水如天（局部）/ Calling for Lu Hui,
The water and sky are one (detail), 137 × 69 cm (2002)

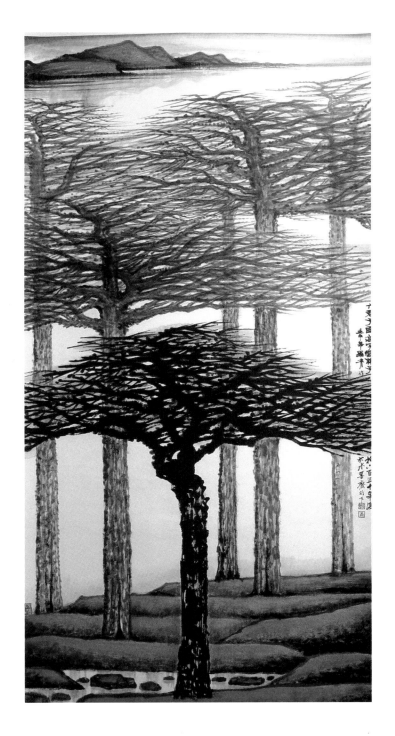

Figure 235. 高呼雲林：六君子 / Calling for Yun-lin [Ni Tsan],
Six Confucian gentlemen, 137 × 69 cm (2002)

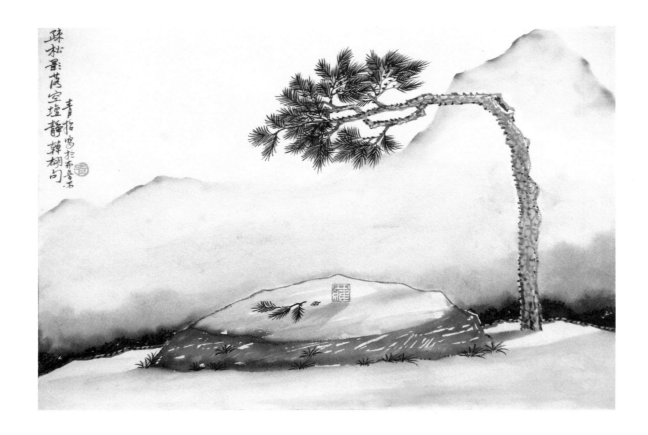

Figure 236. 高呼溥心畬: 空壇見前身 / Calling for Pu Hsin-yu,
To discover one's preexistence, 23 × 32 cm (2003)

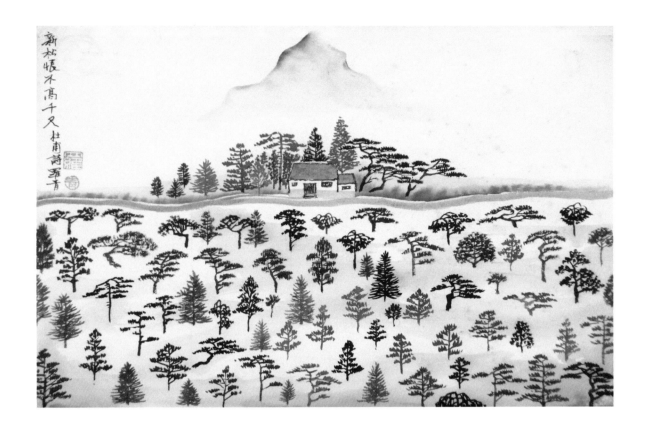

Figure 237. 高呼杜甫：新松恨不高 / Calling for Tu Fu,
Anxious to see the young pine grow, 23 × 32 cm (2003)

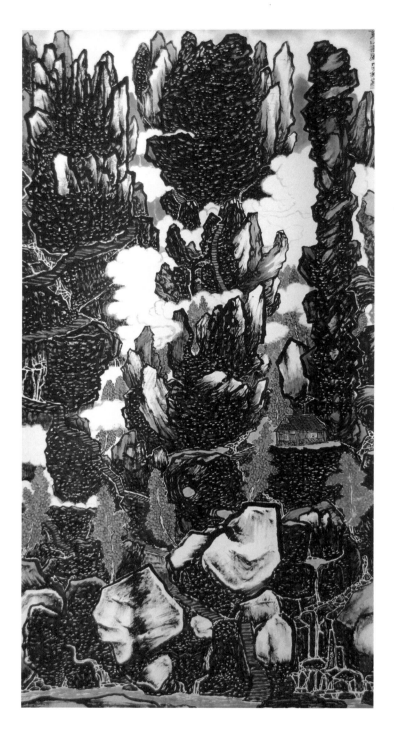

Figure 238. 高呼吳彬：萬山書屋 / Calling for Wu Pin,
A small library among ten thousand mountains, 137 × 69 cm (2008)

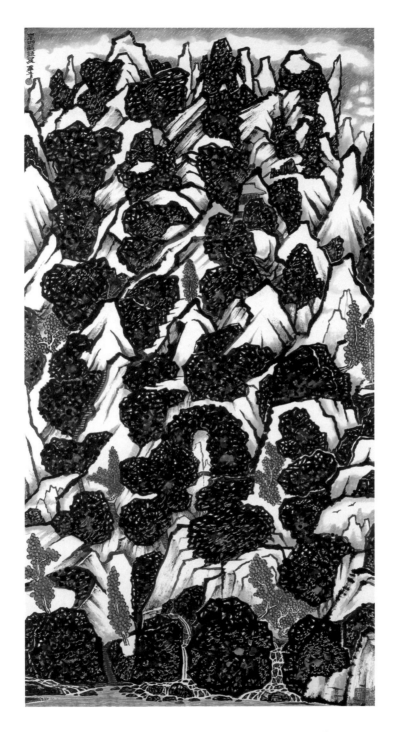

Figure 239. 高呼石濤: 萬山藏綠屋 / Calling for Shih-t'ao,
A green house lurking among the high mountains, 137 × 69 cm (2009)

310

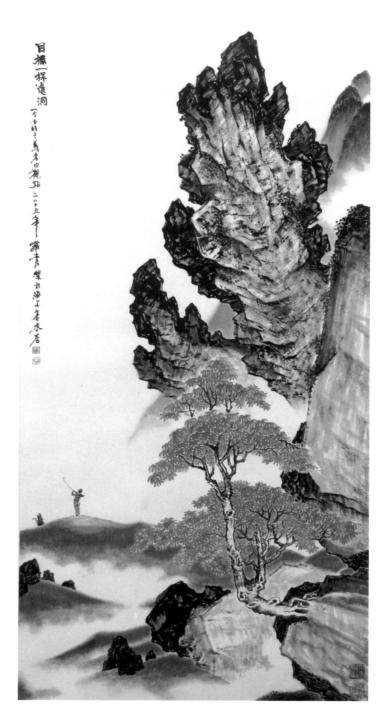

Figure 240. 高呼改琦：一桿進洞 / Calling for Kai Ch'i,
Hole in one, 137 × 69 cm (2009)

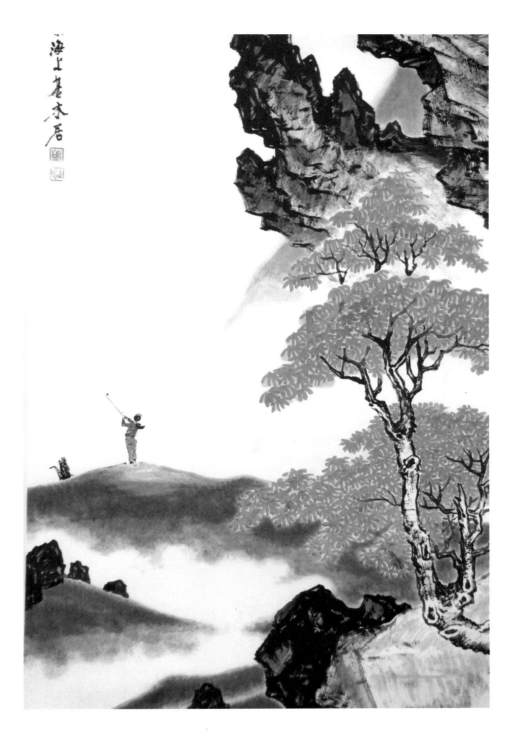

Figure 241. 高呼改琦：一桿進洞（局部）/ Calling for Kai Ch'i,
Hole in one (detail), 137 × 69 cm (2009)

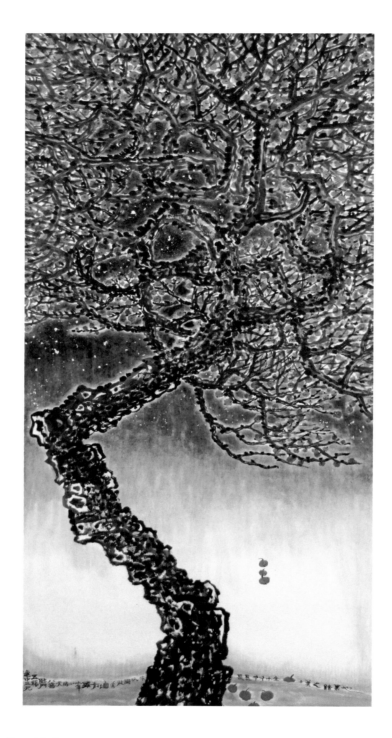

Figure 242. 高呼華嵒：連中三元 / Calling for Hua Yen, Good things come in threes, 137 × 69 cm (2009)

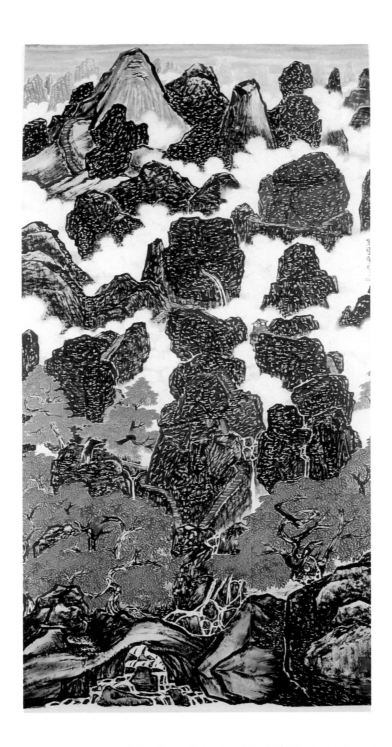

Figure 243. 高呼蕭尺木: 萬重黃雲 / Calling for Hsiao Yun-ts'ung,
Ten thousand yellow clouds, 137 × 69 cm (2009)

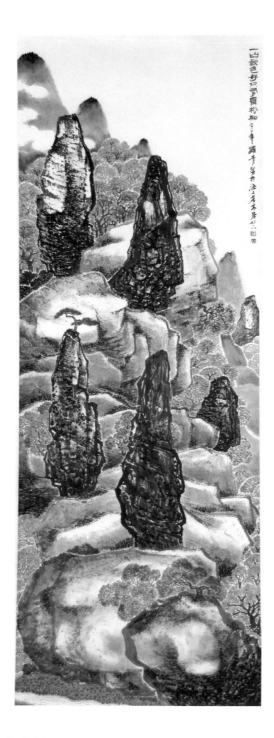

Figure 244. 高呼黃山壽：秋色青松知 / Calling for Huang Shan-shou,
The pines foresee the coming autumn, 120 × 45 cm (2010)

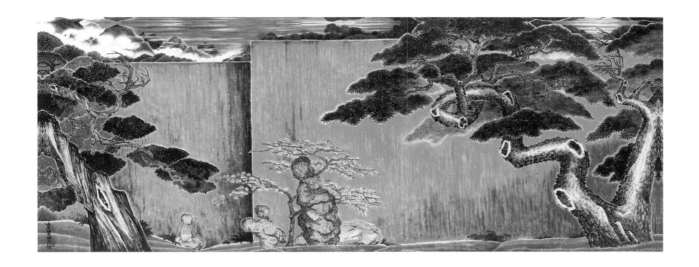

Figure 245. 全唐詩意圖 / The complete concordance of T'ang poetry,
192 × 497 cm (2010)

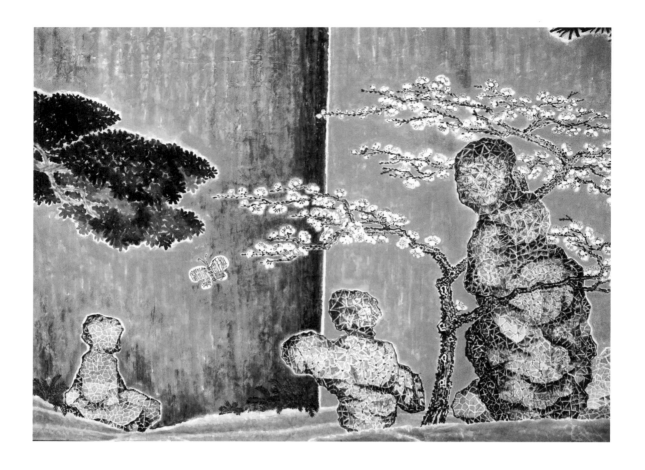

Figure 246. 全唐詩意圖（局部）/ The complete concordance of T'ang poetry (detail), 192 × 497 cm (2010)

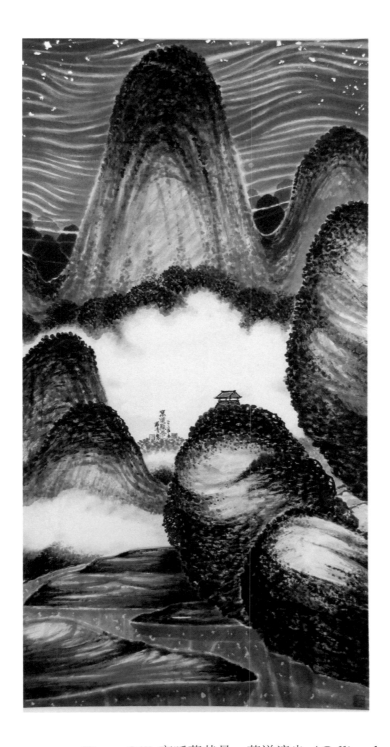

Figure 247. 高呼董其昌：萬道流光 / Calling for Tung Ch'i-ch'ang,
Ten thousand streamers, 137 × 69 cm (2012)

318

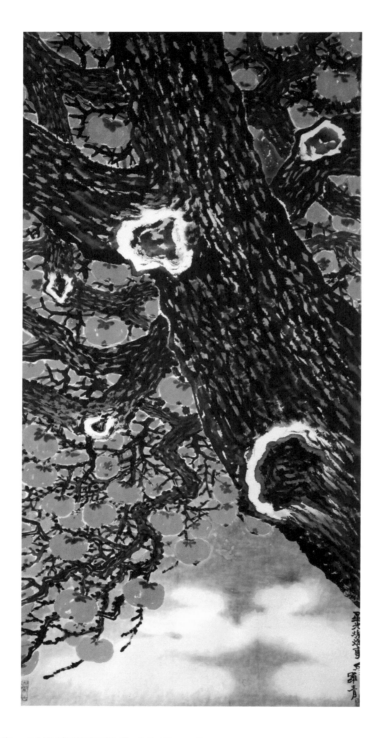

Figure 248. 高呼羅聘: 星光燦爛事事成 / Calling for Lo P'ing,
Starlight bringing good luck, 137 × 69 cm (2012)

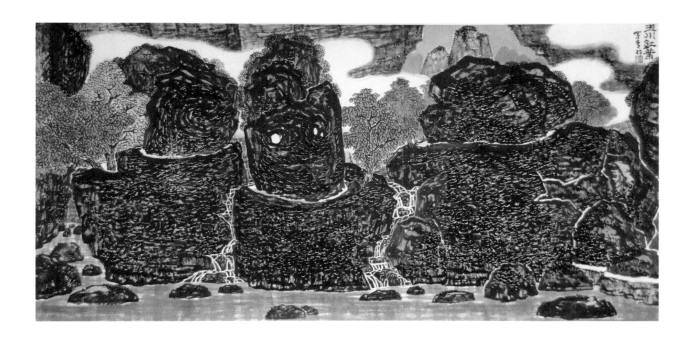

Figure 249. 高呼王蒙：玉川紅葉 / Calling for Wang Meng,
Jade-like river and red trees, 69 × 137 cm (2012)

320

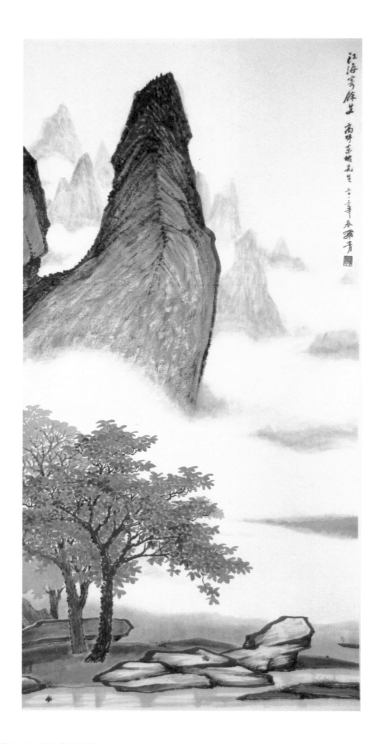

Figure 250. 高呼張崟：江海寄餘生 / Calling for Chang Yin,
To lead a floating life, 137 × 69 cm (2012)

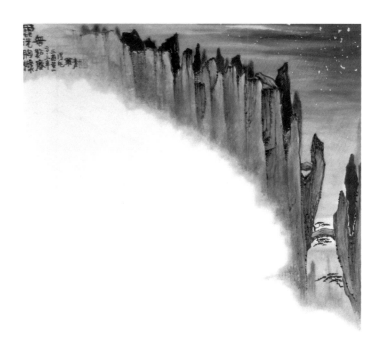

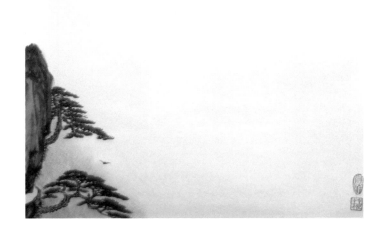

Figure 251. 高呼梅清：青眼看黃山　雲洗胸懷無點塵　/ Calling for Mei Ch'ing,
Clouds wash avarice away, 137 × 69 cm (2013)

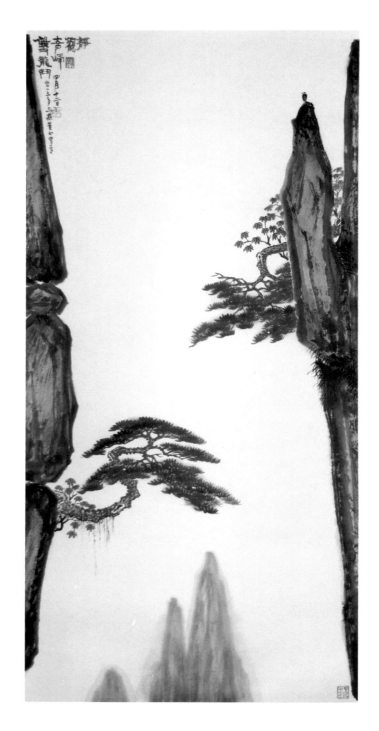

Figure 252. 高呼梅清：青眼看黃山　靜觀奇峰雙龍鬥 / Calling for Mei Ch'ing, Two dragon pines playing in the wind, 137 × 69 cm (2013)

Classical Renovation:
Palm Tree Series

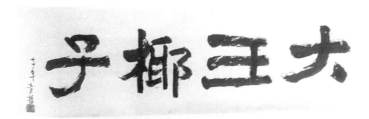

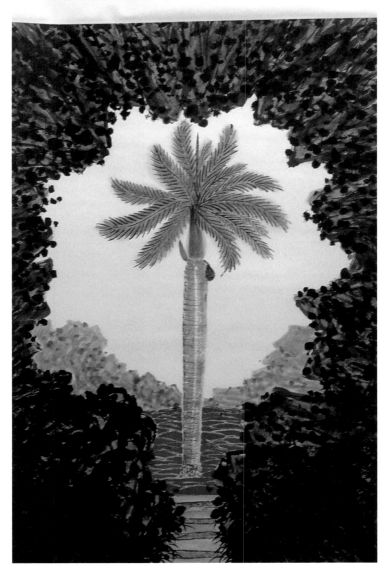

Figure 253. 大王椰子 / The king palm,
105 × 69 cm (1982)

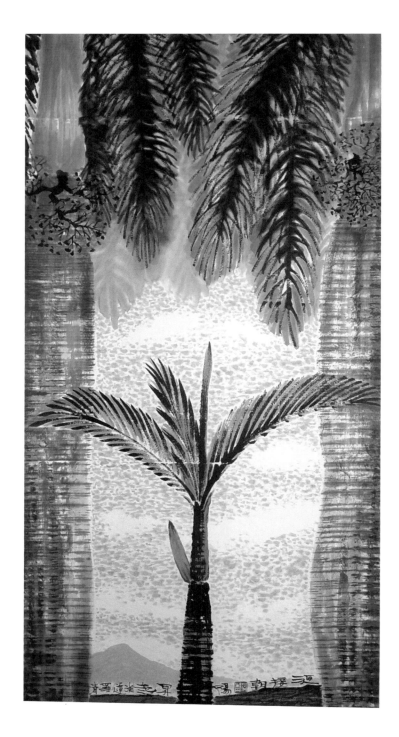

Figure 254. 迎接朝陽升起 / Rise and shine,
137 × 69 cm (1989)

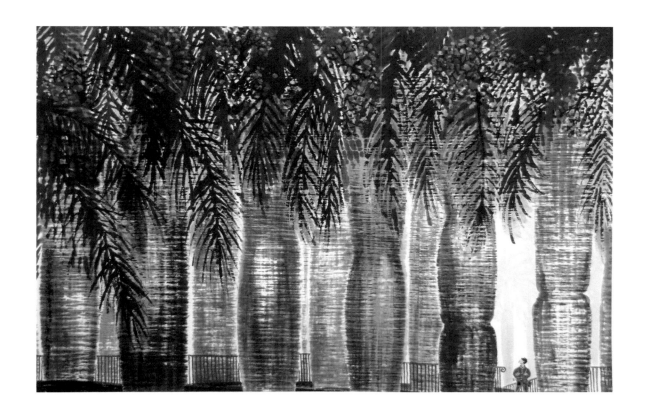

Figure 255. 綠色金剛守家園 / Green-armored guards,
137 × 206 cm (1990)

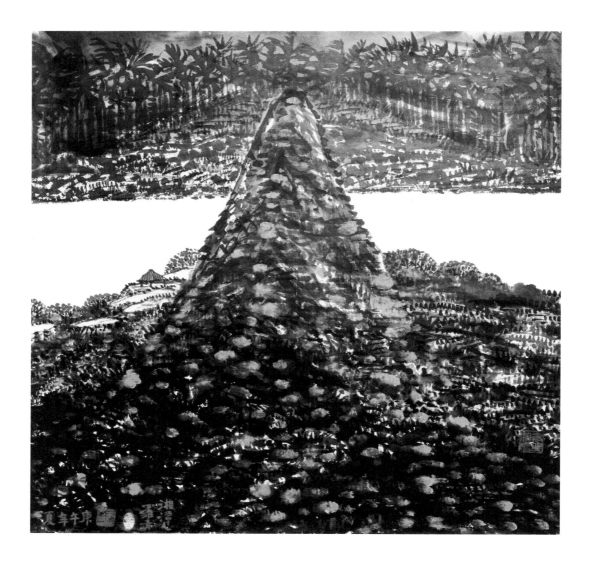

Figure 256. 彼岸風雷動 / Thunderstorms on the other side of the bank,
69 × 69 cm (1990)

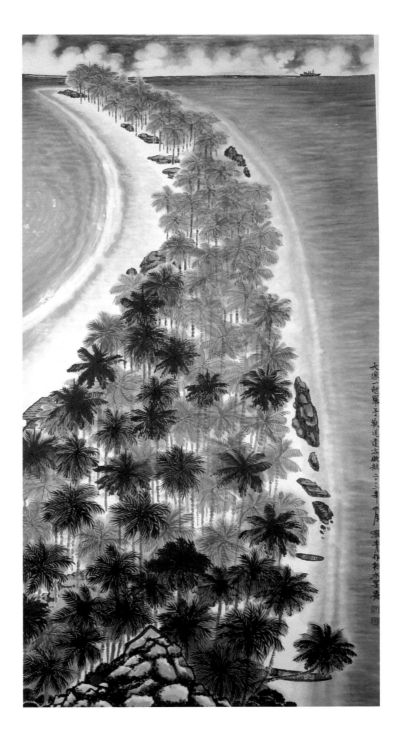

Figure 257. 歡送遺忘啟航 / Seeing oblivion off,
137 × 69 cm (2002)

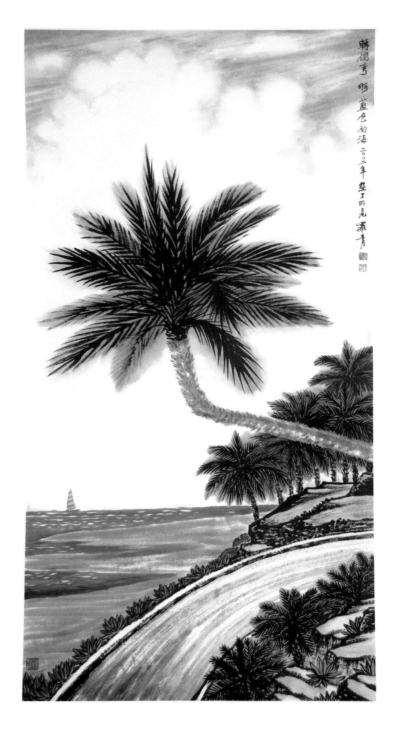

Figure 258. 一轉彎 啊 藍色的海 / Suddenly, the blue sea!,
137 × 69 cm (2002)

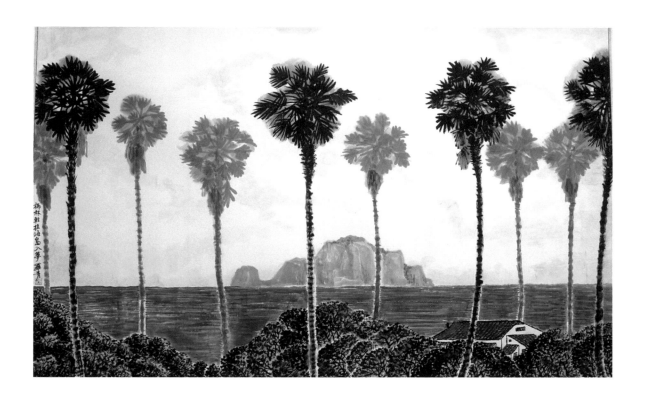

Figure 259. 輕搖海島入夢 / Palms rocking a small island into dreams,
69 × 109 cm (2003)

332

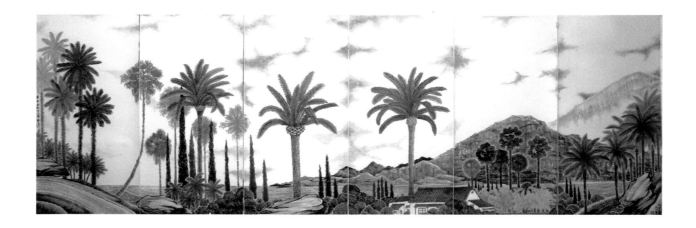

Figure 260. 八大金剛守家園 / Eight giant guards of the heartland,
138 × 414 cm (2006)

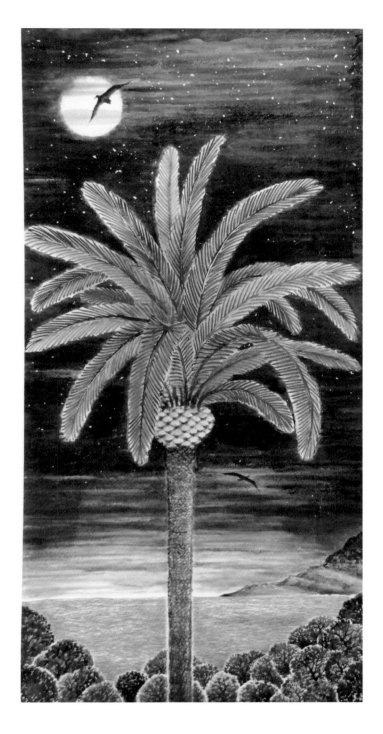

Figure 261. 月光使者眾星隨 / Moonlight messenger,
137 × 69 cm (2008)

Classical Renovation:
Multiple Collages

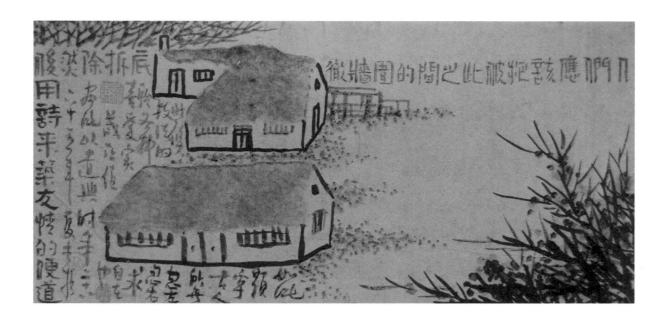

Figure 262. 拆除所有的圍牆 / Tear down all the fences,
22 × 44 cm (1972)

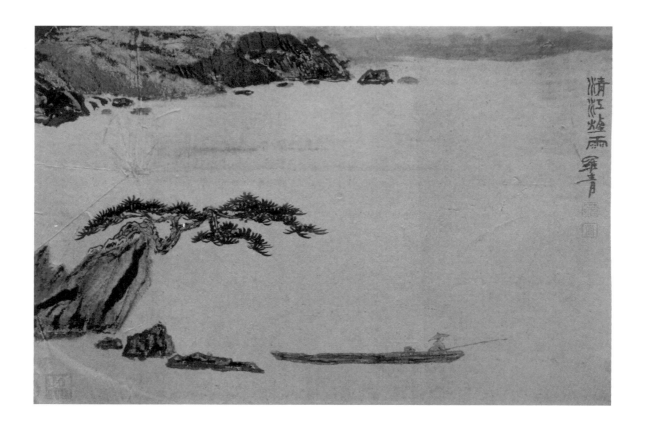

Figure 263. 清江煙雲 / Misty clouds over the clear water,
32 × 46 cm (1973)

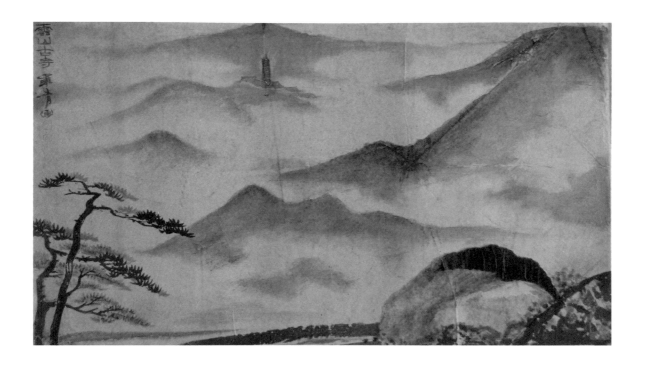

Figure 264. 雲山古寺 / Old shrine in the misty mountain,
27 × 64 cm (1974)

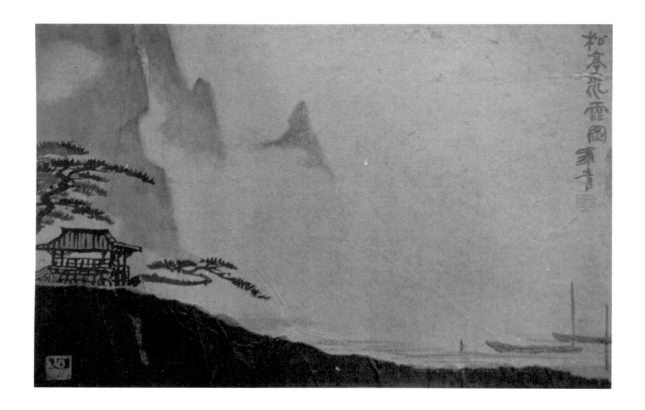

Figure 265. 松亭水雲 / Pine pavilion among nimbuses,
32.5 × 49 cm (1974)

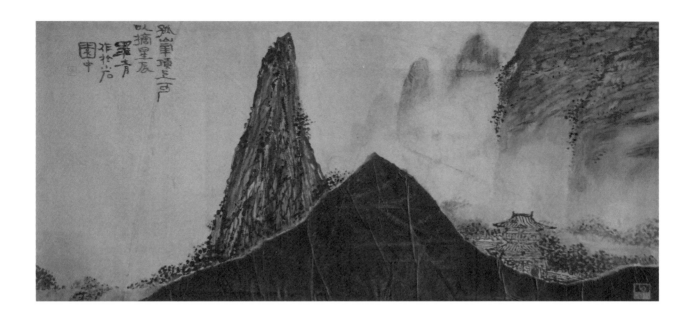

Figure 266. 孤峰頂上摘星辰 / Catching a star on the lone peak,
38 × 82 cm (1975)

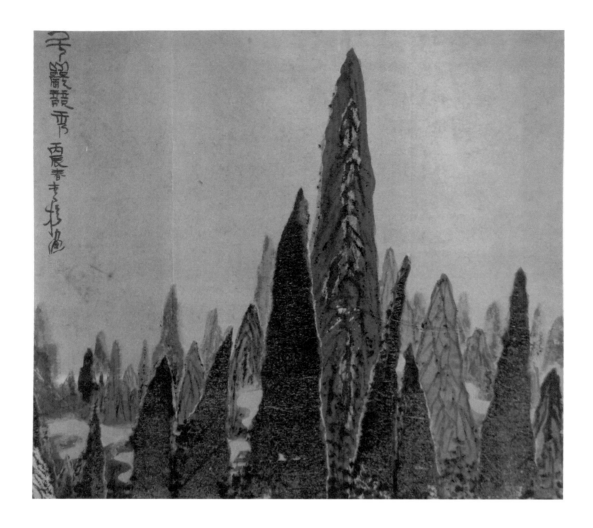

Figure 267. 千巖競秀 ／ Thousands of cliffs contending among clouds,
49.5 × 53 cm (1975)

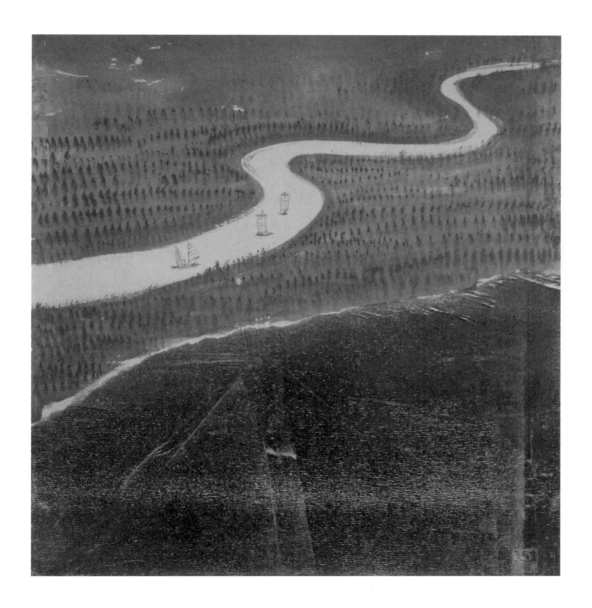

Figure 268. 行舟 / Sailing alone,
46 × 43 cm (1976)

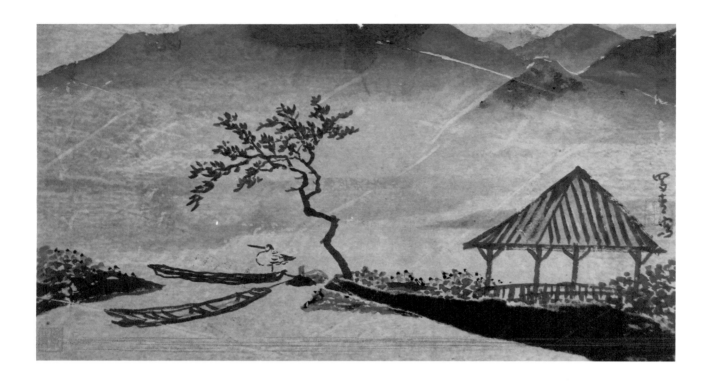

Figure 269. 雲深不知處 / Whereabouts unknown in the depth of clouds,
25 × 45 cm (1976)

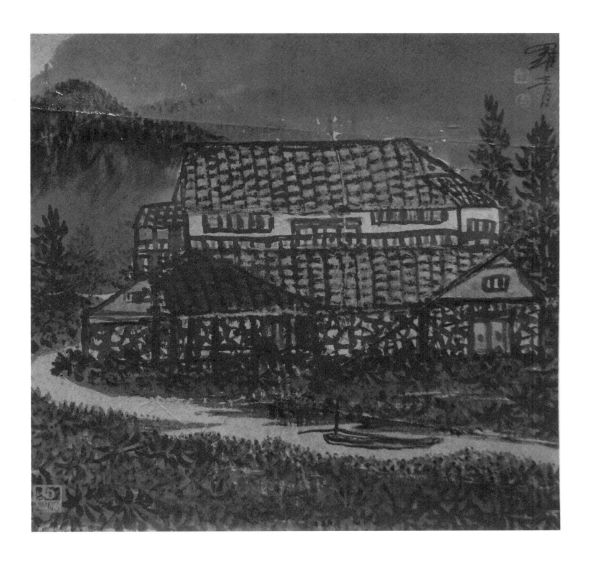

Figure 270. 紅房子 / Red house,
37 × 39 cm (1977)

Figure 271. 皓月冷千山 / Bright moon chilling a thousand peaks,
23 × 27 cm (1977)

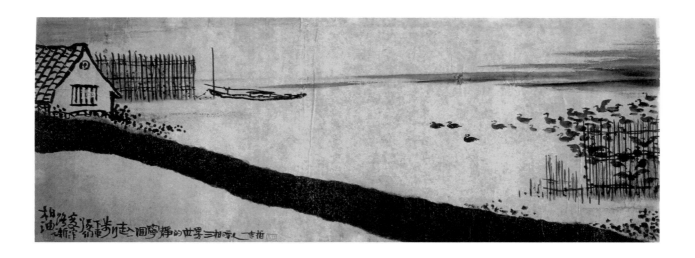

Figure 272. 柏油路漸漸變窄 / Tapering asphalt road,
34 × 78 cm (1978)

348

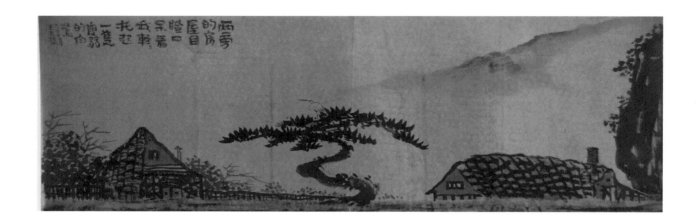

Figure 273. 輕輕托起一隻白鷺 / Gently holding up a white heron,
26 × 78 cm (1978)

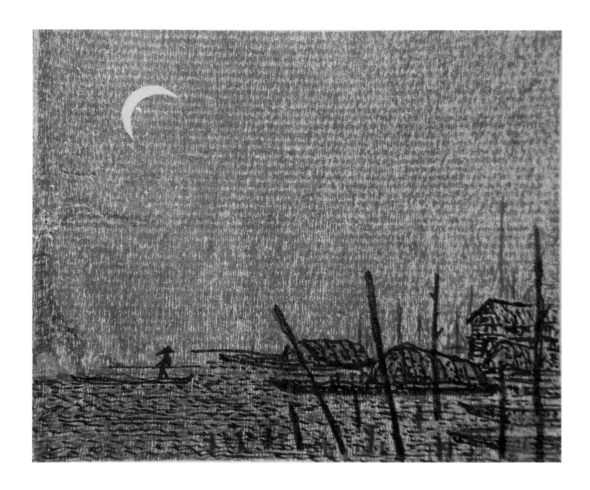

Figure 274. 江月初照人 / When did the moon first on humans shine?,
23 × 27 cm (1979)

Figure 275. 波平如鏡最危險 / The mirror-like river is hideously dangerous, 34 × 78 cm (1979)

Figure 276. 燈塔隱群星 / The lighthouse that outshines the stars,
23 × 57 cm (1979)

Early Works

Figure 277. 仿李靈伽 鄭成功像 / After Li Lin-Chieh,
A Portrait of Cheng Ch'eng-kung, 57 × 41 cm (1963)

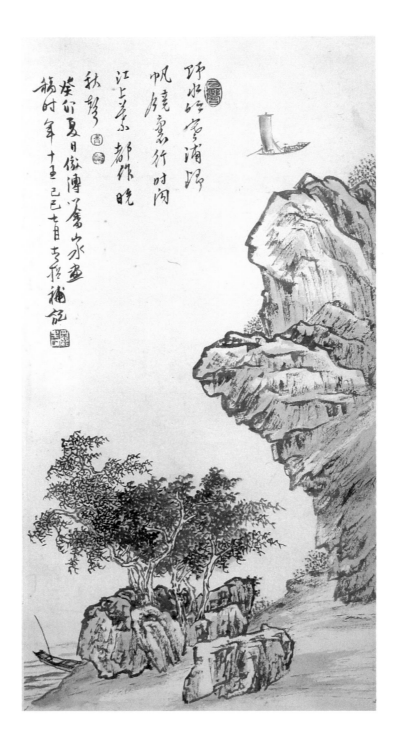

Figure 278. 仿溥心畬 / After Pu Hsin-yu's style,
58 × 28.5 cm (1963)

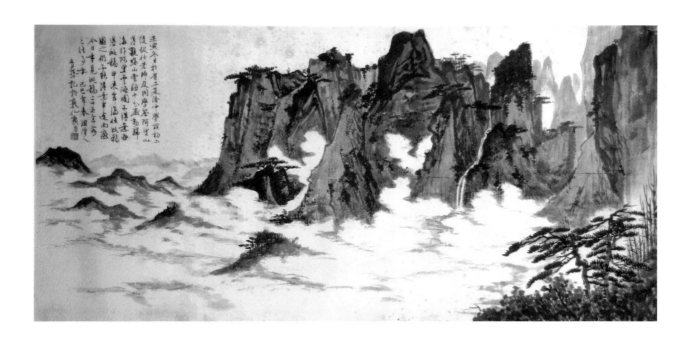

Figure 279. 阿里山寫生 / An impression of Mt. Ali,
60 × 120.5 cm (1964)

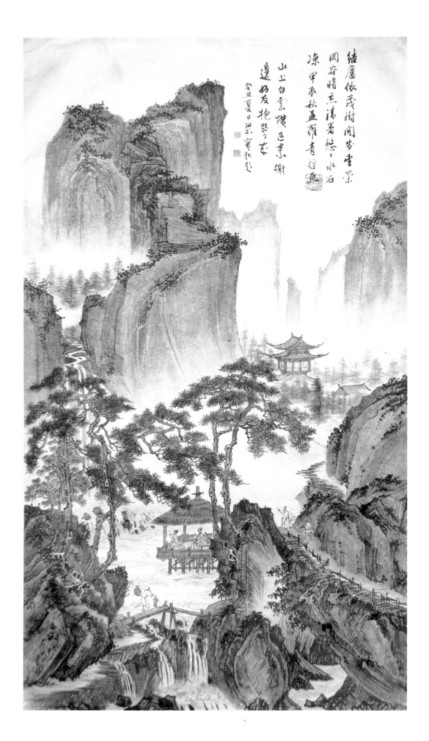

結廬依茂樹間芳雲棠
岡谷暗烹滴蕃悠悠水石
凉甲乘秋孟羅青題
山上白雲橫逗東榭
道好友抱琴来
癸卯夏日呆寅秋処畫

Figure 280. 仿唐寅 / After T'ang Yin the poet and painter,
75 × 41.4 (1964)

Figure 281. 芳草迎紅樹 / Fragrant grass and red trees,
35 × 25 cm (1964)

Figure 282. 仿元人 道人騎驢 / After the Yuan Master,
A Taoist priest riding on a donkey, 59.5 × 30 cm (1965)

Figure 283. 騰驤（梁實秋題）/ Galloping steed
(with Liang Shih-ch'iu's inscription), 69 × 34 cm (1965)

Figure 284. 山水（仿黃公望）/ Landscape
(after Huang Kung-wang) 69.5 × 43 cm (1965)

Figure 285. 獨立蒼茫故國情（任博悟題）/ Reminiscence of motherland
(with Jen Po-wu's inscription), 25 × 56 cm (1965)

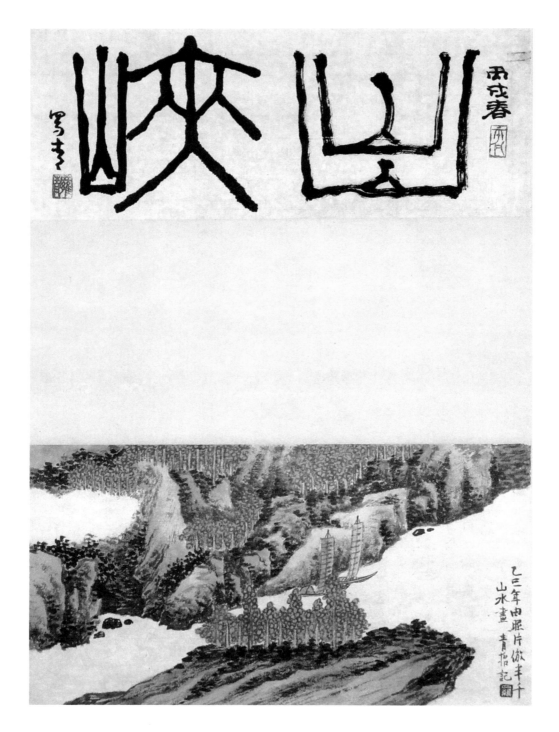

Figure 286. 出峽雙帆輕（仿龔賢）/ Two sails along the gorge river
(after Kung Hsien), 31.5 × 34 cm (1965)

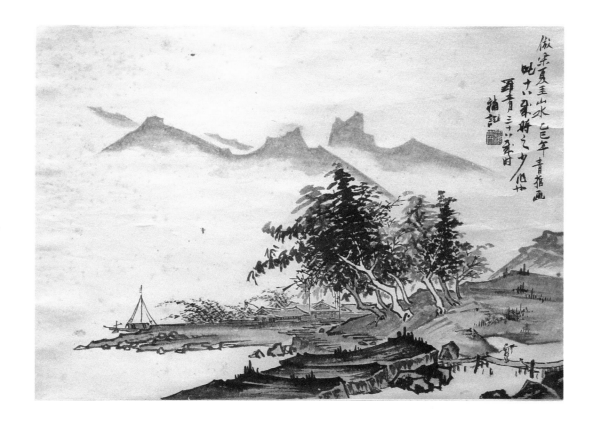

Figure 287. 山水仿夏圭 / Landscape after Hsia Kuei,
32 × 28.5 cm (1966)

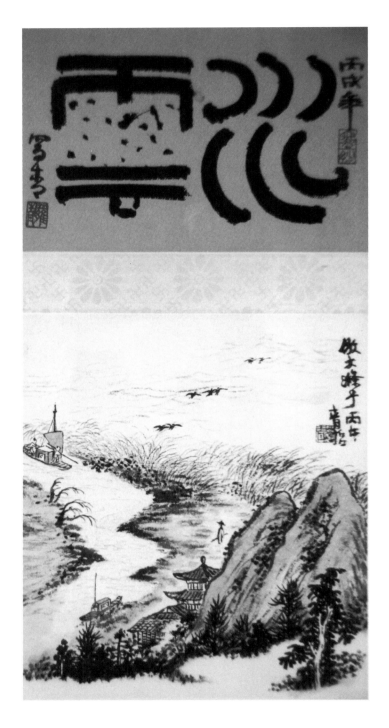

Figure 288. 山水仿石濤 / Landscape after Shih-t'ao,
32 × 56.7 cm (1966)

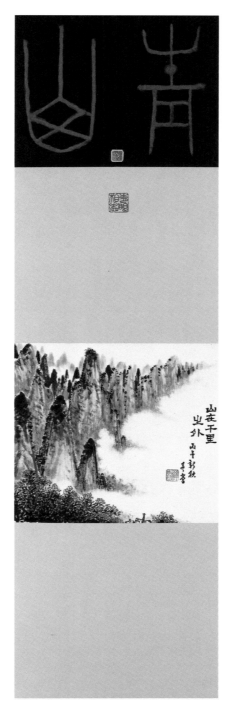

Figure 289. 山在千里外 / Blue mountains stretch endlessly,
23 × 30 cm (1966)

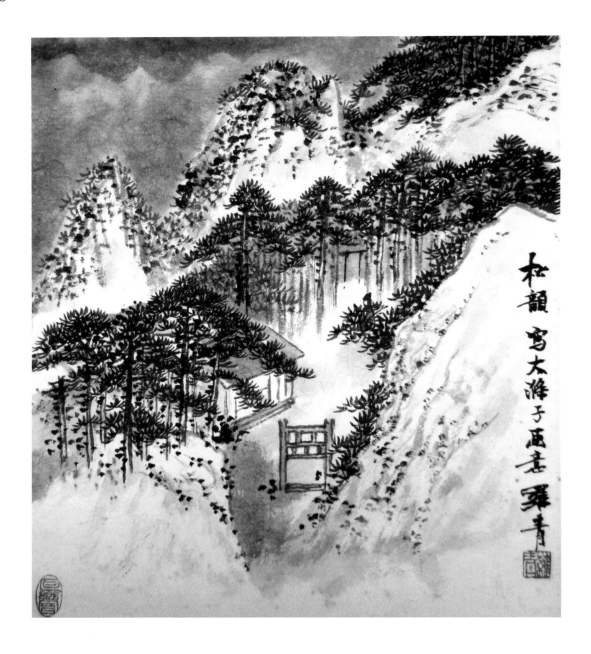

Figure 290. 高呼石濤 / Calling for Shih-t'ao,
32.5 × 28.5 cm (1966)

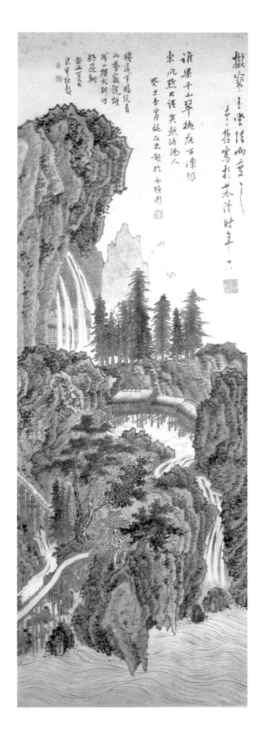

Figure 291. 山水仿溥心畬 / Landscape after Pu Ju,
90 × 30.5 cm (1966)

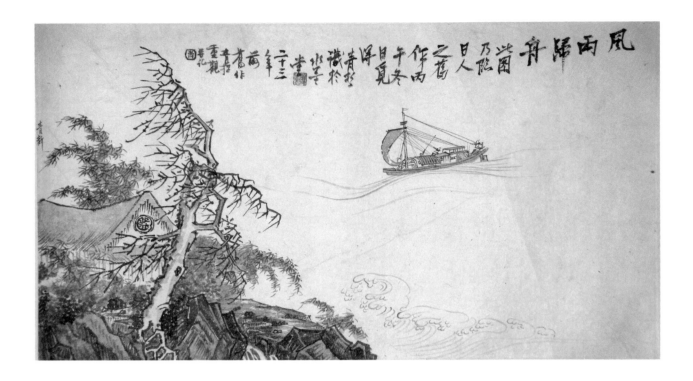

Figure 292. 山水仿雪舟 / Landscape after Sesshū,
32 × 56.7 cm (1966)

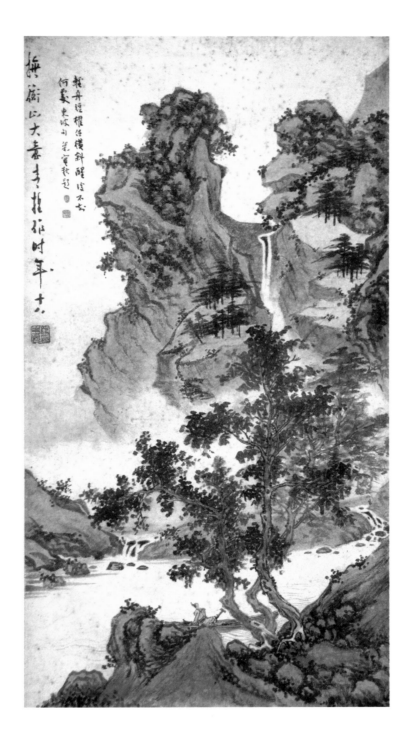

Figure 293. 山水仿文徵明 / Landscape after Wen Cheng-ming,
70 × 37 cm (1966)

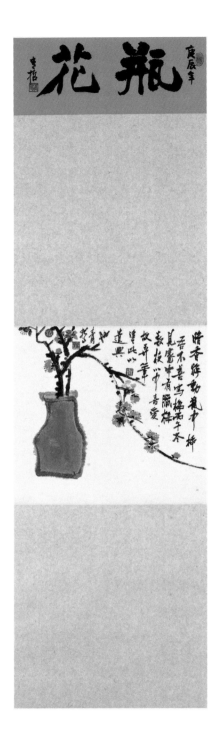

Figure 294. 紅瓶開墨梅 / Red jar presenting ink plum blossom,
28 × 30 cm (1966)

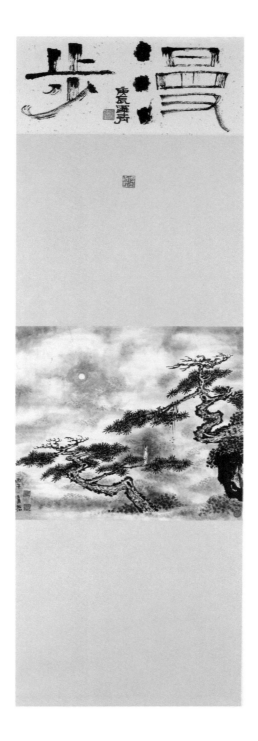

Figure 295. 月夜漫步幽 / Sauntering in the moon light,
28 × 30 cm (1966)

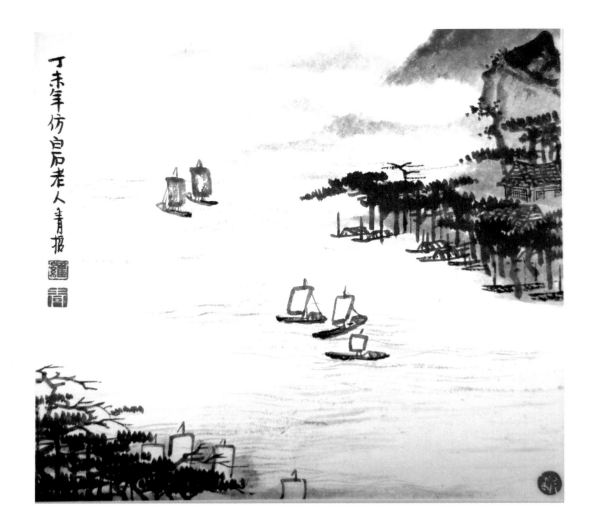

Figure 296. 高呼白石 / Calling for Ch'i Pai-shih,
28 × 30 cm (1967)

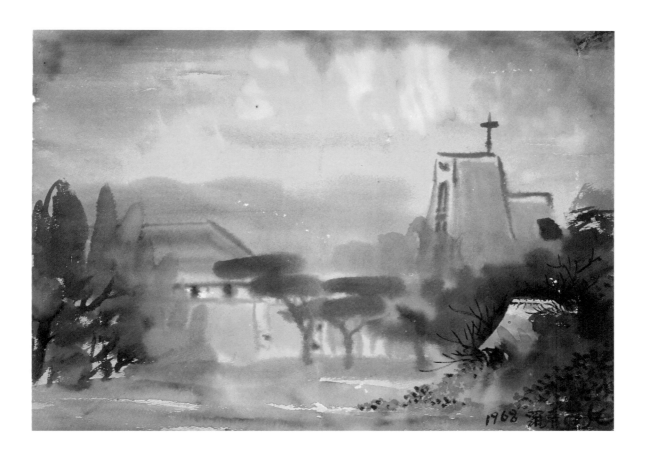

Figure 297. 東海大學寫生 / An impression of Tunghai University, 39 × 54 cm (1968)

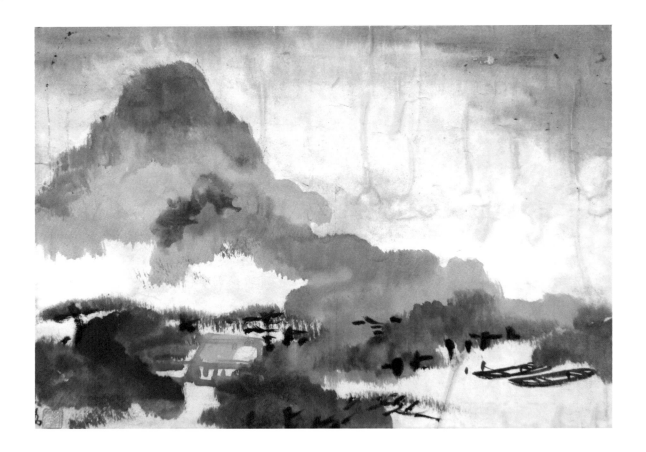

Figure 298. 雲山春色（油彩）/ Cloud mountains in spring
(oil painting), 38.2 × 53 cm (1968)

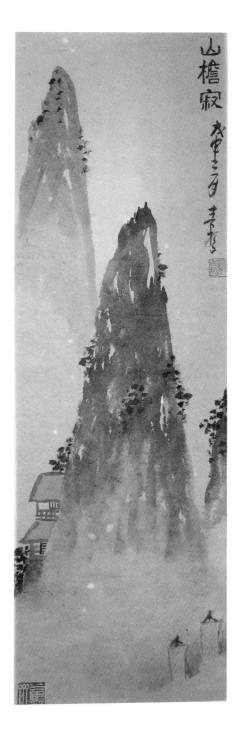

Figure 299. 山檐寂 / Lonely roof in the lonely mountain,
64 × 20.5 cm (1968)

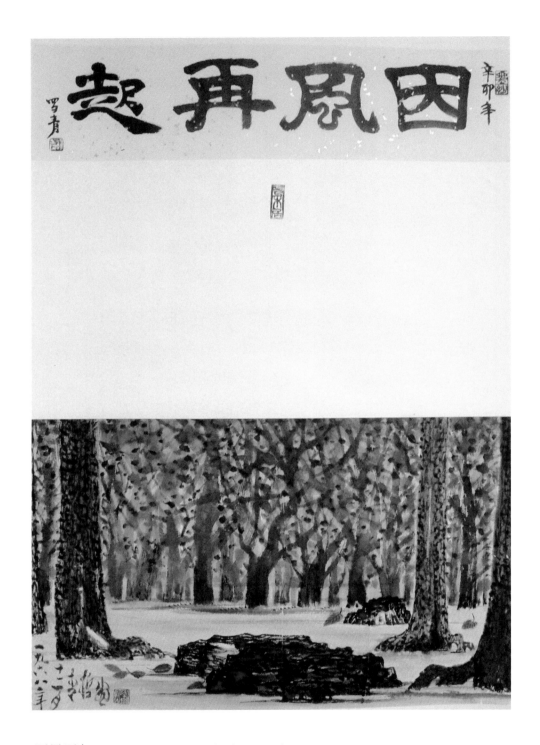

Figure 300. 因風再起 / Rising again with the wind,
34 × 54 cm (1968)

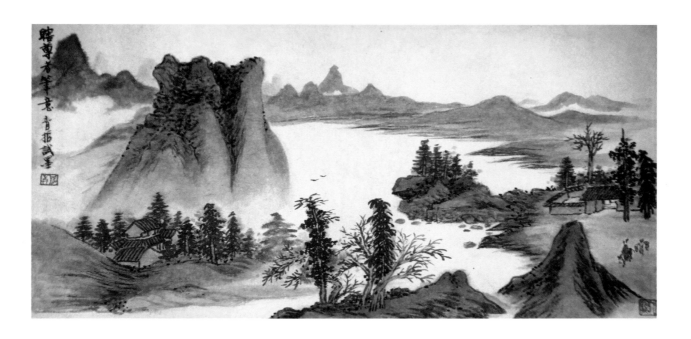

Figure 301. 清江行旅　高呼石濤 / Travel on a clear river
(Calling for Shih-t'ao), 28 × 56.7 cm (1968)

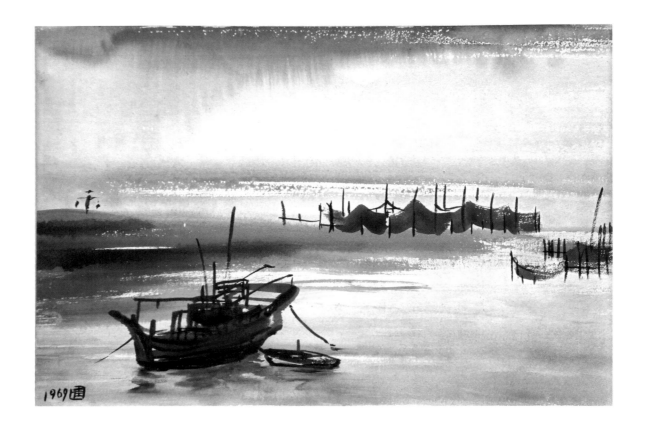

Figure 302. 福隆寫生（水彩畫）/ An impression of Fu-lung beach
(watercolors), 26 × 38 cm (1969)

Figure 303. 橫貫公路寫生 / An impression of the Cross-Island Highway, 48.5 × 37 cm (1969)

Figure 304. 小屋如漁舟 / Boat-like cottage,
22.5 × 31 cm (1969)

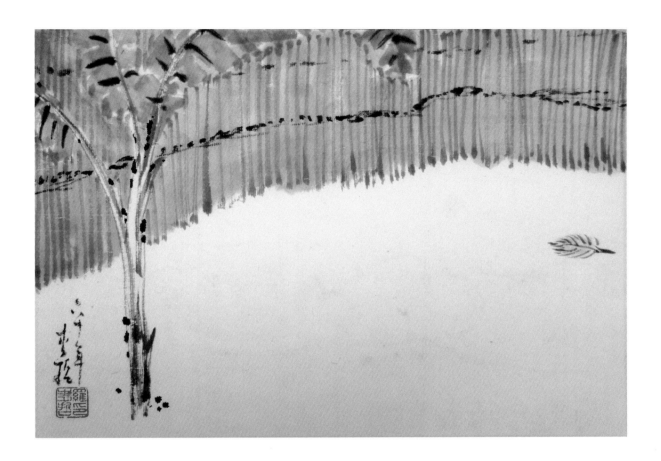

Figure 305. 南籬下 / By the southern fence,
24.5 × 34.3 cm (1971)

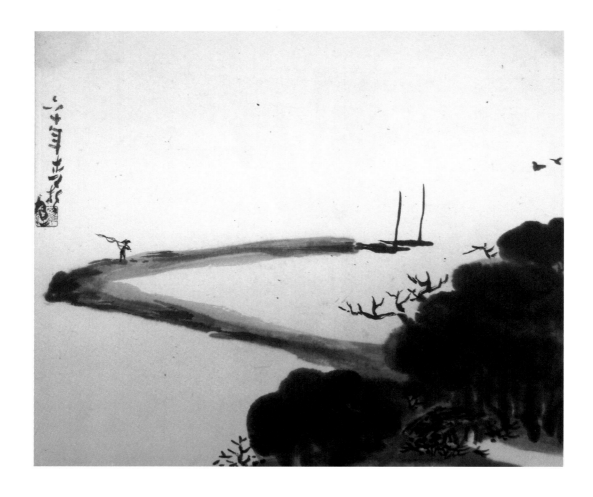

Figure 306. 霧散漁夫現 / Fisherman emerging in the fog,
30 × 40 cm (1971)

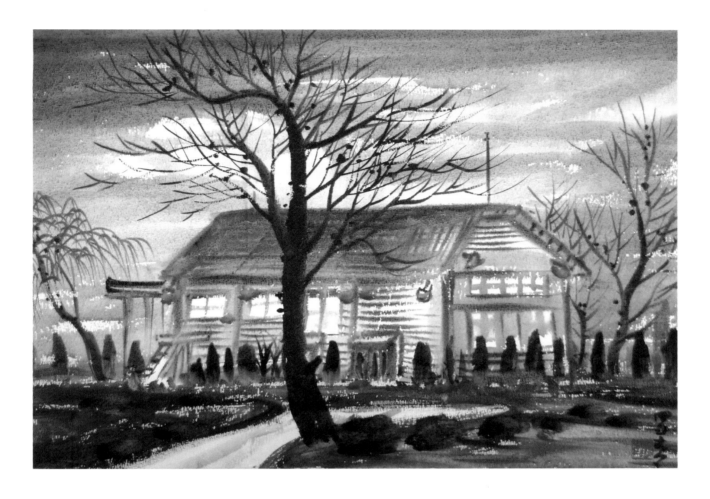

Figure 307. 西雅圖寫生（水彩畫）/ An impression of Seattle
(watercolors), 39 × 53 cm (1972)

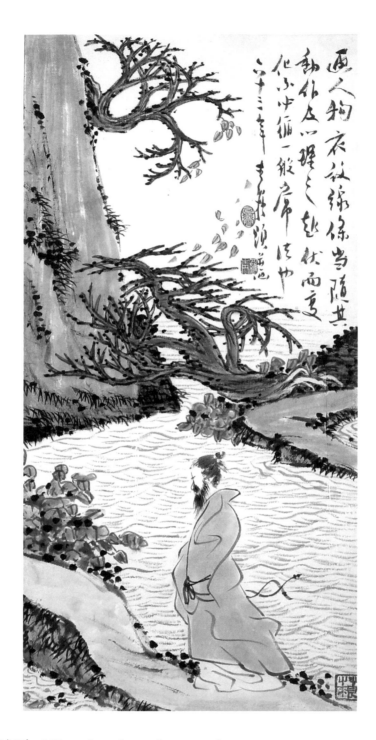

Figure 308. 澤畔行吟 / Chanting along the waterfront,
70 × 34 cm (1974)

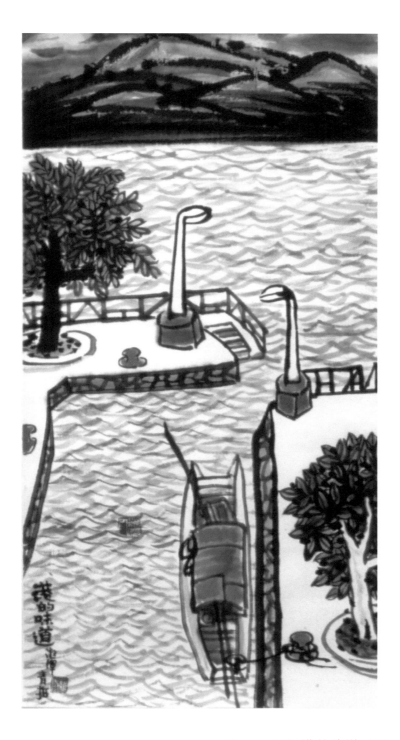

Figure 309. 港的味道 / The taste of the harbor,
69 × 35 cm (1974)

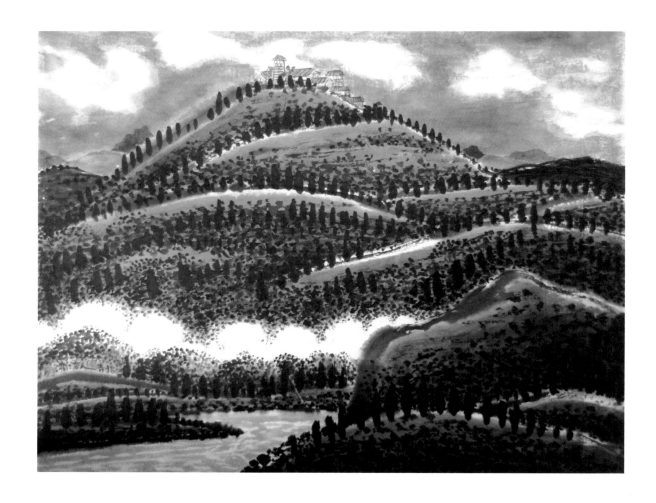

Figure 310. 夏日煙雲 / Misty clouds in summer,
51.2 × 64 cm (1976)

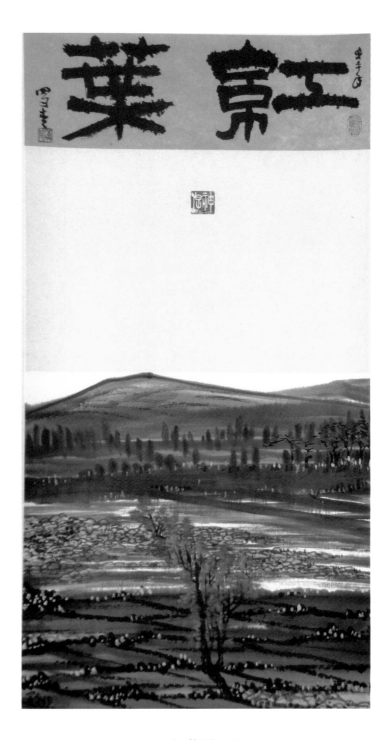

Figure 311. 紅葉照田野 / Red leaves lightening up the meadow, 33.5 × 34 cm (1976)

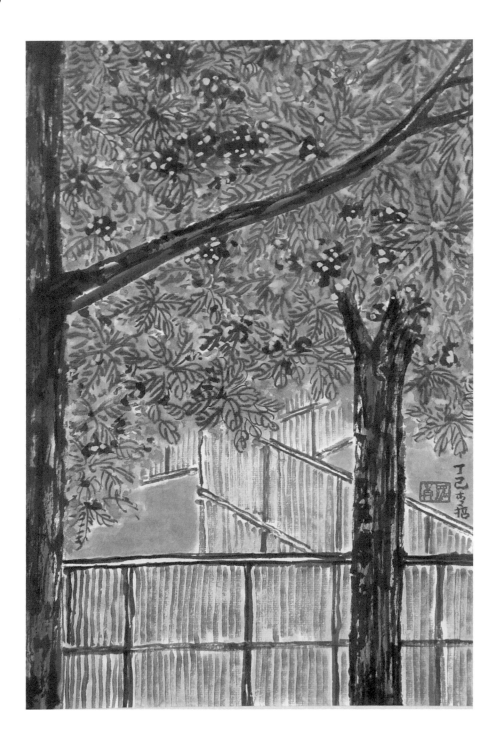

Figure 312. 夏蔭 / Summer shade,
38 × 34 cm (1977)

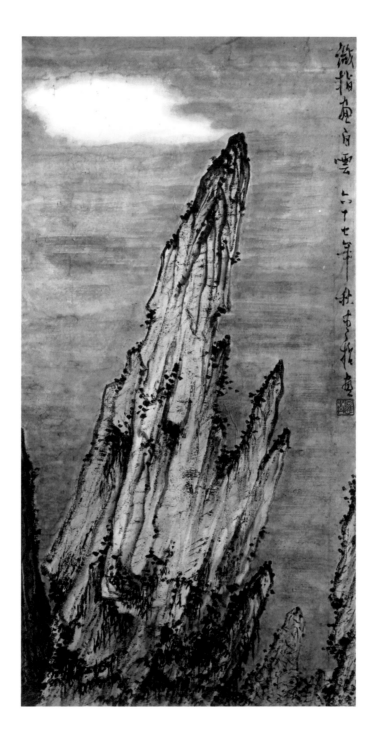

Figure 313. 纖指畫白雲 / Slender fingers drawing the white clouds, 69 × 34 cm (1978)

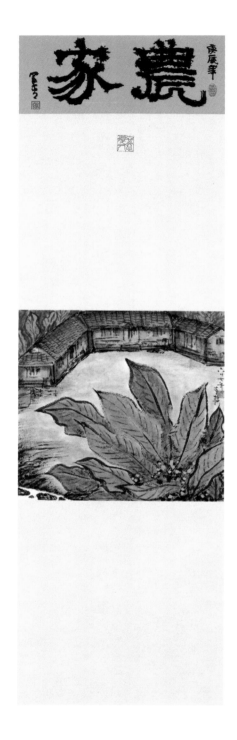

Figure 314. 農家紅瓦屋 / Farm houses on a summer afternoon,
34 × 34.5 cm (1978)

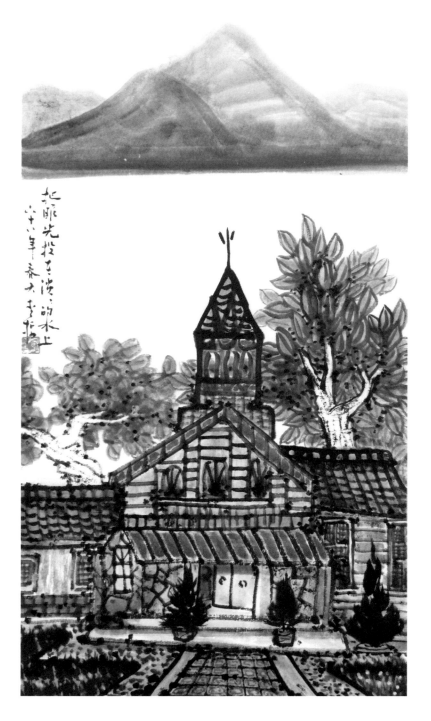

Figure 315. 把眼光投在淡淡的水上 / Glancing at the gentle river,
69 × 45 cm (1979)

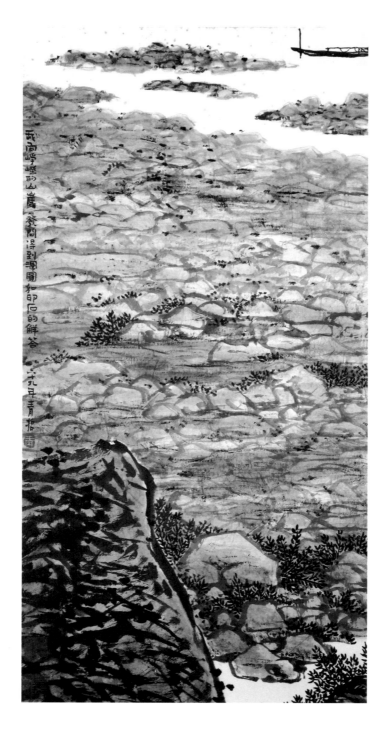

Figure 316. 渾圓的解答 / Pebbles are the ultimate answers,
69 × 45 cm (1980)

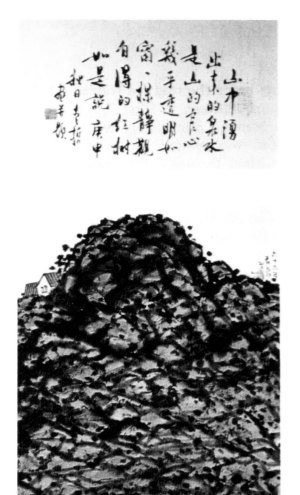

Figure 317. 透明如窗 / Translucent as a window,
69 × 34 cm (1980)

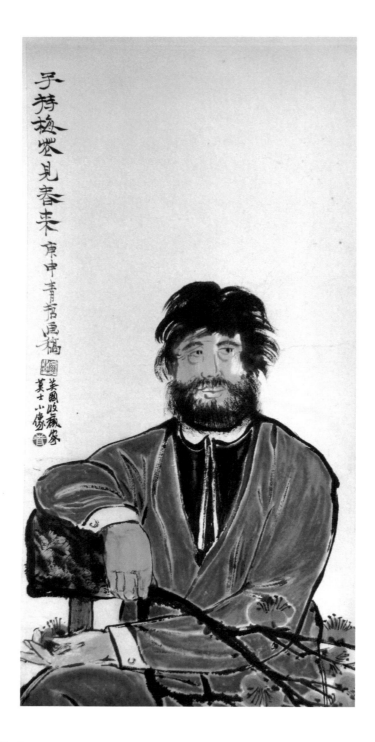

Figure 318. 默士小像 / A portrait of Mr. Moss,
69 × 34.5 cm (1980)

Select Achievements and Works of Lo Ch'ing

Brief Timeline

1948	Born in Tsingtao, Shantung Province, China
1949	Moved to Taiwan
1970	B.A., English, Fu Jen Catholic University, Taiwan
1974	M.A., Comparative Literature (minors in Anglo-American Literature and Art History and Literature), University of Washington, Seattle

Professional Experience

2014	Visiting Professor and Artist, Changsha Normal University, Changsha, Hunan
2013	Visiting Professor and Artist, College of Arts, Shanghai Normal University, Shanghai
2012	Visiting Professor and Artist, College of Arts, East China Normal University, Shanghai
2011	Visiting Professor and Artist, Chinese Art Academy, Beijing
2007–2009	Professor of English and Chinese and Director of Art Center, Mingdao University, Taiwan
2006	Visiting Professor and Artist, Shanghai University, Shanghai
2005	Visiting Professor and Artist, San Diego Museum of Art
2004	Visiting Professor and Artist, Reed College, Oregon
2003	Visiting Professor, Summer Institute of Chinese Art Connoisseurship, University of Maryland
2002	Visiting Professor, Summer Institute of Chinese Art Connoisseurship, University of Maryland
2002	Visiting Professor, Department of Art History, Heidelberg University
2001	Visiting Professor, Summer Institute of Chinese Art Connoisseurship, University of Maryland

2001	Visiting Professor, Department of Chinese, Charles University, Prague
2000	Visiting Professor, Department of Art History, University of Sussex
1994	Visiting Professor, Department of Chinese, Wadham College, Oxford University
1993	Fulbright Scholar and Artist, Visiting Professor, Department of English and Comparative Literature, and Department of Art, Washington University, St. Louis
1990	Visiting Professor, Department of Art History, SOAS, London University
1981–2003	Professor of the English Department, Art Department, and the Graduate School of English Literature, the Graduate School of Art and Art History, the Graduate Institute of Translation and Interpretation, National Taiwan Normal University
1996–2002	Director, Center of Chinese Language and Culture Studies, National Taiwan Normal University
1991–2001	Editor in Chief, Ts'ang Hai Art and Aesthetic Series, Tung-ta Publishing House and San-ming Publishing House, Taipei
1980–1997	Associate Professor, Department of English, National Taiwan Normal University
1974–1980	Associate Professor, Department of English, and the Graduate School of English Literature and the Graduate School of Chinese Literature, Fu Jen Catholic University, Taiwan

Awards and Honors

1963	First Prize, Chinese Ink Painting Competition, Keelung, Taiwan
1969	First Prize, Chinese Calligraphy Competition, Fu Jen Catholic University, Taiwan
1974	First Prize, Chinese Modern Poetry Award, Taipei
1987	First Prize, Lion Biennial Chinese Ink Painting Award, Taipei
1993	Fulbright International Exchange Scholar Award, Scholar and Artist in Residence, Washington University, St. Louis
1994	"Text and Image: A Study of the Signifier System and

Mode of Thought." Prize for Best Paper, International Conference on Chinese Art and Aesthetics, University of East Anglia

1996 Twenty-Seventh Poetry International Award, Rotterdam

1996 Grant from Nobel Prize in Literature Committee to visit Stockholm, and give lectures and participate in colloquia

1996 Best Collected Poems for Teenagers, Taiwan: *Songs of Teenager A-t'ien* 《少年阿田恩仇錄》

1999 Best Collected Poems, Taiwan: *Book of Matches* 《一本火柴盒》

2000 100 Best Books for Children in the 20th Century, Taiwan: *Fireflies: Collected Poems* 《螢火蟲》

Books by Lo Ch'ing in Chinese

羅青詩集. 詩畫集 Lo Ch'ing: Collected Poems and Paintings

2006	羅青 《螢火蟲手抄本》 台北，民生報出版社
2005	羅青 《吃西瓜的方法》 (修訂本) 台北，麥田出版社
2000	羅青 《一本火柴盒》 台北，民生報出版社
1996	羅青 《少年阿田恩仇錄》 台北，民生報出版社
1988	羅青 《錄影詩學》 台北，書林出版社
	羅青 《我發明了一種藥》 台北，親親出版社
1987	羅青 《螢火虫》 台北，台灣書店出版社
1984	羅青 《不明飛行物來了》 台北，純文學出版社
1981	羅青 《水稻之歌》 台北，大地出版社
1978	羅青 《隱形藝術家》 (詩 / 攝影集) 台北，崇偉出版社
1977	羅青 《捉賊記》 台北，洪範出版社
1975	羅青 《神州豪俠傳》 台北，武陵出版社
1972	羅青 《吃西瓜的方法》 台北，幼獅書店出版社

羅青散文集 Lo Ch'ing: Collected Personal Essays

2003	羅青 《詩眼照天涯: 招牌篇》 (散文/攝影集) 台北，世新大學出版社
	羅青 《詩眼照天涯: 窗戶篇》 (散文/攝影集) 台北，世新大學出版社
	羅青 《詩眼照天涯: 綠樹篇》 (散文/攝影集) 台北，世新大學出版社
	羅青 《詩眼照天涯: 雕像篇》 (散文/攝影集) 台北，世新大學出版社

羅青 《詩眼照天涯: 動物篇》(散文/攝影集) 台北，世新
大學出版社

1989　羅青 《七葉樹》 台北，五四出版社

1976　羅青 《羅青散文集》 台北，洪範出版社

羅青詩論集 Lo Ch'ing: Collected Essays on Poetry

2007　羅青 《小詩三百首》(修訂本) 鹿港:左羊出版社

1995　羅青 《詩的風向球》 台北:爾雅出版社

1994　羅青 《詩的照明彈》 台北:爾雅出版社

1988　羅青 《詩人之燈》 台北:三民書局出版社

1984　羅青 《荷馬史詩研究》 台北:學生書局出版社

1978　羅青 《從徐志摩到光中》 台北:爾雅出版社

羅青書畫集 Lo Ch'ing: Catalogs of Solo Exhibitions of Calligraphy and Paintings

2012　羅青 《熊貓之歌》(書畫集), 台北: 99藝術中心

羅青 《芸窗密境: 小品書畫集》, 上海:德佳藝術空間

2011　羅青 《小品大境界：小品書畫集》(書畫集), 台北: 99藝術中心

羅青 《非常羅漢》(書畫集), 台北: 99藝術中心

2010　羅青 《小景大宇宙:小品書畫集》(書畫集), 上海:德佳藝術空間

羅青 《一人文化大革命》(書畫集), 台北: 99藝術中心

2008　羅青 《後現代的探索：上海六十回顧展》上海:太陽虹畫廊

2007　羅青 《現代的反省：繪畫記號學三部曲》 上海:太陽虹畫廊

2006　羅青 《古典的翻新：羅青的世界》 上海:太陽虹畫廊

2001　羅青 《方寸千里》 台北，真賞出版社

1997　羅青 《鐵網皴法》 台北:真賞出版社

1995　羅青 《鋼鐵山水》 台北:真賞出版社

1993　羅青 《羅青書畫三十年》 台北:國立台灣美術館

羅青書畫/美學/語言論集 Lo Ch'ing: Collected Essays on Calligraphy, Painting, Aesthetics, and Language

2009　羅青編 《明道英語讀本第二冊》鹿港:左羊出版社

2008　羅青編 《明道英語讀本第一冊》鹿港:左羊出版社

羅青編著 《英文文法是一匹魔法白馬》 臺北:五南出版社

2006　　羅青　《指上美學—高其佩研究》　北京:河北教育出版社
2005　　羅青　《任熊研究》　台北 / 香港:真賞出版社
2003　　羅青　《情深筆墨靈 》　台北:雄獅美術出版社
　　　　羅青　《紙上飄清香》　台北:雄獅美術出版社
　　　　羅青　《畫外笛聲揚》　台北:雄獅美術出版社
2002　　羅青　《無用之用—中國文字書法之演變》　台北:真賞出版社
1995　　羅青　《原型與象徵：羅青看電影》　台北:三民書局出版社
1991　　羅青　《水墨之美》　台北:幼獅書店出版社
1989　　羅青　《什麼是後現代主義》　台北:學生書局出版社

書畫合集 Catalogs of Group Exhibitions of Calligraphy and Painting

2014　　羅青編《青. 舟已過萬重山—羅青、一舟書畫合集》上海:Smart畫廊
2007　　羅青編 《石頭碰上磚頭—羅青、嚴力雙人展》上海:太陽虹畫廊
2006　　羅青編《與古今對話—羅青、周紹華、姜寶林書畫合集》上海:太陽虹畫廊
2005　　楊思勝編 《華夏繫情：海內外十家書畫集》 (黃君實、歐豪年、周 澄、楊思勝、謝春彥、徐湖平、傅益瑤、羅青、陳健坡、林章湖), 上海:上海古籍出版社

Articles and Presentations by Lo Ch'ing in Chinese and English

2015　　＜咽下一枚鐵做的月亮—弔青年天才詩人許立志 (1990–2014)＞《聯合報》 "聯合副刊" 2015年 1月 7日。
2014　　＜嚇死倉頡—回到造字之前:興之美學與當代書法＞ "蘭亭論壇—日常書寫研討會," 紹興理工學院, 2014年 11月 22–26日。
　　　　＜興之美學: (三)套式語言與興之美學之二＞ 《聲韻詩刊》, 18期 2014年 12 月 15日, 頁68–71。
　　　　＜興之美學: (三)套式語言與興之美學之一＞ 《聲韻詩刊》, 18期, 2014年 8月 15日, 頁103–7。
　　　　＜興之美學: (二)興會抒發式的美學傳承＞ 《聲韻詩刊》, 18期, 2014年 6月 15日, 頁90–100。
　　　　＜興之美學一唯一可與西方模擬再現美學抗衡的中國美學: (一)西方分析 性敘事建構美學的發展與變化＞《聲韻詩刊》, 17期, 2014年 4月 15日, 頁77–91。

	＜頹頡子久—賓虹: "亂柴皴"之創造＞《詩書畫》第13期, 2014年 3月, 頁146–53。
2013	＜范寬 "溪山行旅圖"為何不重要?＞《中國時報》"人間副刊," 2013年 2月 27日–28日。
2012	"O' Panda an' Man: Songs of Panda." In *Lo Ch'ing: O' Panda an' Man*, 4–5. Taipei: 99 Degrees Art Center, 2012.
	"On Ceramic Painting, The Aesthetics of Ceramic Painting: A New Approach." In *Lo Ch'ing: Ceramic Painting*, 1:3–4. Taipei: 99 Degree Art Center, 2012.
	"Panda, a Pensive Confucian Gentleman of Our Times." In *Songs of Panda*, 6–7. Taipei: 99 Degrees Art Center, 2012.
2011	＜手卷思考敘事表意畫的美學原則—以清明上河圖為例＞北京故宮博物院編《清明上河圖新論》北京:故宮出版社, 2011年, 頁148–68。
	＜富春山居圖的重要性何在?—論手卷思考之形成與發展＞《詩書畫》第3期, 2011年, 3月, 頁92–107。
2010	＜顧虎頭畫虎—論女史箴圖卷為顧愷之真跡＞《中國時報》"人間副刊," 2010年 7月 1日。
	"See a Cosmos in a Vignette." In *See a Cosmos in a Vignette: Lo Ch'ing's Lyrical Vignette*, 5–6. Taipei: 99 Degrees Art Center, 2010.
2009	"Visual Thinking and Verbal Perception: A New Approach to Teaching English Grammar to Chinese Students," Conference on Art and Literature, School of Liberal Arts, Mingdao University, Changhua, Taiwan, May 22, 2009.
	"On the Ink-Color Painting of Ch'i Pai-shih," Conference on the Art of Ch'i Pai-shih, Taichung Sea Port Art Museum, Taiwan, May 3, 2009.
2008	"New Approaches in Contemporary Chinese Ink-color Painting," New Ink Art Forum: Innovation and Beyond, Hong Kong Museum of Art, Aug. 23, 2008.
	"Five Ways of Looking at a Floating Boat," International Conference on the Aesthetics and Theories of Chinese Ink Painting, Asia Society & Association of Modern Chinese Art, New York, May 17–18, 2008.
2007	"The Ventriloquist behind the Mouthpiece, An Innovative Approach to the Teaching of English as a Foreign Language." The 1st International Conference on Teaching English at Taiwan Universities: Innovative Ap-

proaches. Changhua, Mingdao University, Taiwan, Oct. 2007.

"The Aesthetic of Hsing, the Only Chinese Aesthetic That Can Confront the Western Aesthetic of Mimesis." The Conference of the 3rd International Biannual Art Exhibition, Chengdu, China, Dec. 2007.

2005 "On Connoisseurship: With Wen Po-jens's Painting as an Example." International Conference on Chinese Painting. Shanghai Museum, Shanghai, China, 2005.

"The Aesthetic Dilemma Confronted by the Chinese American Artist: On the Painting and Calligraphy of C.C. Wang." 2005 Chinese American Studies Conference, Chinese Historical Society of America. Asian American Studies Dept., San Francisco State University, Oct. 6–9.

2003 "Typology, Discourse, and Connoisseurship in Chinese Landscape Painting: A Linguistic Approach." Lecture at the Department of Art History and Archaeology University of Maryland, College Park, July 21.

2002 "Chang Chung's Art Reevaluated: The Bridge of the Bird and Flower Painting between the Sung and Ming." International Symposium on Painting and Calligraphy from Chin to Yuan. Shanghai Museum, China, Nov. 27–Dec. 2.

"A Palace Museum without a 'Palace'?" *Orientations* (May 2002): 77–78.

2001 "Aesthetics of Chinese Calligraphy in the Post-Industrial Era." International Symposium on Modern Chinese Calligraphy. National Taiwan Museum of Art, Taichung, Taiwan, Nov. 29–30.

"Trade Marks and Departmentalization: Shanghai School and Metropolitan Art Style." International Symposium on Shanghai School Painting. Shanghai Fine Arts Publishers, Shanghai, China, Dec. 16–20.

"Typology, Discourse, and Connoisseurship." Conference and Workshop on Connoisseurship in Chinese Painting. Department of Art History and Archeology, University of Maryland, College Park, July 16–August 15.

"Pursuing the Idea of Yang: The Ultimate Concern in Chinese Landscape Painting." Value Systems in the Arts of India and China: New Approaches to the Textual Sources (II). Dept. of Art History, University of Sussex,

	Grant from Arts and Humanities Research, Lewes, England, June 15–17.
2000	"From Colors to Inks: The Change of Value in Chinese Landscape Painting" Value Systems in the Arts of India and China: New Approaches to the Textual Sources (I). Dept. of Art History, University of Sussex, Grant from Arts and Humanities Research, Lewes, England, June 15–17.
1999	"Chinese Ink Painting: A Postmodern Condition Past and Present." Conference on Art and Cultural Politics: China, Hong Kong and Taiwan. Department of Art History and Archeology, University of Maryland, College Park, MD, Dec. 16–19.
	"How to Teach Chinese Culture Class with a Linguistic Approach: Using Chinese Graphic Arts as Examples." Conference on Chinese Language Teaching. Columbia University, New York, Oct. 12–18.
1998	"Chinese Mode of Thought and Teaching Chinese as a Foreign Language." Conference on Teaching Chinese as a Second Language. Macau, China, April, 12–16.
1997	"International Cultural Exchanges: A Personal View." Conference on International Cultural Exchanges. National Taiwan Normal University, Taipei, June 5–8.
1996	"Teaching Chinese Painting from the View of Applied Linguistics." Conference on Art and Art Education, National Changhua Normal University, Changhua, Taiwan, May 11–15.
1994	"Text and Image: A Study of the Signifier System and Mode of Thought." International Conference on Chinese Painting and Its Place in the History of Art, University of East Anglia, Norwich, June 14–19.
1993	"Signifier Bound and Unbound: The Relationship between Text and Image in Contemporary Chinese Literature and Painting." The 45th Annual Meeting for the Association for Asian Studies (AAS). Los Angeles, April 13–19.
1991	"The Chinese New Poetry Movement and the Imagist Movement: Poetics, Technology, and Ideological Domination." *Pedagogy and Research* 13 (May 1991): 279–378.
1990	"Chinese Calligraphy." *The Chinese Pen Quarterly* (summer 1990): 49–61.

1989 "From the Cult of Technology to the Vicissitude of Ideology." *The Chinese Pen Quarterly* (autumn 1989): 37–48.

1987 "On Contemporary Chinese Painting," Preface, Exhibition of Young Artists of Taiwan, East-West Center. Institute of Culture and Communication, Honolulu, March–April 1987.

 "The Chinese Language and Chinese Landscape Painting." *Studies in English Literature and Linguistics* (May 1987): 77–104.

1986 "Chinese Language and Chinese Landscape Painting: A Semiotic View." Arts of the Land Conference, East-West Center, Honolulu, July 1986.

1984 "Latin American Poetry in Taiwan." *The Chinese Pen Quarterly* (summer 1984): 54–73.

1983 "The Opaque Tears: On the Art of Ho Chin-shui," *The Chinese Pen Quarterly* (spring 1983): 50–63.

1983 "How to Drown a Tabby: A Study on Thomas Gray's Poetry." *Studies in English Literature and Linguistics* 9 (April 1983): 50–66.

1982 "The Art of Wang Lan." *The Chinese Pen Quarterly* (autumn 1981): 52–64.

1981 "A Painter and Poet of Repute Speaks Out: We Have to Be More Active in Establishing Art Theories." *The Economic News* (January 26, 1981).

1980 "Ssu-ma Hsiang-ju's Fu and John Lyly's Euphemism." *Tamkang Review* 10, nos. 3–4 (Sept. 1980): 385–413.

Solo Exhibitions, Early to More Recent

1973 Lo Ch'ing: Chinese Ink and Watercolor, First National Bank, Seattle

1980 Lo Ch'ing's Small Landscapes, Pan-hua-chia Gallery, Taipei

1982 Lo Ch'ing: Palm Tree Eulogy, Dragon Gate Gallery, Taipei

1986 Chinese Painting by Lo Ch'ing, Chinatown Cultural Services Center, New York State Council on the Arts, New York

1986 Lo Ch'ing: Ink Painting School of Semantics, Tun-huang Gallery, Taipei

1990 Find the Recluse? Chinese Calligraphy and Painting by

	Lo Ch'ing, Percival David Foundation of Chinese Art, London
1992	China, A Broken Mirror, Dragon Gate Gallery, Taipei
1993	China, A Broken Mirror: Four Seasons, St. Louis Art Museum, St. Louis
	China, A Broken Mirror: Thunder and Lightning, Ashmolean Museum, Oxford
	China, A Broken Mirror: From the South to the North, Asian Arts Center, Towson State University, Towson, Maryland
1995	Iron and Steel Landscape, Pacific Asia Museum, Pasadena, California
1997	Barbed-Wire-Textual-Strokes: City Landscapes, National Music Hall Gallery, sponsored by Chi-ch'ang Yuan Art Center, Taipei
1998	Guess What Will Happen Next? Hung Chan Art Center, Taipei
1999	Postmodern Ink-color in Taiwan, Shih Chung Culture Center Seoul, Korea
2001	Lo Ch'ing, Past and Present, NTNU Art Gallery, Art Dept. of NTNU, Taipei
	Lo Ch'ing's Ten-thousand Series, Gallery Ch'i-ya Chai, Hong Kong
	Calling for Jen-hsung: Calling to the Ancients series, Haishangshan Art Center, Shanghai
2002	Lo Ch'ing Poetry, Painting and Calligraphy, DAI, Heidelberg, Germany
	Lo Ch'ing's Hung Mountain, Haishengshan Art Center, Shanghai
	Lo Ch'ing's Vignette Painting, Gallerie Encre de Chine, Paris
2003	The Art of Lo Ch'ing, Cooley Memorial Art Gallery, Reed College, Portland, Oregon
	Lo Ch'ing's Painting and Calligraphy, La Fabbrica (Franco Beltrametti Foundation) Losone, Switzerland
	The Art of Lo Ch'ing, Apex Gallery, Gottingen, Germany
	Hommage a la Poese des dynasties Tang et Sung, Gallerie Encre de Chine, Paris
2004	The Art of Lo Ch'ing, Honhardt Art Festival, Honhardt

	The Traveling Stones, 4th. Milan X'po: St. Maria delle Grazie, Milan
2005	Lo Ch'ing: Separated Yet Not Separated, LMAN Art Gallery, Los Angeles.
2006	Lo Ch'ing: Painting and Calligraphy, Sunbow Art Gallery, Shanghai
	Aesthetic of Urban Landscape, Sunbow Art Gallery, Shanghai, 2007
2008	Postmodern Approach of Ink-color Painting, A Semiotic Trilogy, Sunbow Art Gallery, Shanghai
2009	Lo Ch'ing: A Retrospective, Goedhuis Contemporary, New York
	Lo Ch'ing: A 60th Birthday Retrospective, Daxi Artist House, Taoyuan, Taiwan
2010	One Man's Cultural Revolution: Lo Ching's Landscape Counter-Revolution, 99 Art Center, Taipei, Taiwan
	See a Universe in a Vignette, Degas Art Center, Shanghai Neo-Arhats, 99 Art Center, Taipei
2012	Modern Chinese Painting, British Museum, London, May 3–Sept.
	Songs of the Panda, 99 Art Center, Taipei
	Cryptic Views through a Bamboo Window, Degas Art Center, Shanghai
2013	Songs of the Panda, Gallerie Encre de Chine, Paris
2014	Lo Ch'ing: Flowers and Birds, 99 Art Center, Taipei
	Lo Ch'ing: In Conversation with the Masters, Goedhuis Contemporary, London

Group Exhibitions

1980	Exploration of Modern Chinese Painting. Spring Gallery, Taipei.
1982	Leading Painters of Taiwan and Hong Kong. Dragon Gate Gallery, Taipei.
1986	The 22nd Annual Modern Art of Asia Exhibition. Tokyo Museum, Tokyo.
	Arts of the Land. East-West Center, Honolulu.
	Poetry and Painting of the Republic of China. Brussels Gallery, Brussels.
1987	The Second Biennial Chinese Ink Painting, Lion Art Magazine, Taipei.

1988	Time and the Unprecedented: Contemporary Arts in the R.O.C. Taipei Fine Arts Museum.
	The Third Asian International Art Exhibition, Committee Asian International Art Exhibition. Fukuoka, Japan: The National Museum of Contemporary Art.
1989	The Beijing Modern Chinese Painting Exhibition. The China Art Museum, Beijing.
1996	First National Ink Painting Exhibition. Institution of National Art Education, Taipei.
	Legacy and Transition of Ink Painting. Chinese Culture Center, San Francisco.
1997	Legacy and Transition of Ink Painting, Exhibition of Ten Artists from Taiwan. Macao and Hong Kong Cultural Center.
	The Flowering Field, Contemporary Chinese Painting, Kaikodo and Luen Chai, New York and Hong Kong.
1998	Second National Ink Painting Exhibition. Institution of National Art Education, Taipei.
1999	Visions of Pluralism: Contemporary Art in Taiwan, 1988–1999. Shan Foundation for Arts, Culture, and Education, Beijing.
2000	Cross-century Exhibition of Chinese Ink Paintings: Touring Exhibition to Macedonia and Czech Republic of Works by Ten Contemporary Painters from Taiwan. Museum of the City of Skopje, Republic of Macedonia; The National Museum, Prague.
2001	Exhibition of Ink Paintings by Ten Distinguished Artists from Taiwan, China National Museum of Fine Arts, Beijing
2002	An Affinity to Mount Huang, Paintings and Calligraphy by Contemporary Chinese Artists. New York, Nanjing, Hefei, and Shanghai.
	Paintings of the Long River Group. Sun Yat Sen Memorial Hall, Taipei.
2003	Ink-color Paintings from Taiwan. Warsaw.
	Spring Painting Festival, Chinese Artists from Mainland and Overseas. Shanghai.
2006	Three Wintry Friends: Lo Ch'ing, Zhou Shaohua, Jiang Baolin. Sunbow Art Gallery, Shanghai.
2007	When Stone Meets Brick: The Art of Lo Ch'ing and Yan Li. Sunbow Art Gallery, Shanghai.

2008	The 20th International Fine Art and Antique Dealers Show. New York.
2009	The New Aspect: 2009 Exhibition of Contemporary Cross-Strait Ink Paintings. National Taiwan Museum of Fine Arts, Taichung.
	New Chinese Ink-color Painting. Shanghai Chu Ch'i-chan Art Museum, Shanghai.
	Beyond China: New Ink Painting from Taiwan. Goed-huis Contemporary, South Kensington, London.
2012	Modern Chinese Ink Paintings. British Museum, London.
	Ink: The Art of China. Saatchi Gallery, Duke of York's HQ, London.
2014	Ink as Experience: Trans-boundary. Shanghai Chu Ch'i-chan Art Museum, Shanghai.
2014	Endless Mountains, Lo Ch'ing and Yi Chou, a Joint Exhibition. Smart Gallery, Shanghai, Nov. 9–29, 2014.

Public Collections

1990	Percival David Foundation of Chinese Art, London
	British Museum, London
1991	Royal Ontario Museum, Canada
	The Saint Louis Art Museum, St. Louis
1992	Museum für Ostasiatische Kunst, Berlin
	Seijo University, Tokyo
	Taipei Fine Arts Museum, Taiwan
	Royal Ontario Museum, Canada
	The Saint Louis Art Museum
1993	Ashmolean Museum, Oxford University
1994	Liaoning Provincial Art Museum, Shenyang, China
1995	Hong Kong Min Chiu Society
1996	Asia Society, New York
1997	Hong Kong Min Chiu Society
2001	Hong Kong Min Chiu Society
	China National Museum of Fine Arts, Beijing, China
2002	Keelung Culture Center, Taiwan
2003	National Taiwan Art Museum, Taiwan
2004	Kaohsiung Art Museum, Taiwan
2007	Chinese Garden, Huntington Library, Los Angeles, USA
2008	Tao-yuan Municipal Art Museum, Taiwan
	Orego Art Foundation, Switzerland

Select Bibliography of Writings on Lo Ch'ing in Chinese

2010 蕭芳珊 《羅青詩藝研究》碩士論文 (台中: 逢甲大學中文研究所, 2010)

2004 曾蕭良 《台灣現代美術大系:水墨類—意象構成水墨》(台北: 行政院文化建設 委員會 / 藝術家出版社, 2014)

2002 林怡君《台灣當代水墨畫中的後現代傾向之研究》彰化師範大學藝術教育研究所碩士論文 (彰化: 彰化師範大學, 2002)

1999 陸蓉之 《複數元的視野: 台灣當代美術1988–1999》 (高雄: 行政院文化建設委員會 / 山藝術文教基金會, 1999)

1990 郭繼生《羅青畫集》(台北 : 東大圖書公司, 1990)

Select Bibliography of Studies of Lo Ch'ing in Western Languages, Including Translations of His Poetry

2015 Andrš, Dušan, trans. *Lo Ch'ing: Báseň je kočka* [Luo Ch'ing: Poetry is a Cat]. Prague: Mi:lu, 2015.

DuPertuis, Lindsay. "Travel and the Narrative Landscape," *Lo Ch'ing: The Poetry of Postmodern Landscape*. College Park, MD: University of Maryland, 2015. http://the-poets-brush.artinterp.org/omeka/.

Isto, Raino. "Painting (in) the Anthropocene," *Lo Ch'ing: The Poetry of Postmodern Landscape*. College Park, MD: University of Maryland, 2015. http://the-poets-brush.artinterp.org/omeka/.

Kim, Suzie. "Colorful Landscapes: The Four Seasons," *Lo Ch'ing: The Poetry of Postmodern Landscape*. College Park, MD: University of Maryland, 2015. http://the-poets-brush.artinterp.org/omeka/.

McGinnis, Rebecca. "Lo Ch'ing: Peach Blossom Spring Reinvented." Unpublished paper.

2014 Kuo, Jason C. *Lo Ch'ing: In Conversation with the Masters*. London: Goedhuis Contemporary, 2014.

Manfredi, Paul. *Modern Poetry in China: A Visual-Verbal Dynamic*. Amherst, New York: Cambria Press, 2014.

Rosemont, Connie. "Lo Ch'ing's Shared Landscape: A Postmodernist Optimist." Unpublished paper.

Sand, Olivia. "Profile: Lo Ch'ing," *Asian Art Newspaper* 17 no. 10 (London: Asian Art Newspaper Ltd., 2014).

2013 Mackenzie, Colin, ed. *The Chinese Art Book*. London: Phaidon Press, 2013.

Leys, Simon. *The Hall of Uselessness: Collected Essays*. New York: The New York Review of Books, 2013.

2012 Von Spee, Clarissa. *Modern Chinese Ink Paintings*. London: British Museum. 2012.

Goedhuis, Michael, ed. *Ink: The Art of China.* London: Saatchi Gallery, 2012.

2011 Lee, De-nin Deanna. "Chinese Painting: Image-Text-Object." In *A Companion to Asian Art and Architecture.* Edited by Rebecca M. Brown and Deborah S. Hutton, 563–79. Boston: Wiley-Blackwell, 2011.

2010 Kuo, Jason C. *Chinese Ink Painting Now.* New York: Distributed Art Publishers, Inc. 2010.

Wang, Jen-Yu. "Luo Qing's Paintings of Post-Industrial Taiwan and Their Incompatibility with Guohua." Master's Thesis, College Park, MD: University of Maryland, 2010.

2008 Allen, Joseph. *Lo Ch'ing.* New York: Goedhuis Contemporary New York, 2008.

Marijnissen, Silvia. "From Transparency to Artificiality: Modern Chinese Poetry From Taiwan after 1949." Ph.D. dissertation, Leiden: Leiden University, 2008.

2004 *Lo Ch'ing: Wang Wei, Leere Berge / Montagne Vuote* [Handmade book, in German, Italian, and Chinese]. Switzerland: Divan Press, 2004.

Ruchat, Anna. *Lo Ch'ing, sei metodi per mangiare un'anguria* [translation in Italian, German with Chinese text]. Milan and Pavia: Fondazione Franco Beltrametti, 2004.

2003 Cook, Silas B. *Lo Ch'ing: Painting and Poetry.* Portland: Douglas F. Cooley Memorial Art Gallery, Reed College Press, 2003.

Ruchat, Anna, trans. [of Hyner's German translation]. *Sei metodi per mangiare un'anguria.* Riva San Vitale: Fondazione Franco Beltrametti.

2002 Hyner, Stefan, trans. and Lothar Ledderose, intro. *Lo Ch'ing: Einen versteckten Drachen wecken* [poetry and calligraphy, German translation with Chinese text]. Locarno: Mendrisio Press and Taipei and Heidelberg: Chengshang Publishing House.

1999 *Lyrisme et extrême-orient.* Issue 1 of *Neige d'août.*

1997 *Made in Taiwan: Een bloemlezing.* Issue 4 of *Het trage vuur.*

1996 Malmqvist, Goran. *The Poetry and Painting of Lo Ch'ing* [Swedish translation with introduction]. Stockholm: Fenix Atlantis, 1996.

Chattopadhyay, Collette. "In the Mind's Eye." *Asian Art*

News 6, no. 1 (Jan.–Feb. 1996): 64–65.

Liu, Manni, ed. *Legacy and Transition of Ink Painting.* San Francisco: Foundation of Chinese Culture, 1996.

1993 Owyoung, Steven D. *Currents 54: Lo Ch'ing.* Saint Louis: The Saint Louis Art Museum, 1993.

Duffy, Robert W. "Lo Ch'ing Distills the Essence of Our Time." *St. Louis Post-Dispatch*, May 2, 1993.

Allen, Joseph R. *Forbidden Games and Video Poems: The Poetry of Yang Mu and Lo Ch'ing* [Translation in English with introduction and Chinese text]. Seattle and London: University of Washington Press, 1993.

1991 Joseph R. Allen. "The Postmodern (?) Misquote in the Poetry and Painting of Lo Ch'ing." *World Literature Today* 65, no. 3 (summer 1991): 421–26.

1990 Checkland, Sarah Jane. "The New China Syndrome." In 羅青畫集, edited by Jason C. Kuo, 80–81. Taipei: Tung-ta, 1990.

Whitfield, Roderick. "Lo Ch'ing's Paintings: First Encounter." In 羅青畫集, edited by Jason C. Kuo, 78–79. Taipei: Tung-ta, 1990.

1986 Allen, Joseph R. "Lo Ch'ing's Poetics of Integration: New Configurations of the Literati Tradition." *Modern Chinese Literature* 2, no. 2 (autumn 1986): 143–69.

1984 Cheung, Dominic, translator. "Dawn Light: Six Young Poets from Taiwan." In *Trees on the Mountain: An Anthology of New Chinese Writing*, edited by Stephen C. Soong and John Minford, 271–304. Hong Kong: The Chinese University Press, 1984.

About the Author

Jason C. Kuo is Professor of Art History and Archaeology and a member of the Graduate Field Committee in Film Studies at the University of Maryland, College Park, USA. He has taught at the National Taiwan University, Williams College, and Yale University. He was a Fellow at the Freer Gallery, a Stoddard Fellow at the Detroit Institute of Arts, and an Andrew W. Mellon Fellow at the Metropolitan Museum of Art, and he has received grants from the J. D. Rockefeller III Fund, the National Endowment for the Humanities, and the Henry Luce Foundation.

He is the author of *Wang Yuanqi de shanshuihua yishu* [Wang Yuanqi's art of landscape painting] (1981), *Long tiandi yu xingnei* [Trapping heaven and earth in the cage of form] (1986), *The Austere Landscape: The Paintings of Hung-jen* (1992), *Yishushi yu yishu piping de tanshuo* [Rethinking art history and art criticism] (1996), *Art and Cultural Politics in Postwar Taiwan* (2000), *Yishushi yu yishu piping de shijian* [Practicing art history and art criticism] (2002), *Transforming Traditions in Modern Chinese Painting: Huang Pin-hung's Late Work* (2004), *Chinese Ink Painting Now* (2010), *The Inner Landscape: The Paintings of Gao Xingjian* (2013).

He has curated exhibitions such as *Innovation within Tradition: The Painting of Huang Pin-hung* (1989), *Word as Image: The Art of Chinese Seal Engraving* (1992), *Born of Earth and Fire: Chinese Ceramics from the Scheinman Collection* (1992), *Heirs to a Great Tradition: Modern Chinese Paintings from the Tsien-hsiang-chai Collection* (1993), *The Helen D. Ling Collection of Chinese Ceramics* (1995), *Double Beauty: Qing Dynasty Couplets from the Lechangzai Xuan Collection* (with Peter Sturman) (2003), and *The Inner Landscape: The Films and Paintings of Gao Xingjian* (2013).

His edited books include *Discovering Chinese Painting: Dialogues with Art Historians* (2006), *Visual Culture in Shanghai, 1850s–1930s* (2007), *Perspectives on Connoisseurship of Chinese Painting* (2008), *Stones from Other Mountains: Chinese Painting Studies in Postwar America* (2009), and *Contemporary Chinese Art and Film: Theory Applied and Resisted* (2013).

His writings have appeared in a broad spectrum of publications, including *Art Journal, Asian Culture Quarterly, Chinese Culture Quarterly, Chinese Studies, Ming Studies, National Palace Museum Bulletin, National Palace Museum Research Quarterly, Orientations, China Quarterly, China Review International, Journal of Asian Studies, Journal of Asian and African Studies,* and *Ars Orientalis.*

His essay "Beauty and Happiness: Chinese Perspectives," based on a lecture he delivered in the Darwin College Lecture Series at Cambridge University, has just been published by Cambridge University Press (UK). He currently serves on the International Advisory Board of the *Journal of Contemporary Chinese Art* and the Editorial Board of the book series Philosophy of Film, published by Brill.